MODIGLIANI *a memoir*

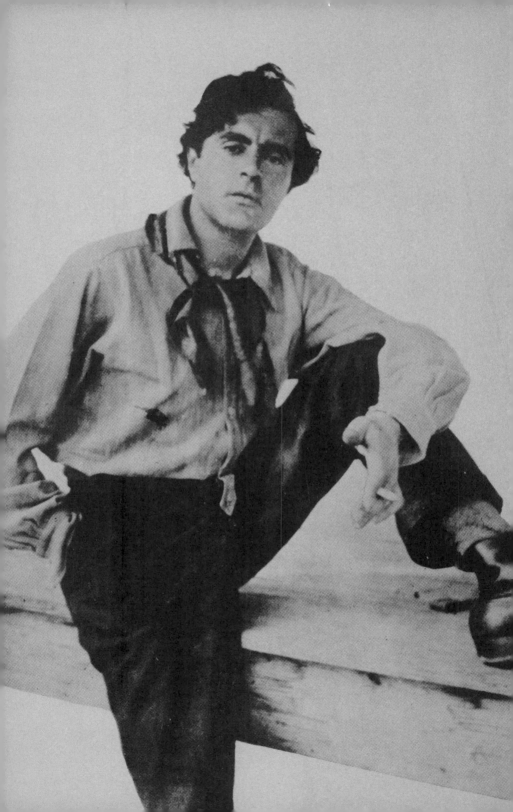

André Salmon

MODIGLIANI
a memoir

*translated by Dorothy and
Randolph Weaver*

G. P. Putnam's Sons **New York**

The author

FIRST AMERICAN EDITION, 1961
© 1961 BY JONATHAN CAPE LTD

This book is an adaptation of a work by André Salmon which was published in France by Editions Seghers under the title *La Vie Passionnée de Modigliani*, © 1957 by Editions Gérard & Co., Verviers, and L'Intercontinentale du Livre, Paris.

This edition designed by Germano Facetti.

Library of Congress Catalog Card Number: 61-6898.

MANUFACTURED IN THE UNITED STATES OF AMERICA

Contents

1

2

3

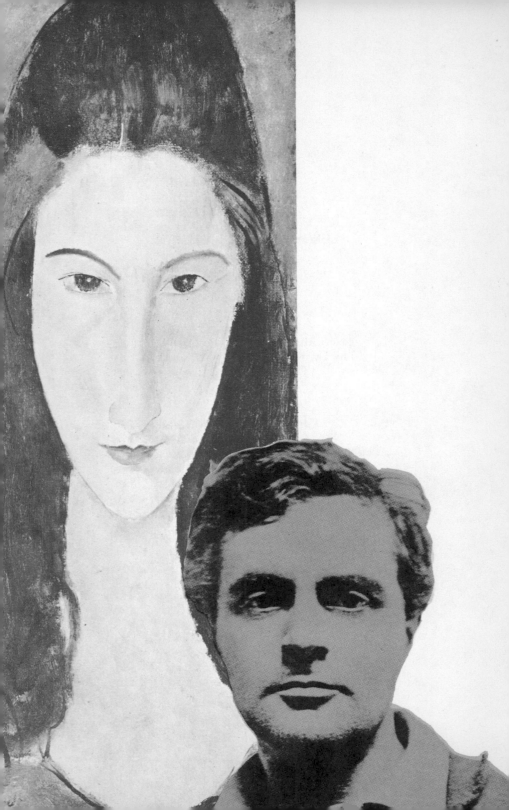

Illustrations

Introduction

AMEDEO MODIGLIANI was born in Leghorn, Italy, on July 12th, 1884, and first came to Paris in 1906, over half a century ago. I was twenty-five at the time, just a few years older than the man who was to become my friend and whose fame as an artist began only at his death.

Modigliani died tragically on January 25th, 1920, in the paupers' ward of a Paris hospital. His death was pathetic above all things – whose death is not? – but thanks to the efforts of a group of us, including Kisling, Ortiz de Zarate, Léopold Zborowski, and other close friends, he was given a truly magnificent funeral. Since then Zborowski too has drifted on as though he were entering a dream without end. Zarate died in New York under the scalpel of brain surgeons eager to try out their latest discoveries. Kisling died at Sanary-sur-Mer where he had established himself in his last years and where I am now writing this memoir. My house is filled with many associations with my work and my old friends; it looks out on the Mediterranean and is situated on what is now called the Boulevard Kisling, which the local mayor and I opened last year.

In the following pages I have tried faithfully to tell the story of Modigliani's life, much of which I witnessed. Though fate was too much for him in the end, the artist never ceased to face misfortune with a natural nobility of soul. His destiny was fulfilled in France; yet on his pauper's death-bed his last words were for his native land:

'Cara Italia.'

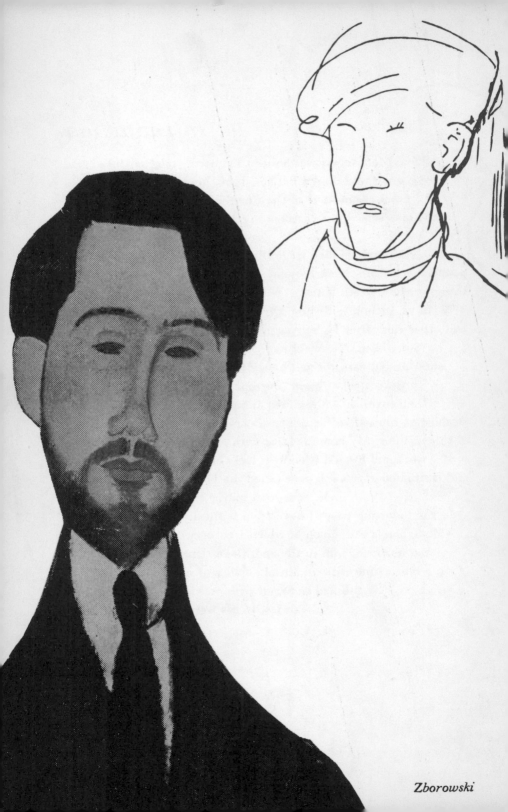

Zborowski

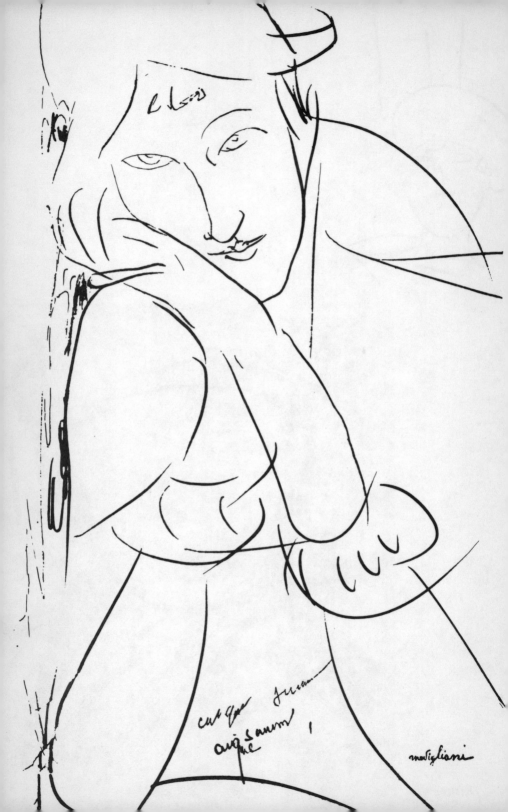

Part One

Modi, Open the Door!

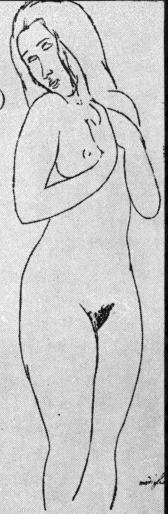

Galerie B. Weill
5o rue Taitbout Paris (9me)

EXPOSITION

des

PEINTURES

et de

DESSINS

de

Modigliani.

du 3 décembre au 3o décembre 1917.
(Tous les jours sauf les dimanches)

1 *Modi, Open the Door!*

'MODIGLIANI! Open up. Let me in. It's Ortiz. Ortiz de Zarate. Amedeo. Modi. Open the door, I say. I know you're in there. Are you there, Jeanne? Modi. Open the door, for God's sake. Jeanne. Modi. I'm sure you're both there. Please, please open up. Let me in, Amedeo. Modigliani!'

Zarate's anguished cries were punctuated by fierce blows and kicks on the door, but he was unable to force it open.

'What's all this noise about?' demanded the concierge, who had come running to see what was going on. 'Oh, it's you, M. Ortiz. I could hear you from upstairs, where I was just taking up the post. What's the good of yelling and pounding like that? Can't you see there's nobody at home?'

'Ay de mi!'

'What does that mean?'

'It means that I am terribly afraid. It means that I think — no, I'm sure — Modigliani is in there. So if he doesn't open the door ... Modi! Open up! It's me. It's your old friend Ortiz.'

He gave the door another kick and the concierge lost her temper. 'Oh no you don't!' she exclaimed. 'You're not going to keep that up. Look here, M. Ortiz: you haven't been taking another little dose of that hashish, have you?'

'No, madame, I have not taken any hashish.'

'Well, maybe he has, then.'

'If he had, we should have heard him laughing or moving about violently — unless ... '

'Unless he's not in, of course. You shouldn't let your ideas run away with you.'

'How can I help them running away with me, as you call it, when I can't get any news?'

'You didn't think to ask for him at the Rotonde?'

'Of course I did. I asked at the Rotonde and at the Dôme. Nobody has seen him for three or four days. How long since you last saw him?'

'Three or four days, perhaps. But it wouldn't be the first time he'd gone gadding off with that girl — though it's hard to tell whether she lives here or not — I mean with him. Maybe she's gone back to her family. They do sometimes. Hasn't M. Kisling seen him either?'

'I don't know. I went round to the Rue Joseph Bara, but he wasn't in his studio.'

'Everybody goes out sometimes.'

'Yes, but I had to make sure. Kisling's out with Zborowski. I sent someone to find them. They're going to come here.'

'And what are you going to do now?'

'Haven't you a key to the studio?'

'Certainly not. This is a respectable house.'

'Then I'll have to break in the door.'

'Do you think you've any right?'

'I don't give a damn.'

'Especially since you're a foreigner. Besides, you're probably not strong enough.'

'I've been naturalized.'

'Didn't I tell you? It won't give. You're wasting your time.'

'Ah, here's Victor. Give me a hand, Victor.'

Victor worked at the coal merchant's across the street. He had just carried a sackful of anthracite to the fourth floor and a load of wood to the fifth, for it was very cold in January, 1920.

'Victor might get into trouble,' objected the concierge.

'Don't you worry. I'll push as hard as I can, and as Victor is the stronger he can push against me. Push away, Victor.'

The concierge uttered her last warning: 'You're going to get into trouble, I tell you. And if M. Modigliani isn't there, you'll have him to settle with when he comes back and finds his door broken in.'

facing: Self-portrait, 1919

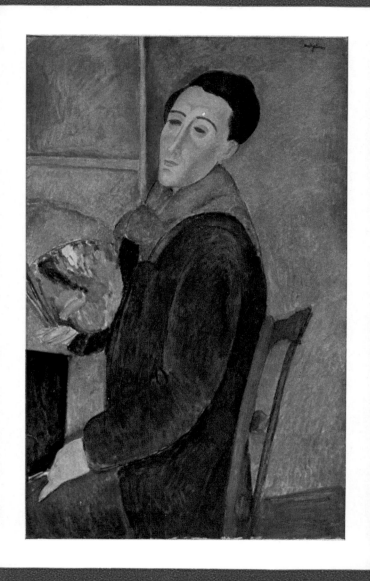

'You don't know what you're talking about. People always have trouble with Modigliani. But what the devil does that matter? He is a friend of mine. Ready, Victor? Now!'

Creaking and groaning, the door gave inwards, and at that moment Kisling and Léopold Zborowski arrived on the scene.

IT would be an exaggeration to say that in the year 1884 the city of Leghorn was in any way an unusual city. On the contrary: it had its fair share of locally eminent and prosperous men, and it was much prouder of its commercial heritage, symbolized by the colourful signboards displaying the names of the great merchant families, than of any coats of arms over old palace doors. Letters of credit were generally more esteemed than belles-lettres.

Since the Grand Dukes of Tuscany had given up their residence in Leghorn, the Merchants' Exchange, situated near the crowded Venezia Quarter, had established itself as the centre of attraction. The time was long past when Cosimo de' Medici, anxious to give Tuscany an outlet to the sea, had undertaken to turn a village into a bustling port whose prosperity would be assured by the labour and enterprise of adventurers and outlaws from every country. Armenians, Greeks and Jews had been the first to answer his call, and they were soon followed by Turks and Albanians who erected their mosques among the churches and the synagogues. It is to these various religious groups that the city owes the conservation of what picturesque aspects it may still possess, the present mania for modern industrial architecture having otherwise triumphed over the beauty of the past.

Leghorn is manifestly no city of the arts. It attracts no tourists, other than a few left-over Bonapartists who turn up every now and then to make a nostalgic visit to Piombino, the little port some sixty miles to the south from which the boat for Elba leaves twice a day. The steel-owners, the cadets at the naval college, the merchants, the stock-jobbers and brokers, and those whose welfare depends directly on the activity of the port, probably have a moderate respect for Bandini's statue of

Ferdinand I which faces the sea, and even for the monument to Victor Emmanuel II; but it is more than likely that they are wholly indifferent to the statue of the painter, Giovanni Fattori, who was head of the Florence School of Fine Arts when Modigliani studied there in 1898.

Those citizens of Leghorn who on the morning of July 12th, 1884, chanced to recognize the local youth who had returned from Rome the night before, doubtless looked askance at this twenty-year-old as he sauntered along the waterfront with a roll of music under his arm, listening to the lively banter of the sailors, street-porters and loiterers. They must have thought that the son of one of their best families was foolish, if not culpable, to waste his time on nonsense when more serious matters were claiming the attention of energetic young men. Of course the people of Leghorn were too Italian not to share their countrymen's instinctive love of music — the nightly receipts of the Rossini Theatre were a significant proof of it — but were there not more than enough composers already, from Piedmont to Sicily, scribbling music scores? If the sons of respected families now began to dabble in the art to the detriment of their ancestral counting-houses, what was the world coming to? No one in Leghorn took young Pietro Mascagni seriously, although his *Cavalleria Rusticana* was one day to bring him a fortune equal to any his fellow-townsmen could earn.

At the very moment that Mascagni was strolling about, storing in his mind the medley of sounds in the port, a mother was giving birth in a house near by to a boy who was to grow up into an equally famous artist, though in a different medium. The family into which he was born was Jewish, one of many that lived in Leghorn; but it was a family only moderately attached to Mosaic traditions, which perhaps was why the child was named Amedeo after certain princes of Sardinia and Savoy.

Almost everthing that has so far been written about Modigliani's origin is inexact. Those who have been misled about

him are to be excused. They wrote too soon after his death, too close to the scene; they did not take the time to make a thorough investigation of the facts. The dramatic personality of their subject naturally lent itself to the most romantic interpretations and assertions, and many writers have speculated upon the more bizarre aspects of his life and indulged in all good faith in the wildest suppositions.

For example, they have stated that Modigliani's father was a banker and was in financial straits at the time of Amedeo's birth, yet I have been told by Signor Giuseppe Funaro, a Leghorn lawyer who had the greatest reverence for Amedeo's memory, that the artist's father was just a small businessman: and Modigliani's only surviving brother, Umberto, has been more precise, stating simply that his father had a business in hides and coal — a modest occupation in an expanding industrial city like Leghorn. It is therefore impossible to rely too much on the accounts given by certain writers, or even on the data supplied by some of the painter's most intimate friends.

Not that those of us who were young together in Montmartre and Montparnasse would have dreamed of inquiring into the antecedents of anyone we knew. The individual himself was all we cared about; we did not trouble our heads about his family. Nevertheless it is my duty here to be as accurate as possible in all details concerning Modigliani, and to that end I have had to search for information of a kind that would have been of little interest to me in the days when I used to run into him at the Rotonde or the Dôme or in the studio of our friend Kisling.

I learned something of Modigliani's past from Gino Severini, the Futurist painter who later revived the art of mosaic in accordance with the Ravenna tradition. In 1956 Severini had occasion to go to Milan, where he paid a call on Signor Umberto Modigliani. He later told me: 'I was very much moved when I saw him and heard his voice, for he bore a remarkable resemblance to his brother. His way of speaking, with a slight

Leghorn accent, was exactly the same. Had Amedeo lived, he would surely have looked just like Signor Umberto.'

Amedeo was the youngest of four children; besides Umberto he had another brother and a sister. Their mother could claim to be of French descent, because her maiden name of Garcin was a typical Lyons name. A sister of his mother's, though well over ninety, was said to be still living in Paris in 1956; but the painter never spoke of his aunt, and it is not known whether he ever visited her. His eldest brother, Giuseppe Emmanuel, whom his French friends did not meet until after Modigliani's death, was a well-known Italian socialist who eventually ran into trouble with the Fascist regime. Signor Funaro described him as a distinguished lawyer and an important member of the Italian parliament. Marguerite, Amedeo's sister, was a French teacher. She died in Florence during the Second World War.

As for Umberto, he had studied electrical engineering. The only memento he possessed of his brother Amedeo was a beautiful drawing of a head, done in a style clearly influenced by Negro art and probably dating from the artist's early Parisian days. Oddly enough, it was not signed 'Modigliani' or even 'Amedeo', but 'Dedo', the pet name his family had given him when a child.

As a small tradesman, the head of the Modigliani family had little confidence in anything except his own sacrosanct business, even though it barely afforded him a living. He did not look with much favour on Amedeo's boyhood ambition to become an artist, and the boy's decision may even have been the cause of serious disagreement between them. The mother, on the other hand, cherished the hope that her son might some day take his place among the great Italian painters, and her faith in him was such that it enabled her to temper her husband's disapproval with considerable skill and tact.

Signora Modigliani adored her youngest-born with his fine dark hair and flashing black eyes. He was so handsome that

most of his Parisian friends later mistook him for an athlete, few of them knowing or even suspecting that since adolescence he had been in the grip of a relentless disease. Indeed, Amedeo put on such a bold front and took so little care of himself that Gino Severini, to whom he had once mentioned the physical suffering of his youth, could hardly believe it and completely forgot about it afterwards.

If a mother's love could have done anything, Signora Modigliani would surely have been able to cure her son; but the best impulses do not always result in the wisest decisions. When young Amedeo had his first haemorrhage of the lungs, his mother in a burst of enthusiasm took him off to Venice for a change of air. The experiment probably did his health more harm than good, but his first contact with that gemlike city made him more than ever determined to follow the career of an artist.

Meanwhile, Giuseppe Emmanuel was preparing to study law, and perhaps already dipping into Karl Marx; Umberto was to go to Liège, which had a reputation for electrical engineering; and Amedeo spent all the time when he was not occupied with drawing in poring over *The Divine Comedy*. He succeeded in learning almost the whole of that great work by heart, and its magnificent cantos were to influence him in everything he did for the rest of his life.

Modigliani's first teacher was Micheli, the Leghorn painter. He is not well known and has been neglected by most art dictionaries, but he taught his young pupil, who could already draw far better than he, how to use his brushes and mix colours, and, since he was a conscientious, honest man, and not at all vain, he doubtless advised Modigliani to leave him and go to study at the School of Fine Arts in Florence. The idea appealed to Amedeo, but he must have had considerable difficulty in getting his father to agree. Fortunately he surprised the dealer in coal and hides by his unexpected industry and application. He had begun to make a reputation for himself in Leghorn,

less as an artist, since the citizens were not interested in art, than as a painter who was 'good at portraits'. He even made a little money at his painting. The wealthy burghers of Leghorn, who gloried in having in their living-rooms portraits of themselves, their wives or their children, did well to entrust their vanity to this pupil of Micheli's, for though Modigliani was never an academic artist, he always astonished everyone by his ability to get a good likeness.

Now, however, the idea of Florence filled his mind, and he was excited at the prospect of leaving the family circle for the first time. His father was still sceptical about his son's future and shrugged his shoulders, but at least he did not behave like a heavy-handed paterfamilias. To his mother, Amedeo's departure was a real sorrow, but her faith in him never wavered. She would unhesitatingly have given her life to ensure his fame and fortune.

Modigliani's father was disappointed that his youngest son would not be joining him in the business, for he had chosen him as his eventual successor and had therefore consented to let Umberto become an electrical engineer and Giuseppe Emmanuel a lawyer. What kept him from despairing over Amedeo was his confidence, not in the boy's talent, which he was not competent to judge, but in his proficiency. His first local successes, though modest, had been encouraging; a portrait-painter who worked hard and could get a good likeness might at least manage to earn a living — a task difficult enough even in the coal and hides trade.

'You can get a likeness all right,' Signor Modigliani told his son. 'In my opinion, the best thing you've done — and it's been talked about enough to help your reputation even outside Leghorn — is that portrait of Signor Bergallo, the chemist; and also the one of Signora Frizzole, the shipping-agent's wife. The one you did of Signorina Nannipieri, the judge's daughter, isn't bad either. Her mother is so pleased with it that she would gladly give you a letter of introduction to her sister who

lives in the Val d'Arno — she might like to have a portrait done of her son Ugo, who is at the military academy in Modena. If so, you might do Ugo Taccone's portrait when your vacation begins, before coming back here, since I don't suppose he'd want to give up any of his Sundays off to posing. It's quite a distance from Modena to Florence, and the boy's whole leave would be taken up by the trip and the sitting, which is asking a good deal, even to please his mother. If you were a celebrated painter, he might feel differently; but you aren't, and I doubt if you ever will be. At any rate, though I haven't much confidence in your success, I hope you'll be able to make a go of things; after all, you do have a living at your finger-tips — of a sort. And your mother and I will stand by you, you can be sure of that. We shan't be able to do much for you, with business as it is, but we'll do what we can.'

Signora Modigliani was saddened by her son's departure, but she believed firmly in his future and quietly set about studying the family budget to see whether, without depriving anyone but herself, she could secretly add to the meagre allowance her husband had offered. He was a good man at heart, but to him everything in life was valued in terms of double-entry book-keeping.

The mother's was not the only feminine heart to be affected by Amedeo's going. Several others were troubled also, though naturally in a different way. There was a certain young lady who rapidly abandoned her passion for him when her mother drily informed her that he, the son of a petty tradesman, had turned down the offer of an engagement which should have been flattering. There was also a little charmer with whom Modigliani had taken liberties while on an excursion to the bathing-resort of Antignano and who had been quick enough to recognize that his ardour might some day become dangerous. As for the whore who was his first model and who had posed for him in the nude, she had enjoyed his aggressive intimacies, and, even while planning to console herself with someone else

that very night, she may have stood pensively at the window as he passed by on his way to the station, his knapsack and brand-new artist's gear slung over his shoulder.

Once he had settled in Florence, Amedeo found that the School of Fine Arts could teach him little, the instructors there being hardly more inspired than the kindly Micheli and even less capable of discerning a hint of budding genius in any of their pupils. It was not long before he began to desert the studio classes, feeling that he could learn more from the museums, which he visited constantly in a state of feverish excitement. After living frugally for some time on the small allowance his family sent him and the little he could make from his portraits, for which he sought fewer and fewer commissions, he decided to move on to Rome, and then to Venice.

Modigliani never recounted to any of his friends what happened to him during the travels of his early youth. It is only from other sources that we know anything of his stay in Venice, where the impact of the masterpieces he saw was hardly more important than his meeting with two young men, Ardengo Soffici, the painter and writer, and his friend, Giovanni Papini, the 'sorcerer's apprentice' of philosophy. Both were then unknown but, like himself, destined for fame.

MODIGLIANI had often passed Soffici and Papini in the streets of Florence, but they had never met formally, though they had noticed one another in the Uffizi Gallery. Modigliani sensed at once that these young men of about his own age might be congenial, while they in turn were attracted by the stranger whose burning eyes seemed to feast on the wonders of the city. Yet they failed to make one another's acquaintance in Florence because of the lack of a suitable opportunity, a natural restraint preventing them from expressing their mutual sympathy or even revealing it by look or gesture. Had they attended the same lectures at the university or been fellow-students at the art school, they would undoubtedly have become friends very quickly. As it was, they met in a café on an occasion when they all three chanced to visit Venice at the same time.

One morning, having encountered the others at various points between St Mark's and the Biblioteca without exchanging greetings, Modigliani went into the Café Florian in the Piazza San Marco. Being alone, he dipped into a little book he had brought with him and was so absorbed in it that he did not look up when Soffici and Papini came in and took a table next to his.

Presently a banal incident was responsible for Modigliani's introduction to the two young men, and it was Soffici who took the initiative. The waiter had left on Modigliani's table a newspaper belonging to a previous customer, a copy of the *Berliner Tagblatt*. It was of no interest to Modigliani, who continued to concentrate on his pamphlet, and, after hesitating a moment, Soffici leaned over and asked if he might borrow the newspaper. Then, seeing that it was in a foreign language, he feigned disappointment.

'Oh, it's German,' he observed, 'I am afraid it's no use to me either — although, if I may say so, I should guess from the title of your booklet that you are reading something more serious than international gossip.'

Modigliani was never given to talking much, and he always spoke slowly except when he lost his temper, which happened fairly often. Now he looked up very deliberately, liked what he saw, and remembered seeing this young man in Florence as well as in Venice.

'I am reading something that, to me at least, is absolutely fascinating,' he said politely, 'but I imagine most other people would find it dull.'

The booklet was a catalogue of all the Italian and foreign editions of *The Divine Comedy*, compiled by some fanatical bibliographer.

'Are you a student?' Soffici inquired. 'Are you writing a thesis?'

Modigliani laughed briefly. 'I am a student so far as being enrolled at the Florence School of Fine Arts goes, but I never intend to set foot there again.'

'My friend and I remember seeing you in Florence recently. May we introduce ourselves? This is Giovanni Papini — writer, philosopher, and something of a poet. My name is Ardengo Soffici. I am a painter, like you, and I too have a taste for poetry.'

'My name is Amedeo Modigliani. From Leghorn.'

'Do many people in Leghorn read Alighieri?'

'I am probably the only one, but one does not always need companions when reading.'

'*The Divine Comedy* should be every Italian's reading primer,' said Papini, speaking for the first time.

'I didn't exactly learn to read from this second Book of Books, but it was by reading it very young that I learned to understand everything I have read since and to like or dislike it accordingly.'

27

'How old were you when you first read it?'

'I was only a child, but I absolutely refused to read all those ridiculous books people usually try to inflict on children. They tried them on me too, of course, but I couldn't be bothered with writers like Jules Verne. As for those awful fairy tales by the Comtesse de Ségur, the less said the better.'

'It's true,' Soffici agreed. 'There is a scarcity of good children's books in Italy. I had not really thought about it since I got my own childhood reading out of my system. Our younger brothers and sisters have had little to learn from except translations from the French. What do you think, Papini?'

'I think it to the credit of our needy authors and of Italian writers in general that they have refused to write idiocies for children. The literary hacks who do are not serving the children but the distributors of such trash, who are chiefly responsible for murdering children's minds.'

'You are right, Papini. All honour to those who refrain from such writing, and shame on Italian parents who are stupid enough to import such dangerous rubbish from abroad because it is not produced at home.'

'We always agree about everything, Soffici, and yet — '

'What, are you going to change your mind?'

'Certainly not. Only think what good results a certain disguised perversity might have on young minds capable of piercing the disguise — the sort of perversity that children's books are full of.'

'In other words, an "earthly paradise" — but not at all like Dante's.'

'More like it than you realize. It might be amusing to try it.'

'It could be tried out as a weekly in the French style and called *Le Petit Etrusque Illustré*.'

'I would be glad to do drawings for it,' Modigliani said

gleefully. Such gaiety was unusual for him, since even as a child he had seldom been known to laugh.

'What do you say,' Papini suggested, 'to my beginning the series with a *Catechismo Purgativo*, a book to be given to all the best schoolchildren?'

'Don't be alarmed by Papini's talk, Signor Modigliani. Giovanni is a serious thinker and a good writer and will win his laurels some day, but he is a rabid atheist. That doesn't shock you, I trust?'

'No, because I am not a Christian.'

'The crown of laurel Papini dreams of — he won't admit it, but he does — will not be found on that font where he was christened.'

'So you've read Dante too,' Modigliani cried.

'I will return a bard, and at that font
Where I was christened take my laurel crown.'

His handsome face was suddenly distorted by an ugly grimace, as if reciting Dante's lines had been painful to him. Then he added gravely: 'Signor Papini is an atheist. I am a Jew.'

'There's nothing wrong with that,' Soffici responded. 'As for Papini, one never knows, and I may have been too hasty in my prophecy. I hope we shall see each other again, Signor Modigliani, and that we shall become good friends. And if we live to be very old, or at any rate middle-aged, who knows whether we may not see Giovanni Papini a candidate for sainthood, with the odour of sanctity and all the rest of it. Would you find that something to laugh at?'

'I have no particular desire to laugh.'

'And you, Papini, can you imagine yourself converted — converted by the Devil?'

'I don't envisage such an eventuality,' Papini retorted, 'but you'd better watch out. You pride yourself on never talking

nonsense, even in jest. Let me remind you that the Devil believes in God.'

The conversation was to prove oddly prophetic, for the free-thinking Papini did indeed end up a faithful son of the Church.

The three young men felt that the ice had now been broken between them. So, casually untying the strings of the little portfolio he always carried with him, Modigliani took out his sketch-book and said to his new friends:

'Don't bother to pose. Just go on talking. It won't hinder me — quite the contrary. I'm going to sketch you both.'

Soffici, the eldest, made an ideal model. He had a hard and piercing gaze which suggested a strong will: but it was the gaze of a sensitive man too intelligent to be ruled entirely by his emotions, and quite different from the expression in Modigliani's glowing eyes, which reflected a childlike nature that neither poverty, nor the love of women and art, nor torments of any kind, could change.

Soffici had a fine, oval face, thin but not sickly, whereas Modigliani, whose health was already threatened by disease, had a larger, more strongly-modelled countenance which gave him a deceptively athletic appearance. His cheeks looked dark because his beard grew so rapidly that he was obliged to shave closely twice a day if he intended to dine out or go to the theatre. But the most striking thing about him was the intensity and liveliness of his gaze, burningly fixed upon whoever was talking to him.

As for Papini, Maurice Chapelan, who knew him in his later years, said that the Italian writer had a forehead like Beethoven's, the nose of a boxer, and eyes like Sartre's (only pale green) behind glasses like Marcel Achard's. My own recollection of him is chiefly of a look of suffering behind his steel-rimmed spectacles. His eyes were already beginning to show the effects of too much reading; they were half-ruined by fine print and poring over so many manuscripts and texts.

When Modigliani sketched Soffici and Papini his drawings did not yet have the stamp of his particular genius, but both men appeared to be satisfied with the likenesses he did of them, just as his bourgeois sitters in Leghorn had been. He presented his new friends with the sketches, signed them, and no doubt added a quotation from Dante, as was his habit in later years.

'Have you any other drawings in your portfolio? Would you show them to us?'

'They are hardly more than quick sketches.'

Most of them were heads: hasty portraits done on the spur of the moment in the street or at a café. There were a few nudes, and also an ascetic face which Papini thought was that of a priest but which was actually that of a museum attendant.

Soffici and Papini examined the drawings: Soffici from the point of view of a professional artist, Papini seeking the spirit which informed them. They were not yet really striking, though they were good enough and had a certain naive carefulness about them. But although Soffici thought it best not to express too definite an opinion about the sketches as a whole, one head which Modigliani had done recently caught his attention and so appealed to him that he cried out, 'Carpaccio!'

'Do you really think so?' Modigliani asked.

Now that a mutual understanding had been established, the three young men touched on a number of serious subjects in their conversation and then proceeded to more superficial matters, pausing from time to time to listen to a young couple, apparently on a cultural honeymoon, who were sitting at the next table.

The two were French. The young man looked about twenty-five, dark-haired, well-built, and soberly dressed in a light-grey suit; there was nothing especially noticeable about his appearance, except a high rolled collar and the butterfly bow of his flowing tie. The girl could not have been more than twenty. She was an attractive blonde, dressed in some sort of

filmy mauve material to give the soft effect that was then in vogue — the kind of softness to be found in Reutlinger's photography, which was inspired by the painter-engraver Helleu. (Photography has always followed in the wake of painting.) The three onlookers wondered if the pretty young woman was as enthusiastic as her husband about the cultural pilgrimage which he had persuaded her to undertake. She was obviously in love with him, but she seemed blindly and angelically incapable of improving her mind.

Her husband asked the waiter in correct but rather academic Italian to tell him if he knew of any little 'typically Venetian' restaurant. Seeing that the young foreigner was carrying a copy of Ruskin's *The Stones of Venice*, the waiter, who had once worked in one of the best Italian restaurants in London, answered the Frenchman in perfect Soho English.

The odd couple then got up, and three pairs of eyes watched them intently as they walked away.

A great deal has been written on the subject of Modigliani's life and work, but very little of what has so far appeared outside Italy has given the credit it deserves to this providential meeting with Soffici and Papini in Venice, even though the normally uncommunicative Modigliani mentioned it once or twice in Paris. It is highly improbable that there was anyone on hand to overhear and note down exactly what was said during their conversation, yet if we judge by what is known of their characters and characteristics and by what Modigliani himself recounted, we can imagine a dialogue something like the following.

When the young couple in search of aesthetics had disappeared from view, one of the three friends remarked sardonically: 'Peeping Toms of the galleries, that's all they are.'

'They are like all those lovers in the stupid novels of the last ten years.'

 facing: Beatrice Hastings, 1915

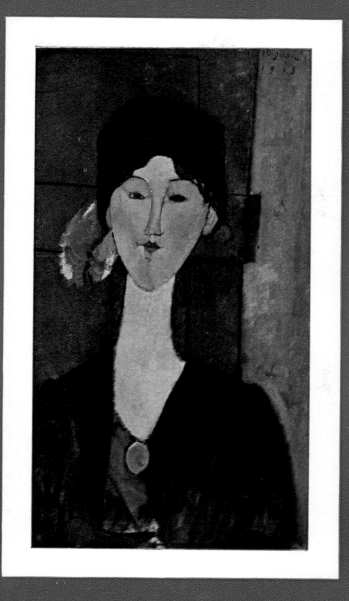

'The love of art and the art of love — they mix them up. They stare vacantly at everything they see, like two amorous fools.'

'If the museum attendants could read their minds, they would throw them out on the spot.'

'It would be doing them a service.'

'But how can you get rid of such people?'

'By starting a nice little intellectual revolution.'

'Of the kind the Milanese poet, Marinetti, is working for so doggedly: something that might help to rid Florence of a few of its gaping tourists who are so sensitive to the beauty of the past.'

'And make a healthy place of Venice too, though its reputation for decadence is imported, in my opinion.'

'What says our friend from Leghorn, that fortunate city which does not attract the over-intelligent tourist?'

'I don't believe your reformers will touch the museums, and consequently people will continue to visit them — which I think is a good thing.'

'Perhaps, but we must hope to avoid devotees like that big booby and his pretty wife. An artist — that is to say a realist — would have found something better to do with her.'

'An artist should give the public something new, something revolutionary and constructive, to chase away this decadence.'

'Just what I mean, only I could not put it so well. In Paris — because we now have to look towards Paris since Rome is no longer Rome — the artists they call Les Fauves don't go far enough. They leave it to others to learn from Cézanne's great example.'

'I don't know Cézanne's work very well,' Modigliani said, 'though I see what you mean by condemning the snobbery of tourists like that pair. But I haven't the heart — '

'The heart has nothing to do with it.'

'Yes, it has. I haven't the heart to make fun of them. You can think what you like, but I see no reason to be so hard on people just because they read Ruskin.'

'Really? Have you ever read him?'

'Very little, though enough to know what he is driving at. But there is another book that has helped me greatly.'

'Which one is that?'

'Something other than *The Divine Comedy*?'

'A collection of sonnets: Dante Gabriel Rossetti's "The House of Life".'

'Do you read English?'

'No. I read the poems in a French translation.'

'Was it the name Dante that attracted you?'

'Perhaps.'

'You must be careful that Dante Gabriel Rossetti doesn't deliver you bound hand and foot to the Pre-Raphaelites. Rossetti indeed! I also read some of his poems in a French translation. Very beautiful, of course, but the work of an aesthete. As for his painting — '

'Rossetti evoked the Italy of his fathers, but it was a little like an Italian organ-grinder remembering Italy in the streets of London.'

'Aesthetic poetry, aesthetic painting — and all mixed up together, which is even worse. "The Blessèd Damozel" — ugh!'

'All damozels are not blessèd, nor their lovers either.'

'Nor is love always blessèd.'

Such careless bantering could upset a man like Modigliani, who, despite his weakness for women, retained a certain purity of soul and preferred to consider these problems in the light of Dante's flames of hell.

'Besides, your precious Pre-Raphaelites show hardly any pre-Raphaelite influence, apart from Botticelli.'

'Their art was at best scarcely more than decoration.'

'But what about the real pre-Raphaelites, the early Italian

masters? The Renaissance painters learned from them, after all.'

'Odd to think that the pupil of the real pre-Raphaelites was — Raphael.'

'A point which English humour has overlooked.'

'But we have to admit that the London painters have done Modigliani a good turn. The best thing he has done, judging by the drawings he has just shown us, is to go back to Carpaccio and copy him. Those heads are Carpaccios now, but they will be Modiglianis later on.'

The three young men could have gone on talking together all day, but it was nearly noon and they had to separate, warmly promising to meet again. Then they lost sight of one another in the maze of narrow streets.

Modigliani followed a pretty girl. She apparently found him to her taste, but, being a working-girl, she thought she ought to hold him off for a while.

'Leave me alone,' she commanded. Then, as the young man persisted, she exclaimed more forcefully: 'Stop it! Let me alone!'

He was not deceived by her pretended hostility. He began talking to her. Deciding that she liked what he had to say, she soon accepted his invitation to share a modest dish of spaghetti, and afterwards opened the door of her bedroom to him.

Perhaps she became his model, as well as his mistress, for a day, and posed for him, and he did a charming drawing of her head and offered it to her, before leaving, to hang up on the wall of her forlorn little room.

Modigliani was never to forget that morning in Venice. He never saw Soffici again, for the poet-painter had visited Paris and left before his young friend went to settle there; but Modigliani later recalled him, under the pale skies of Montparnasse — and Papini too, whose books, such as *The Failure*, later overwhelmed most Italian intellectuals.

But Papini's word of praise for the sketch he had done seems to have made a lasting impression on Modigliani. One night, years afterwards, when he was drunk and dozing in a corner of the bar at the Rotonde, he was heard muttering to himself: 'Carpaccio! ... '

4 *Recollections of the Rue Laffitte*

MODIGLIANI first came to Paris in 1906, burning with excitement and curiosity to see all the innovations and new trends in the world of art of which he had heard so much but knew so little. Having steeped himself in the Italian masterpieces of the past right back to those of the Etruscans, he was now eager to discover the latest developments in modern art.

In 1906 the Faubourg Saint-Honoré had not become the permanent art gallery it is today. The antique-dealers, fashionable dressmaking establishments, makers of smart footwear, jewellers and gift-shops still outnumbered the picture-dealers. Hessel was already there, but the house of Bernheim-jeune had not yet appeared, and the Rue La Boétie did not become a rival art centre until much later. It was in their establishments near the Madeleine that Bernheim-jeune and Druet, Rodin's café-owner friend, gave the place of honour to the top-ranking artists of the Salon d'Automne.

The windows of the art-dealers which so fascinated the young Modigliani were all tempting, though there were no more than three or four of them in the entire Rue Laffitte at that time. Here ex-candidates for the Prix de Rome and collectors, relying only on their own taste and intuition, could feast their eyes on the Impressionist splendours displayed at the Durand-Ruel Gallery, for instance.

The Durand-Ruels had been the first to discover Impressionism, and they ought to be given due credit for their courage as speculators — though they protected themselves by buying other pictures of recognized value by well-known artists which were easy to sell, so that they could bide their time until they could make a fortune out of their Monets, Pissarros, Sisleys, Guillaumins and Lebourgs.

The only gallery of importance in the neighbourhood was

Modigliani: A Memoir

Georges Petit's in the Rue de Sèze. It was located in an old baroque building whose façade suggested some little opera-house or the residence of a great courtesan. There any un-enlightened collector with little acumen and even less strength of will could treat himself, at a price, to a painting by one of the minor modern artists: a Roybet servant hussy, or an El-Greco-like La Gandara of the writer Maurice Barrès leaning dreamily on the ramparts of Toledo. Less often, really first-rate works were exhibited at the Georges Petit Gallery on those days when a big public auction took place before a distinctively Parisian crowd, Georges Petit then enjoying a privilege which the Auctioneers' Association has since trans-ferred to the Charpentier Gallery. When this happened, the young artists were relegated to the third floor, which no one ever visited.

Cézanne was included in the younger groups and those who were not yet accepted because he had not 'arrived', even though he was now old; anyone who wished to get acquainted with his and their productions had to go back to the Rue Laffitte and limit himself to that narrow street.

The painting of the so-called revolutionaries burst upon the world in that section of the Rue Laffitte which lies between the Rothschild banking-house and a large insurance company on the one side, and a stamp-dealer's and an antiquarian book-seller's on the other. Its headquarters was Ambroise Vollard's shop, which was a sort of repository for masterpieces whose artistic value was still under discussion. Here the initiates, or would-be initiates, hastened — only to find that there was nothing on view at all. To be allowed to see any of his wares it was first necessary to win over M. Vollard, who was a creole from the island of Réunion and a born trader. He was shrewd and clever, but at the same time extremely fond of what he had to sell. Physically he was like a pensive old elephant, talking through his trunk in an eloquent but half-embarrassed manner.

Once Vollard's confidence was won, he might nonchalantly fish out a canvas from behind some piece of furniture — a Cézanne, perhaps, which was positively startling in its severity. Nothing could equal the spectacle of the somnolent picture-dealer wiping the dust with his sleeve from a painting of the Jas de Bouffan, Cézanne's home at Aix-en-Provence, or a Montagne Sainte-Victoire, or a Woman Bathing, superimposed roughly on a Poussin landscape. Or else he would go and fetch some masterpiece from the cellar (where he had his dining-room), and then take it back hurriedly after the prospective customer had examined it. His shop, stuffed with hidden treasures, was always said to be the untidiest in all Paris. When Vollard put on the first exhibition of Vlaminck's work, hoping to make a new fortune as a result of the success of the so-called Chatou School, the artist sent his own charwoman round every morning to give the place a very necessary dusting.

Adolphe Willette, the star illustrator of the *Courrier Français*, once amused himself by doing a cartoon of Vollard's display window. It proved to be a masterpiece of its kind. It showed a dirty shop window being washed by a slave hired for the purpose, complete with ladder, sponge and bucket, while through the glass could be seen a Cubist canvas, an African or Polynesian statuette no sharper in outline than the Cubist composition, and an old peasant shoe with dangling laces, such as Van Gogh might have painted. The cartoon might have served as a coat of arms for the House of Vollard, though since Vollard had discovered Cézanne, the tilt at Cubism was perhaps not altogether fair in view of the fact that without Cézanne (and Seurat) there would probably not have been a Cubist movement.

Clovis Sagot's gallery was a little farther up the street from Vollard's. Having started as a print-dealer, Sagot had set up his modest establishment in a former chemist's shop—which was not inappropriate, as he somewhat resembled the chemist

Homais in Flaubert's *Madame Bovary*. No one knew in what circumstances his predecessor had been obliged to leave, but it was assumed that they were questionable, since he had left behind a large supply of medicaments in jars and bottles and a cupboard full of poisons, and old Sagot took as much delight in these as he did in his modern paintings.

If Picasso caught cold through taking his dog for a walk one cold November night and Sagot chanced to hear of it, he would promise a cure without delay, and the next day bring him a rancid concoction which was about as harmless as a dose of cyanide. In the same way he presented André Derain with a nice little bottle of laudanum for the supposed purpose of soothing an attack of chilblains. People accepted the good-hearted art-dealer's innocent ministrations in order not to offend him, and in the end his remedies all went into the dustbin. Only Max Jacob had the temerity to experiment *in anima vili* with M. Sagot's fearsome potions. Nevertheless Père Sagot had a definite flair for painting. He was the first to become enthusiastic over the work of the young Picasso of the 'Blue Period'.

When Modigliani began his round of the galleries shortly after his arrival in Paris, he visited in a single afternoon those of Georges Petit, Durand-Ruel, Vollard — who was in a good mood that day — and Sagot, who was always in a good mood. One wonders what he thought of it all, but he was probably unable to say at first. He felt sure, however, that the Impressionism, which he saw at Durand-Ruel's with its clear colours, was already out-dated; he was disturbed by the few examples of radically new painting which he encountered at Vollard's; he was bewildered by the abrupt transition from Etruscan to Negro art; and, since his taste and ideas had been formed by the museums in Italy, he was in no hurry to turn his back on the well-executed and conscientious work ('white-collar work', according to Derain) exhibited at the Georges Petit Gallery. He was haunted by a Picasso painting of a blue raven he had

seen. It was as if the raven were picking at his brain, a raven that seemed to be croaking 'Nevermore'. It occurred to him that the word might well apply to his feelings about the pictures at Georges Petit's.

Modigliani had had his first glimpse of Picasso one day near the Place Clichy when two passers-by had turned to stare at a little man dressed in a pair of plumber's blue jeans, his open short coat flapping over a flame-coloured sweater, his trousers held in place by a red flannel sash, the traditional waist-band worn by carpenters in those days. He had extraordinary eyes, like currants, and he sported an English cap from under which a lock of hair hung down over his forehead. With him on a lead was a large white dog. Modigliani heard one of the passers-by say to the other: 'Did you see Picasso with his cur?'

So that was Picasso. Modigliani envied the two young men who could recognize this artist who, by the time he was twenty-five, had been in turn anarchist, illustrator of several small Barcelona weeklies, realist inspired by Steinlen whose drawings of the working class had aroused some interest, and artist in the tradition of the Toulouse-Lautrec of the Moulin Rouge, the Lapin Agile, and all the other bars from those in the Rue Royale to the Fauvet bar in Montmartre — Picasso, the creator of blue beggars, of mothers whose blue offspring tugged vainly at their shrivelled breasts, of clowns and sprightly acrobats.

Some time afterwards Modigliani had occasion to go into a café near the Madeleine for a glass of the red wine which reminded him of his native Chianti. He had just raised his glass for another mouthful when he noticed the little man in the English cap standing on the pavement outside. A nondescript worn jacket had replaced the workman's coat, and corduroy trousers the jeans; the dog was no longer with him but there was no mistaking those black, penetrating eyes.

Obeying an impulse of which he would never have believed

himself capable, Modigliani ran out to speak to the Spaniard from Montmartre. 'I beg your pardon,' he stammered, 'but aren't you M. Picasso? My name is Modigliani — Amedeo Modigliani. I am from Leghorn.'

It had never been easy to scrape acquaintance with Picasso, but just as he could assume an indefinable haughtiness under the pretext of inattention, so it often amused him to be responsive when it suited him. If he now decided to overlook Modigliani's presumption, it was less because of his courteous manner than because of his flashing eyes.

'Are you a painter?' Picasso inquired, puzzled as to what kind of person this young foreigner might be. Modigliani was well enough dressed in a conventional suit of excellent Italian cut, but he had such a bush of hair, thicker than Picasso's but more unkempt, dishevelled.

'Yes,' Modigliani replied, 'I am a painter. I have only just come to Paris. I saw you recently near the Place Clichy and I have been wanting to know you ever since I saw a pastel and a gouache of yours at Sagot's, where I went again this morning. The pastel was signed "Pablo Ruiz", and the gouache "Picasso", but they were certainly by the same hand.'

'Those are old things,' Picasso grunted, 'the kind of things you do for the love of it because you don't know any better. But you are right: they are not bad. What sort of thing do you do?'

'I'd rather not talk about my own work yet. Will you come and have a drink with me? Would you like to go to some other café? I know a very good one in the Rue Royale. I am staying at an hotel near there.'

'No,' Picasso said gruffly, 'it's much better here. There are fewer fools here than in the Rue Royale.'

It is not easy to talk about painting with an artist like Picasso. He is naturally too much of an egoist to enjoy discussing anyone else's work, although he has had no hesitation in acquiring it for his personal pleasure. His purchases include works as

different as possible from his own manner of the moment and range from the Douanier Rousseau to any promising young contemporary. That morning it was Modigliani's personality that happened to interest him, and he did not mind conversing with the young Italian so long as they did not talk solely about the art of painting.

'Why do you stay in an hotel?' Picasso asked him. 'It's foolish.'

'Because I am a foreigner.'

'So am I.'

'I have only been in Paris a short time.'

'Why don't you try to find yourself a studio? You can get one easily enough. There are plenty in Montmartre. An hotel, humph! I lived in an hotel when I first arrived in Paris. It was foul. A *suciedad*,' he added in Spanish.

'A *sporchezza*,' Modigliani echoed in Italian.

'I remember one I stayed in: the Hôtel du Maroc. My friend Max Jacob had to work as a labourer to pay his share of the rent for the room we shared. Don't talk to me about hotels! Get yourself a room in Montmartre. A painter has no damned business knocking around the Madeleine or the Opéra. Degas never lived near the Opéra, even though he did get some of his models from its dressing-rooms. Van Dongen settled in Montmartre when he started painting — mostly tarts showing their thighs through their underwear. He could get all the whores he wanted to come up from the Boulevard Rochechouart and the Madeleine and pose for him with their legs in the air on a couch in his little studio in the "Bateau-Lavoir", the Floating Laundry, at 13 Rue Ravignan, where I am living now. Unless you paint flowers, what the devil are you doing living near the Madeleine? There's nothing else to paint there.'

'This friend of yours, Max Jacob: is he a Jew?'

'Yes, but a bad Jew. I mean a Jew who doesn't give a damn about Jewry or rabbis or synagogues except when some fool curses the Jews in front of him. Max was born in Brittany, and

as far as I am concerned he is more a Breton than a Jew. Do you understand?'

'Of course I understand. Your friend Jacob is the same kind of Jew as I am. We both belong to the Second Lost Tribe. What about you?'

'I was born and baptized in Malaga. My father is from Galicia; my mother's Genoese.'

'So you are known by your mother's name — Picasso. It's a Genoese name.' And then Modigliani inquired politely: 'Are you married, M. Picasso?'

Picasso seemed uncertain how to answer, so he replied with a bit of practical advice: 'Go up to Montmartre,' he said. 'You'll see everything there: painting and all the rest of it, women too, if they amuse you. It's my turn to buy you a drink, but I haven't enough money with me. I suppose you didn't find old Sagot in this morning when you called?'

'M. Picasso, let me buy you another drink. Don't be offended. I am not rich, but my family haven't deserted me entirely and I'm expecting a money-order any day now. Let me lend you a franc or two.'

'Why not?' Picasso replied.

Many years later Picasso met Modigliani one night when the young painter was drunk in Montparnasse and settled the small debt by thrusting a hundred-franc note into the pocket of his corduroy jacket.

Shortly after his first meeting with Picasso, Modigliani left his hotel and moved up to Montmartre. He rented a room in an old house not far from what was then known as the Maquis, a relatively large, irregularly shaped area adorned by a few scrubby trees. André Warnod, writing in 1925, described the place as follows in his book *Berceaux de la Jeune Peinture:*

It was a vast open lot, covered with hovels and ram-shackle huts and inhabited by a colony of tramps, beggars, second-hand dealers, down-and-outs, and a few artists.

The Maquis extended from the open-air dance resort of the Moulin de la Galette to the Rue Caulaincourt, on the site now occupied by the Avenue Junot, and reached as far down as the Place Constantin Pecqueur. Demolition was begun there shortly after the Paris Exhibition of 1900 in order to make room for the houses on the even side of the Rue Caulaincourt.

During his sojourn in Montmartre, Modigliani lived for a while in the Rue Lepic on the edge of the Maquis; then Rue Norvins; then Place Jean-Baptiste Clément; then Rue du Delta; and finally in an abandoned convent in the Rue de Douai.

It is probable that when Modigliani first settled down in his Montmartre room filled with second-hand furniture he was obliged to call on his family for funds. I saw the room soon after he moved in. It was by no means luxurious, but it did contain a couch which could serve as a bed, as well as a bed with good cotton sheets, several chairs, an armchair of uncertain style, and, what was most surprising to visitors from the 'Bateau-Lavoir', a broken-down piano covered with a large cashmere shawl. The draped piano, looking like some old lady from a country town, was regarded by most of us as being the last remaining sign of Modigliani's loyalty to that bourgeois background which he eventually repudiated so dramatically.

The walls were decorated with photographs of masterpieces of the various Italian schools of painting.

As for his own pictures, there were usually two or three in stretcher-frames on the floor, face to the wall. He was very reserved about showing them, and would only rarely gratify the curiosity, polite or sly, of his visitors. There was little in that room to indicate how far his genius was to develop.

Gilberte and Red Wine

IT is difficult to explain why Modigliani, who was so eager to make Picasso's acquaintance that he accosted him in the street, never went to see the Spanish artist in his studio in the 'Bateau-Lavoir'. We never ceased to marvel at it.

Picasso himself ignored it; he was not the kind of man to discuss such matters. What, then, could have made Modigliani hold back? Perhaps it was pride — that subtle form of pride that has more in common with false modesty than with humility. It may have been self-consciousness, or even annoyance at feeling that he could not vie with the young celebrity who was soon to become the focus of a revolutionary movement in the world of art. Picasso had scrawled in blue chalk on the rickety door of his studio 'The Poets' Rendezvous', and it was here that Henri Matisse and Vlaminck, the two oldest of the group, used to forgather with Derain, Georges Braque, and Maurice Princet, the 'mathematician of Cubism', who was more of a philosopher than a mathematician. Max Jacob was always on hand, and Guillaume Apollinaire came with Marie Laurencin.

We would often run into Modigliani in the neighbourhood of the Place du Tertre — usually after dark, since he was as much a night-prowler as we were. But he only went to the Lapin Agile occasionally, and he was more usually seen about with a pretty girl. His method was to accost the girl with a certain formality, and then take her home with him, gently but firmly.

I cannot truthfully say that the Picasso group was distressed by Modigliani's absence. Newcomers were accepted now and again in our little 'Bateau-Lavoir' circle, but no one went out of his way to introduce them. Everyone had good friends

outside the studio, but we did not call on one another; we met in the street, or at the Lapin, or else in the Place du Tertre at Mère Catherine's. This establishment was founded in 1792 and in our day was presided over by old man La Bille, who worked as a messenger for the Banque de France until apéritif-time. He came back in the evening and served drinks at the bar in his shirt sleeves, still wearing his official bicorne with its Tricolor cockade. Sometimes we would assemble at Spielman's at the sign of the Clairon des Chasseurs; at others we would go to the Chalet, which was owned by the fat Adèle, who was so devoted to artists; or to the previously-mentioned Fauvet bar in the Rue des Abbesses, where, if you put two sous into a slot-machine, you could see a life-size wax figure of Salammbô perform a belly-dance. The illusion was perfect after the third *mominette*, the cheap absinthe based on potato alcohol which we drank.

Modigliani came into the category of friends who belonged outside the studio, although he could have joined us there at any time had he so wished. He interested us because he was personable; because, despite his conventional clothes, he had a distinguished bearing; and because, even on the most banal occasions, there was a certain air of mystery about this handsome young man so innocent of any desire to be picturesque. We also like him because his occasional remarks gave the impression of a lively intelligence — so far as one could ever ascertain, before it blazed into incoherent brilliance.

As a group of young men all anxious to astonish the world and dazzle it by our theories and talents, we were inclined to discuss the quirks and failings of others, and naturally Modigliani came in for his share of criticism. 'No one knows yet what he has in him,' one of us would say, 'but it isn't possible that a young man like that should fail to produce something significant.' And for several of our group the black flame in Modigliani's eyes was enough to

convince them that destiny had a remarkable future in store for him.

Once, when a number of us were sitting in Mère Catherine's, someone remarked: 'Even if he has got good stuff in him it wouldn't necessarily have come out by now, but if he is determined to drown himself in cheap red wine, what price the genius you say he has? He doesn't seem able to resist the bottle. I haven't seen him actually tight so far, but if the new arrival doesn't know everybody around here yet, the cafés on the Butte certainly know him. He takes a glass here and a couple more there. I tell you it's dangerous to be a solitary drinker. It's all very well for you to laugh because I preach against drinking too much — I'm not drinking by myself. What will you have, the rest of you?'

A fellow-artist carefully mixed the *mominette* he was about to drink and replied: 'As you say, he doesn't know many people yet. He has hardly any companions and not a single real friend. Perhaps it's being alone so much that makes him go for the "red ink" so hard. You get depressed if you're by yourself all the time, especially if you're given to thinking too much. No matter what people say, thinking doesn't help anything.'

'You don't know much about him,' declared Max Jacob. 'He's not as solitary as you think. I'll go so far as to say that he's not alone often enough.'

'What do you mean?'

'It's not the wine I worry about. It's the women.'

'You jealous?'

'Jealous of what? It's just that he's so handsome — and knows it — that when he's not running after the girls, they're running after him: and he can't resist them. Whether it's weakness of character, vanity, or appetite, the danger is the same.'

At this point a blond young man came into the café and joined the party. He was rather small, and an incipient beard

facing: The Butte Montmartre

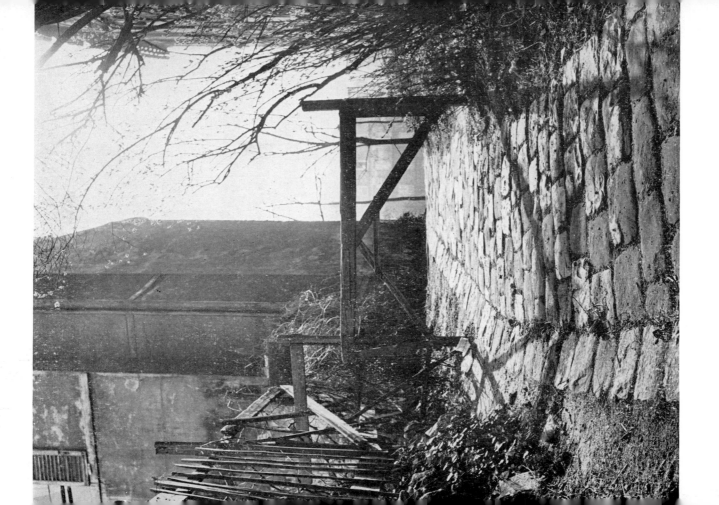

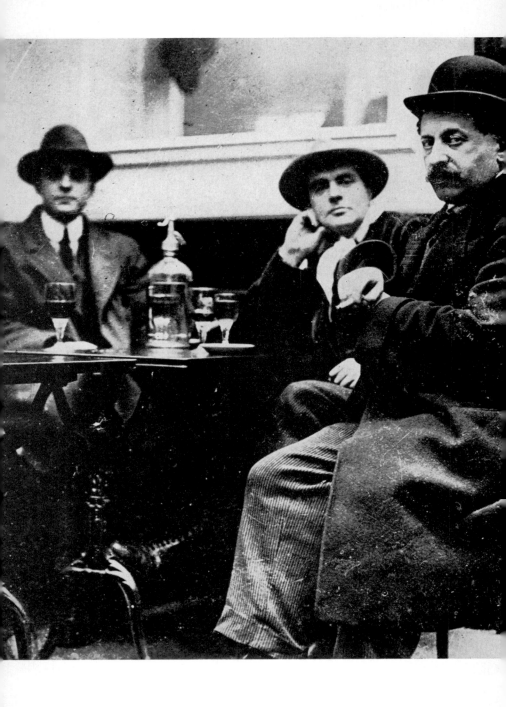

paradoxically made his face look childlike. He wore a work-man's blue overalls and was possibly not displeased by the imitation of Picasso, although it was his usual style of dress since he was only an off-duty painter and was normally employed in the electric power-station. He was André Utter, though he had not yet been taken on by Suzanne Valadon nor begun to look after her son, Maurice Utrillo, for whom he was one day to act as stepfather, guardian, and manager.

'See here, Max,' Utter said to Jacob as he sat down, 'we know all about these ideas of yours about women being the ruination of men — '

'And of artists in particular,' cut in Jacob.

' — but I just wanted to ask you whether, when you're holding forth on the subject, you ever give a friend like Picasso the benefit of your infinite wisdom?'

'No, because apart from the fact that my friend Pablo's so-called wife is like Caesar's in my eyes, that is to say above suspicion, Pablo's case is not to be compared to any other, and especially not to Modigliani's. Pablo keeps a woman in the house to save himself the trouble of having to run after women in general or of having to give in to their advances, and if I refrain from expressing my opinion about women in front of him and about his woman in particular, it is for the following reasons: first, it would be useless because I should not be telling him anything that he does not already know; and second, Pablo would immediately repeat my remarks to his darling Fernande Olivier, who would thereupon persuade him to forbid me ever to darken his door again. And that would be something I should never get over.'

Thereupon the poet-painter left the café and sauntered off across the Place du Tertre.

In those days the Place du Tertre still had a village atmo-sphere about it. The sight-seeing buses had not yet begun to

bring their hordes of tourists up to Montmartre, and it was not until after the First World War that the restaurant-owners took to setting out tables equipped with pretentious lamps whose shades looked like saucy petticoats lighted up from underneath.

As Jacob strolled along, he caught sight of Modigliani talking to a pretty girl at a point about half-way between the Cabaret du Coucou and the former local town hall. The girl was as attractive as hundreds of others of her sort. Her name happened to be Gilberte, but she was exactly like the dozens of Lolas, Gabys, Suzannes or other Gilbertes who roamed about the quarter. It would have been difficult to say which of the two was more enamoured, and, as Jacob watched, the couple wandered slowly off down a side street together.

Once they reached his studio, Modigliani, the intellectual artist who delighted in fresh young bodies, sat on a rickety stool, watching Gilberte undress. She pretended to disdain the screen, which was the classic appurtenance of every well-equipped studio, and it was impossible to know whether he was trying to hide his nervousness as a man or his impatience as an artist, as he prepared his sketch-book with its sky-blue cover and slapped his thigh each time he glanced at his new model.

At last she was naked, and, pleased with herself and her own docility, she presented herself for his inspection. He did not wish to do a Bottini of her, or a Seurat, or a Fragonard, or a drawing in any of the styles which had occurred to him as she undressed. He wanted to interpret her himself, create an authentic Modigliani, a picture that would reflect his own style, talent and personality. Picking up his drawing-paper, he hurriedly began to make sketch after sketch as if in fear that he might not succeed in accomplishing what he had in mind. He filled several pages with light, deft drawings, each time explaining to Gilberte the pose he wanted her to adopt. No

position was too difficult, complicated or tiring for her, but she got no thanks for her co-operation. Finally, deciding that she had had enough, she went over to the couch and curled up on it, hiding her face in the cushions.

'None of that!' Modigliani warned her sharply.

'Very well, my sweet,' Gilberte replied.

'Anyhow,' he added more amiably, 'the sitting is over for today.'

Before putting his sketch-book away, he tore out one of the drawings and offered the girl her portrait. It showed her naked and demure, her head bent slightly towards her right shoulder, her half-open hand resting on her left breast.

'You may have it if you like.'

'What the hell would I do with it, thanks all the same? I haven't even got a room to put it in.'

Modigliani tore up the drawing, without provoking the slightest protest from her. She did not even sigh, but smiled at him hopefully. She had not asked anything for posing, and now, feeling that she had served the cause of art sufficiently, she was eager for love. Naked, she approached the artist, placed her hands on his shoulders, and, lifting her face to his, murmured invitingly: 'You're not bad-looking, are you?'

Modigliani gave one of his characteristic smiles, not far removed from a threatening grimace. But Gilberte was not frightened; she was afraid of nothing; in fact, she rather hoped for a spice of violence with her pleasure. He grasped her firmly by the hips and now he gazed at her as a man, not as an artist. Here in front of him was Gilberte — the woman, not the model — beseeching him with her eyes, crying out to him with all her young body.

Neither Modigliani nor Gilberte made the mistake of talking about love. Each was frankly and sincerely pleased with the other: Gilberte because she felt a distinct pride in having offered herself to an artist and was not unappreciative of his

good looks, Modigliani because he had gratified the original of one of his finest drawings.

Gilberte began to dress again, and now it was with an artist's eye that her lover followed her gestures, muttering the names of other painters he admired, just as he had done when she stripped for posing. Gilberte paid no attention. She was rarely surprised at anything in life, and her natural stupidity protected her from the most elementary thinking. Suddenly, as she stood before the cracked mirror to adjust her hat with its hat-pin as long and murderous as a dagger, Modigliani leapt up, seized his sketch-book, tore up all the drawings he had worked on that day, just as he had done a while ago with the one Gilberte had refused, and shouted: 'Modigliani! Modigliani!'

The girl looked at him placidly. 'What's got into you? You're not going to start blubbering, are you?'

'I have never cried in my life,' the artist retorted, his composure apparently regained.

'When shall I see you again?' Gilberte asked, preparing to leave.

'I don't know.'

'And where?'

'Oh, around. Somewhere.'

'You can always find me at the Kermesse in the Rue des Abbesses. You know it?'

'Yes, I know it.'

'Give me a kiss. It's funny how nice you can be when you want to, and yet such a swine at the same time. But we'll talk about all that the next time. Goodbye, Modi.'

Modigliani did not answer. He did not look up as she departed. Gilberte had no room of her own to stay in, she had been good about posing, and she had not been exactly irresponsive while making love. It was not because of her stupidity that he was willing to let her go. He was simply resisting the idea of allowing any woman to stay with him even for a short

time, although it would be assuming a great deal to say that this determination made him happy.

Once Gilberte had gone, the loneliness of his studio began to weigh on him. He had so far accomplished little in it except to make love. His thoughts turned to wine as a consolation — wine, and plenty of it.

THE little coal merchant in the Rue Lepic who, like so many
of his trade, ran a bistrot as well would soon have only the
regulars left, but as Modigliani entered he was trying to throw
out one of the most troublesome customers — Maurice Utrillo,
known familiarly as Maumau.

'That's enough, Maumau,' the coal merchant exclaimed in
his lisping Auvergne accent. 'You're driving us crazy with
your nonsense. You think it's witty but all the wit you've got
is to drive other people out of theirs. Now get along with you.
Outside!'

'Who? Me?' Utrillo replied in a hurt voice. 'I never said I had
wit, and if I did I wouldn't say so to you because you haven't
got any and wouldn't know what it was. I'm just a poor devil
who's bored stiff because other people bore me, and that makes
me boring in my turn. You don't think I get any kick out of
painting, do you? I don't like painting and I don't understand
art, especially modern art. It was all my dear mother's idea.
She thinks it'll keep me from boozing. My dear mother's a
painter herself, of course. If she'd had any other profession,
she'd have wanted me to try that just to keep me off the
bottle, and you should be the first to admit that work never
kept a fellow sober ... How about letting me have another?
It'll do me good and you won't be the loser ... And if you want
to know why my dear mother's a painter instead of keeping
on as a trapeze-artist, it's because she fell one night and broke
her jaw ... Come on, just one more — to please me. Still
nothing doing? You're a swine ... But as I was saying, if my
dear mother had kept on as an acrobat, she'd have wanted me
to go in for that to keep me sober. Not that I couldn't have had
a good job in the circus. There's always plenty of work: water
the horses, feed the carcasses of the said horses to the wild

animals, clean out the ring, wash down the elephants ... Perhaps I'd have made a good clown.'

'Yes. The one who always gets his face slapped.'

'At least I'd get paid for it. And don't think I don't know what it is to get slapped. What I go through for pinching the sous I give you! ... Come on, give us another, I can pay for it ... You know something? If I had more money I'd clear out like you want me to, but I'd take a bottle with me, and you'd sell it to me quick enough. I shouldn't go home, though — Mother'd take it. I'd go and drink it on a bench in Saint Pierre Square at the foot of the steps up to Sacré-Cœur. You like Sacré-Cœur? So do I. How about God? You like Him?'

He would have slumped to the ground if Modigliani had not caught him in time.

'Will you look at that, now!' yelled the bar-keeper happily. 'So you like Maumau that much, do you? You can have him.'

The boozer, the painter who disliked painting, straightened up again, revived by this apparently friendly greeting. He gently broke free of Modigliani's grasp and stared at the newcomer as a half-drowned man might gaze at his rescuer. He gradually recovered his balance — if not his muddled eloquence.

Modigliani tossed several coins on to the bar. 'Give us a couple of bottles.'

'I only sell unopened to take away.'

'It's even worse than the other, and that's saying something. Make it two unopened, then.' Modigliani held out one of the bottles to his protégé. 'Here. Don't drop it.'

'Me drop a bottle? You crazy? If I fell down myself I'd save the bottle.'

'Then take it and come along.'

Momentarily sobered, the addled Maumau tucked his bottle under his arm and set off, squinting sideways at his benefactor. By the side of Modigliani, who held his head high like some Eastern prince in the service of the Venetian Republic, the black-suited Utrillo with his over-long arms and narrow chest

seemed disjointed. His complexion was pallid, his eyes troubled, and his drooping moustache too large for his face.

One of the remaining customers watched them departing and, turning to the coal merchant, remarked: 'You've got some fine specimens around here. Who were those two?'

'The one who had the bright idea of taking the other away with him is new to Montmartre. He's a painter, I think — a foreigner, but none the worse for it, even though you can't always understand his French. I don't remember where he comes from. Lisbon, perhaps.'

'He's a Portuguese, then? He looks more like an Italian.'

'Yes, he is.'

'Then he can't be from Lisbon.'

'Can't he? Oh, I've got it: it's Leghorn.'

'What about the other one?'

'That's poor old Maumau. It's a pet name. His real name is Maurice — Maurice Utrillo — after the Spanish artist who legally recognized the bastard as his son as a favour to the boy's mother. She used to be a beauty, so they say. You heard Maumau speaking of his dear mother. She was a trapeze-artist who became a model for a famous painter, and he taught her to paint the way he did. The boy signs his pictures Utrillo, but many people up here still call him by the nickname the kids used to yell at him when he was soused, and believe me he's been soused most of the time since he was fourteen.'

'What did the Montmartre kids used to call him?'

' "Litrillo" — for a litre of wine. Utrillo — Litrillo. Not bad, is it?'

Armed with their bottles, Modigliani the painter so consciously concerned with art, and Utrillo the illiterate painter so befuddled with drink, staggered down to Saint Pierre Square together. Modigliani had at last found a friend.

Once there, the two roisterers made so much noise and disturbance that they ended their celebration at the police station in the Place Dancourt.

GILBERTE was only too eager to boast of her handsome Modi's prowess to Lola, her best friend. She told her about it after such a hair-pulling contest between them that it would have been hard to know which had won. The quarrel had taken place in the rear of a shop belonging to a certain Mme Garandin, a second-hand clothes-dealer in the Rue de la Fontaine, the young ladies of Montmartre being obliged to go to almost any lengths in times of extreme necessity. If Gilberte now confided so fully, it was because she was not of a very jealous nature and neither possessive about her conquests nor capable of fidelity, life having taught her, as it had many of her kind, that it is unwise to have too many illusions.

She now gave Lola a sensational account of the ecstatic time she had had with Modigliani, and even went so far as to advise her friend to go and pose for him too. 'It's worth it, chérie' she assured her. 'Modi's out of this world. He's got better manners than the others. And as for you know what, you can take my word for it, he's really something. The only trouble is I think he likes to booze too much. The first time I saw him was one Sunday evening when he was leaning on the bar in that bistrot in the Rue Lepic, across the street from the dance hall — '

'Which reminds me,' Lola interrupted, 'have you found a room yet?'

'Yes, I'm dossing down in an empty house. They call it the Priest's House, after the curé who owns it. He's let it get run down, and I mean run down, seeing what it would cost to put it into shape.'

'Are you comfortable there?'

'You bet! There's six of us, including me: a sculptor and an engraver, and their girls, and an actor who's a queer. So you see

I'm in clover. The engraver's girl even slipped me a pair of black lace stockings the other day — not real lace, of course, but best fancy-imitation. Here, have a look. See the length? You won't find anything like these at old Ma Garandin's ... But if I was you, I'd go and have a look at Modi. You're a model, you can go to his place any time. Only don't get too excited about it. Don't think of trying to move in with him. That's not his line.'

'I'm not as mad to live with a man as all that. If you ask me, I think your Modi's like all the others.'

'He's a nice boy.'

'Of course he is, so long as you don't get tied up with him.'

Nevertheless, the curious but wary Lola soon went off to see what the studio in the Rue Lepic was like, the neat and tidy studio with the Indian shawl thrown over the silent, upright piano, and everything suggesting that its occupant was a serious artist. It was perhaps not quite as neat as it had been at the beginning, in the days before Modigliani had started drinking hard, but it could not be compared with a sordid hide-out like the Priest's House.

Modigliani opened the door in response to Lola's discreet knock. He looked as if he had just been roused from sleep. He was in his shirt sleeves and, glancing around in a daze for his belt, he clumsily adjusted his clothes. On the table was an opened bottle of wine and a half-empty glass.

'What do you want?' he demanded.

To be sure the visitor was a woman, and young; she was pretty and probably stupid; but what did that matter? He was not going to be joined to her for life, for better or for worse.

It was as an artist that he first eyed her; and as an artist he felt a sudden desire to laugh, because outwardly Lola appeared to possess all the graces of a figure by Giacomo Grosso, one of the masters of the *ultimo ottocento* and a forerunner of that *pittura*

lirica, which he had liked at the age of sixteen and scorned
ever since. But when it came to painting a nude, Grosso had
known how to pick his model. Modigliani called it 'pimp's
painting'.

Lola answered his question by asking coyly, 'Model,
M'sieur?'

'You've come at a bad time. I'll be getting a little money
in a day or so, but I haven't a sou just now. Too bad, because
you're rather beautiful.'

'You needn't worry about the sous. I've often seen you
around. We'll talk about the money some other time. I can
pose for you today, if you like. Just between friends.'

'Come in.'

Lola wondered if she had won.

'Would you like a drop of red wine?' he asked. 'There's a
clean glass somewhere.'

'You haven't any white, have you? I like white better.'

'No, but there's a drop of rum.'

'That'll do. I like rum.'

They drank together.

'Do you want to work?' Lola asked. 'Shall I get undressed?'

Modigliani, who had already drunk a good deal of wine
before Lola's arrival and even more rum since, began to scowl
horribly. His handsome face was transformed. He was like a
devil or one damned, and, laughing in a way that would have
terrified women other than Lola or Gilberte, he shouted
'Grosso ... Grosso ... Assurdo! [Absurd!]'

Then he seized Lola in his arms and carried her, wriggling
and delighted, over to the couch, where she so enchanted him
that the artist in him soon forgot his contempt for Giacomo
Grosso, the glory of the *ultimo ottocento*.

After Gilberte and Lola, Modigliani treated himself to a
whole series of Marcelles, Gabys, Lulus and Raymondes. Then
he withdrew into a long period of continence, which coincided
with a long period of drunkenness because it was first and

foremost a period of doubts about his art and black despair.

Drink. Escape. It was a relief to go drinking with Maurice Utrillo, whose company he so ironically welcomed; Maurice, the inspired painter who did not like to paint; Maumau, the village idiot of the lovely village of Montmartre.

DRINK. The craving for drink, and the need for it.

'What malady is to be compared to that of alcoholism?' The terrible words of Edgar Allan Poe cry out from the written page.

'I drink to get drunk,' said Verlaine, 'not just for the sake of drinking.'

Verlaine drank for reasons of spiritual despair, not because he was dissatisfied with himself as an artist. Modigliani was abstemious in his youth, but he began to drink when, in his impatience to become a genius, he grew discouraged with his seemingly small talent. Fulfilment came to him too late to save him from the ravages of alcohol and later of narcotics. When I quoted Poe's despondent words to him one evening we spent together in Montmartre, I was not telling Modigliani anything that he did not already know. He was familiar enough with the American writer's work, which for him had a place somewhere between the *Inferno* and the *Paradiso*, and in spite of his drunken state he replied with a certain dignity: 'Did Poe say that? It is very good. He drank, did he? Then you can be sure that he had to drink; that it was essentially, *essenzialmente*, necessary for him to drink. Poe. Do you remember his story of the black cat in the wall and the ape murderer — the ape in the Rue Morgue, a street in Paris that doesn't even exist? And yet how convincingly Parisian the story is, even though Poe never saw the place! The Rue Morgue ... mortuary ... death ... Not that death is so very important. Things we think are important are so often unimportant, compared with the demons tormenting the damned in those infernal regions Dante travelled through ... But tell me something about Poe's last short stories: "Ligeia", for instance. It is so close to the *Paradiso* and the *Vita Nuova*. Ligeia ... Beatrice ... Ligeia ... '

Modigliani: A Memoir

I listened to him as he pronounced the gentle name of Ligeia, repeating it with ineffable softness, with as much emotion as I later heard him shout out in ecstasy the word 'Opulentia' — the inspired title he gave to a nude he did of a small-time model, making a sort of murderous divinity out of this easy-going girl who was no more than a fat, good-hearted kitchen-maid.

9 *The Devil's Merry-go-round*

MODIGLIANI was a tortured soul. He was sane enough, but he was burdened with a tormented mind. It was this consuming torment that got the better of him when he was alone and vitiated his real strength of character. To soothe his troubled spirit and silence his painful self-questioning he had to find an immediate panacea. Unfortunately the only remedies available were those which were supposed to deaden pain. Those who, like Modigliani, imagine they are strong despite a secret illness, are seldom afraid to resort to drastic measures. He had tried red wine and rum. Now he heard of hashish.

Before the First World War a good many young men were able to get drugs at little or no cost. From Montmartre to the Latin Quarter people talked of the spread of narcotics as casually as if they were discussing art for the masses. When Modigliani first arrived in Paris, even the slenderest purse could afford at least a taste of such poisonous delights. It was not difficult to find the drugs. For instance, there was a little place in the Rue Croix des Petits Champs which specialized in Chinese ornaments and jades for lovers of Oriental art. The cash-desk was presided over by an attractive and dignified lady. On entering the store you simply went up to the desk, put down a modest sum, and said: 'Good-morning, madame. Could you give me a little box?' The lady would then take a tin box out of the drawer and hand it over with a disarming smile. If you needed a few accessories, such as a clay pipe or some silver needles, the young lady assistant would wrap them up for you without batting an eyelid. It was no more complicated than that, and the addict did not pay much more for the coveted drug than he would have paid for English or American tobacco.

It was not until the early years of the present century that

the vogue for narcotics began to spread among young artists and writers. They were initiated into the use of these forbidden delights by a charming woman whom I shall here call Manon, the name by which Paul Fort immortalized her in his *Paris sentimental, ou le Roman de nos Vingt Ans.* In the course of her amorous experiences Manon made the acquaintance of a naval lieutenant in the Reserve. This gentleman had spent considerable time in the China Seas, and in consequence was an adept at smoking opium. He induced Manon to try, and she took to it enthusiastically. But, as an inveterate smoker, Manon found practising the art all alone very dull. She introduced the habit of smoking opium to her young friends, who would never have dreamed of experimenting with it before meeting her, and they in turn persuaded others to indulge.

Another drug supplier was a peculiar individual by the name of Pigeard, or 'Baron Pigeard' as he was known on the Butte. He had mysteriously come into money, and was anxious to open a rival establishment in a little house that he occupied in the very heart of the Maquis, where the artists and writers were thickest. It is possible that the Baron thought it might be a useful means of seducing a few young ladies, but for whatever reason, he was soon engaged in trafficking — in so far as anything so disinterested could be called trafficking — in hashish as well. Modigliani was to become one of his customers.

Some authorities assert — and I agree with them — that it was not the Baron who started Modigliani on this phase of his downward path. They point out that when the artist moved from the Madeleine to Montmartre, he made it plain that he did not care for the company of the dilettante perverts who were typical of a certain section of Montmartre society, while for his part M. Pigeard never deigned to visit any of the artists in their studios. In any event, apart from the fact that opium did not appeal to Modigliani, it was not until much later that Pigeard added to his flourishing business in poppy-juice by

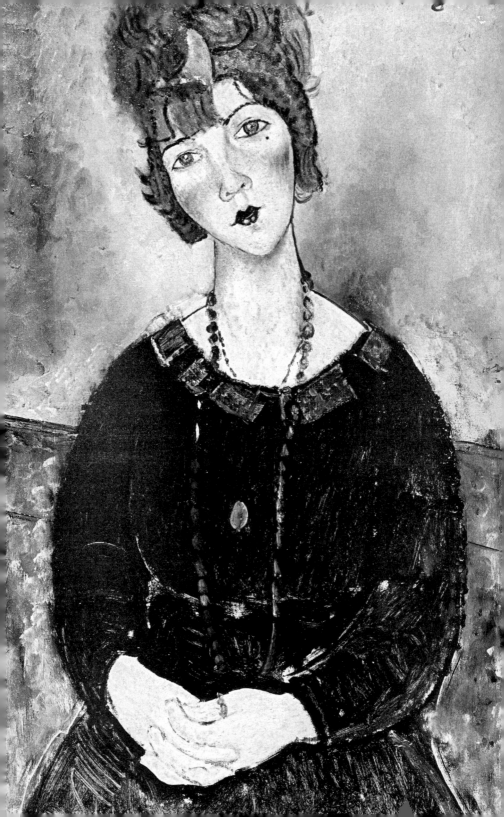

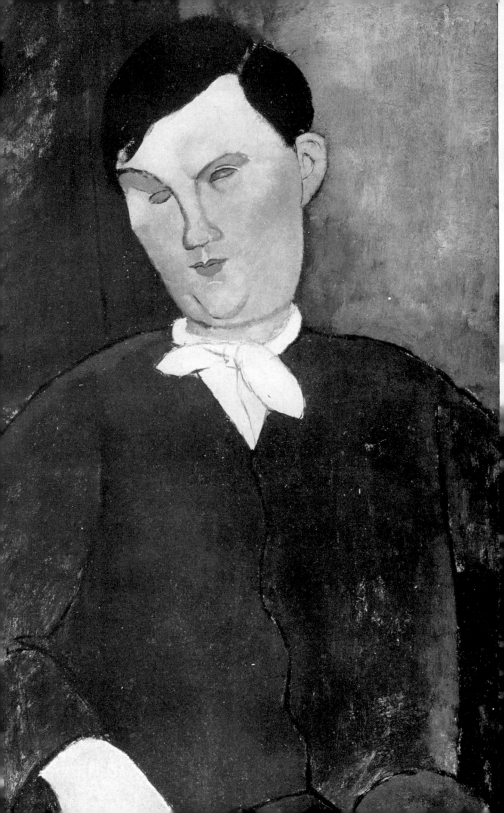

opening a department for the sale of hashish. Modigliani's initiation came about quite differently.

One of the few salutary effects of the First World War on Paris was to disperse the gangs of picturesque vagrants who had for so long infested the Latin Quarter and the Butte Montmartre. Those on the Left Bank went about declaring that they were the disciples of François Villon; the Montmartre hooligans claimed Baudelaire as their 'patron saint'. These disciples of Villon were clever enough when it came to rascality, and they were certainly not ignorant of drugs. They may have been afraid of narcotics, but they undoubtedly trafficked in hashish.

These rogues were in the habit of going up to Montmartre now and then in insolent gangs. Once they had assembled at strategic points, they would set about distributing hashish to their Montmartre counterparts, who, ruffians though they were, nevertheless aspired to emulate Baudelaire. The delinquents from the Latin Quarter would sell their opposite numbers on the Butte a pure extract of *canabis indica* at a very low price. It was a tempting bargain. Yet in order to convince their customers that their drug was more genuine than some of their other wares, notably the fake gold coins which they marketed, the disciples of Villon were obliged to give away free samples.

No one seemed to know where they obtained the deadly merchandise with which they debauched their Baudelairian friends. They owed part of the supply, at least, to an odd individual whose identity remained obscure even after his death. He was a phenomenal character and a personality of some consequence in the Latin Quarter. He was said to have been the favourite pupil of the celebrated chemist Moissan, who among other things succeeded in isolating fluor and produced the first artificial diamond. When later this hashish-purveyor and worker of wonders committed suicide for the sake of a tart who refused to return his love, he was on the point of perfecting a form of synthetic camphor. Meanwhile

the hashish he furnished from his hide-out in an attic in the Rue Montagne Sainte-Geneviève was not synthetic, like his camphor, but only too genuine and of the best quality for the worst of purposes. No one knew how he acquired it, and no one asked. Being disinterested, like the Baron Pigeard, he never sold a single ounce of his precious drug: he just gave it away for the sheer joy of debauching his young friends. He left it to others to market it.

It must have been some of the hashish from this source which a sallow young man in a somewhat clerical garb offered to Modigliani one night on the terrace of a bistrot in the Rue des Écoles. The artist had come down from his Montmartre fastness to try to shake off a fit of depression.

'Pardon me for intruding on your privacy,' said the stranger, 'but are you Italian by any chance?'

'Like yourself,' the artist said shortly.

'You don't live in this part of the city?'

'No.'

The Italian (I shall here give him a fictitious name) sat down casually at the next table. 'My name is Tullio Zuzino,' he announced, though receiving no encouragement to continue the conversation. 'I am from Turin. Judging by your colouring, you are from the south of Italy, I suppose.'

'No, from Leghorn, but I am a Jew. I should be obliged if you would now shut up.'

His new acquaintance gave a pallid smile.

'I expected you to say that,' he remarked meekly, 'but it doesn't offend me in the least and I beg you not to get angry. My name is Tullio Zuzino, as I said. I am a sculptor. You are a painter or a poet, no doubt. Oh, you don't need to answer if you don't wish to. Yes, I am a sculptor, a poor sculptor. I work for an antique-dealer. My work is repairing the irreparable. Can you imagine such a thing? My family wanted me to go into business. My father owns a shop in Turin and sells ready-to-wear clothes.'

'My people are shopkeepers too. But I hope you're not going to bore me with family history all evening,' returned Modigliani.

'One of my sisters is a nun,' the other went on imperturbably. 'She is to be envied. Faith can be a very fine thing, but unfortunately I have none. But first and foremost, there is ecstasy. You must have experienced ecstasy by now. You are an artist, are you not?'

'Oh, go to the devil!'

'How huge you appear to me, my dear compatriot! You seem to have grown larger, larger, perfectly vast, sitting there in front of an enormous drink on a table as big as a racecourse. It seems to be going round and round. Of course it is really I who am going round ... You know, I was bored this evening. I often am. Life can be so frustrating, don't you think? And I don't like repairing antiques very much, things like Assyrian warriors — enormous ones, you know, although sometimes they look small, much smaller than midget figures, for instance. I was feeling as bored as you are, so you should listen to what I have to say. Because I know an excellent remedy for it, a wonderful remedy. My dear compatriot, wouldn't you like to ride on the merry-go-round with me?'

In spite of himself Modigliani found that he was listening to the man. He was irritated by him; yet he was unable to resist the intruder's insidious talk.

'Did I introduce myself?' the man repeated after a pause. 'I can't remember. Anyway, my name is Tullio Zuzino. I must have told you. I said I was a sculptor. Some day I want to carve horses for a merry-go-round: big horses, bigger than the Assyrian warriors. But the warriors are all fakes — as faked as possible, my friend ... I also do illustrations for a publisher of school-books: natural history subjects. Reptiles and birds are my speciality. Sometimes I confuse the two. The first time it happened was one evening after I had been drawing serpents and birds all day. As I was very tired, I took a little of my remedy.

Then I went out for a walk. Even though I did not get off the merry-go-round, I seemed to be standing on the pavement in the rain and I had a rooster's feet instead of my own. That is one of the disagreeable side-effects of the remedy, although you get used to it. Besides, they all disappear once you are riding gaily on the merry-go-round again.'

Zuzino rattled on in his high-pitched voice, and then burst out laughing.

'I've got the merry-go-round right here in my vest pocket, my dear compatriot. *Ubbriachezza! Voluttuoso inferno!* [Drunkenness! Delightful inferno!] Do you remember those *terze rime* in which Alighieri, when he was wandering about here centuries ago — '

'Shut your mouth!' Modigliani yelled so loudly that the barman dropped his copy of *Paris-Sport*. 'Don't you dare to mention the name of Dante in the midst of all your idiocies!'

Perfectly serene, Zuzino's ascetic face lighted up with another of his vacant smiles. Modigliani calmed down, and, gazing squarely into the other's pale, glittering eyes, he perceived a queer glint in them. Modigliani had seen madmen before now. He had, moreover, spent many an evening in the company of the unstable Utrillo, and he felt that he knew something about the mentally disturbed. But Zuzino's eyes were not those of a madman.

He concluded that the man was drunk, although it was not the usual sort of intoxication. It would be hard to say whether or not Modigliani had a sudden flash of intuition, but the fact remains that, almost without realizing it, he heard himself saying: 'Let's have a look at your merry-go-round.'

'It's just a pastime,' Zuzino assured him, as he took a small tin box out of his vest pocket. He opened the box and, with an affected gesture, held it out in the hollow of his hand — a hand that was much too flabby to be a sculptor's. In the box were two putty-coloured pills.

'That's all I have left,' Zuzino said apologetically. 'I wanted

to ride on the big merry-go-round tonight, which has huge horses and tiny, beautiful women mounted on them, so I took an extra dose. Erotic? I can't tell. You would have to know how it feels to be a wooden horse. I am rider and wooden horse at the same time — and if it rains, I shall grow rooster's feet.'

He burst out laughing and his voice became more and more shrill.

'Two more pills,' he cried, 'just two. Would you care to share them? Then you can try it out with me, while I give my horse an extra spur, enough to last all night — under the stars — if it doesn't rain. Otherwise I shall become a rooster, the kind they open up to take the auspices ... As for you, my friend, allow me to give you a word of advice: go straight home and climb on to your merry-go-round there; and if you have anything to nibble on after swallowing your pill, the horses will go round all the faster.'

Modigliani took the pill from him and swallowed it at once.

Most specialists on the subject assert that the toxic effects of hashish begin from the very first dose. At all events, a single pill was sufficient to turn Modigliani into an addict, for although he thought he was just experimenting with it in the hope of relieving his depression that fateful evening, he derived far too much satisfaction from the poison not to want to try it again. True, there were days when his Montmartre friends would find him perfectly calm; there were times when he did not touch the drug, or even red wine or rum; nevertheless, his craving for it grew. Where was he to obtain it now that he had lost touch with Zuzino and despised the young ruffians from the Latin Quarter? Where else but from the Baron Pigeard? Later on, when he went to live in Montparnasse, he made the acquaintance of another artist, the Chilean Ortiz de Zarate, who also had a weakness for hashish ...

THE Lapin Agile is in the Rue des Saules, opposite the
wall surrounding the Saint Vincent Cemetery, which looks
more like a horticultural garden than a burial-ground. It is
so verdant and cheerful that many a young man of twenty
without a roof over his head might have wished in those days to
make it his last resting-place.

When we were all very poor, a period which some of us
now look back on nostalgically, we used to congregate at the
Lapin, which was a passable imitation of a country inn. We
probably did not go there as often as legend has reported, but
we met there occasionally, and we were always puzzled as to
why Modigliani so rarely joined us. Perhaps it was the arti-
ficial rusticity of the place which repelled him, or it may have
been that he shunned our gatherings for the same ambiguous
reasons that made him refuse to visit the 'Bateau-Lavoir'.
He continued to avoid Picasso, whom he had been so
eager to know. However, he did not hesitate to visit certain
habitués of the Lapin in their studios, and among them was
Max Jacob.

At the Lapin Modigliani would at least have found some
worth-while acquaintances, for the café was not always filled
with noisy gangs of insolent young daubers. There were times
when you could have the pleasure of discussing the wildest
ideas — a very important privilege when one is young and
searching for the truth. True, 'Frédé' (Frédéric Gérard, the
proprietor) sometimes felt obliged to interfere when a dis-
cussion got too heated, and whenever he considered that we
had gone on long enough he would take up his guitar, strum
a few chords, and then call out genially: 'Silence, friends.
We're going to have a little *real* art now.' And after treating
us to a bit of Marcel Legay, a verse or two of Paul Delmet, and

a few stanzas from Ronsard, he would end with one of his own bucolic compositions.

One morning Modigliani woke up resolved to go and see Max Jacob in the Rue Ravignan and André Derain in the Rue Tourlaque to discuss with them some of his own artistic problems. He had not drunk too much the night before, and luckily for him he had not been able to get any hashish either, because the obliging Baron Pigeard was away. Luckily also, Modigliani was too recent an addict to be greatly affected by this deprivation.

Modigliani was naturally fastidious, and despite the primitive conditions his poverty imposed on him he decided to have a bath. As he sat splashing himself in his diminutive zinc tub he suddenly burst into a fit of laughter that owed nothing to hashish, at the thought that the painter Bonnard appeared to regard the tub as an ideal setting for his models and used it in Modigliani's opinion to excess.

Excess: the word gave him pause. Was he not guilty of excess himself? Was he destined to over-indulgence in everything — in drink, women, drugs, even in his beloved Dante? Was he abusing his integrity as an artist, so that by isolating himself among men who produced only the most banal work it was becoming impossible for him to claim fellowship with any artist worthy of his respect?

He shaved methodically and, shaving-brush in hand, meditated on how the paint-brush should be applied to the canvas and on the distribution and blending of tones, which one critic had defined as 'colour control'. The mirror was cracked, which foreboded seven years of bad luck, but the nearest shop was too far off for him to bother about buying a new one even if he had been able to afford it.

When he had finished washing and dressing, Modigliani began to wonder about the time, only to find that half the morning had already gone. Even so, Max Jacob might not be up, for he nearly always went to bed late. The half-starved

Max spent most of his time painting or writing poetry or deciphering texts in the Bibliothèque Nationale. Once his day's work was done, however, he liked to put on the frock-coat his father had tailored for him in the family workshop in Quimper and go out into society, where he could show off his talents in various ways. Sometimes he would recite a prose-poem he had composed, explaining Picasso's Cubism, which he 'simplified' for the benefit of his audience; sometimes he read ladies' hands, preserving the good things of the past, showing discretion as to the present, and spicing his promises for the future with a dash of naughtiness. Finally he would sit down at the piano and give an imitation of his mother singing the songs of her youth — 1870. 'My mother's golden age was the golden age of operetta,' he would say. If the party happened to take place at the home of his cousin, M. Gumpel, the rich industrialist, M. Gumpel would slip a few francs into Max's hand in the privacy of the cloakroom.

That morning, however, Jacob had not been out the night before and, hearing Modigliani's discreet knock, he immediately opened the door of his drab little room looking out on a gloomy court.

Clad only in a singlet and corduroy trousers but — like his visitor — carefully shaved, Jacob sat enthroned on a broken-down couch. Near him on a small table were an enamel coffee-pot, a plain white cup without a handle, a cup with a flower design on it which Picasso's mistress, Fernande Olivier, had won at a fair and presented to her dear detested Max, and a glass. The glass and cups were coffee-stained, and next to them lay a box with several lumps of sugar in it. The scene was an excellent still life of poverty, but not of destitution. As he talked, Max began clearing it away. His tidying-up was summary, for he merely piled the coffee-pot, cups and glass into a zinc foot-bath, which was within easy reach.

'Housework!' he exclaimed. 'What a merry-go-round. Do you have a charwoman? No, I thought not. But then, you're so

handsome that the women would fairly queue up to do your housework. There are always the remains of your midnight supper to clean up, the bed to be made, and it all has to be done over and over again. But be careful: a woman can begin with a bit of light housework and before you know it you're both on the merry-go-round.'

'Oh, the wooden horses.'

'What wooden horses? I meant the merry-go-round of marriage. I have never married. I haven't even a charwoman, but all my friends have — the same one, in fact. She works for Picasso, and so helps out my good friend Fernande Olivier. She also does a bit of work for M. Georges Braque, M. André Derain, M. Maurice Princet, and for M. André Salmon, who is at present finishing a volume of verse between writing two popular novels. That charwoman is a regular walking gazette. She never tires of talking about the curious and singular incidents which brighten the lives of all those gentlemen. What hasn't she told me about the greediness, the frivolity, the inconstancy of so many of the young ladies who have been attached to my painter and writer friends! You are likely to have women play tricks on you too, if you don't watch out. Let me give you a bit of advice: be careful not only of women but also of what certain fools call "ideal beauty" in men also. You are no fool, but we are all at the mercy of idiots, and many of them are fascinating and full of charm. So you see where that can lead.

'Amedeo, you are so handsome that all the women fight over you. I believe in your future — don't spoil it. May I speak quite frankly to you? Then be careful. I feel that you are on the right track, but only if you are able to put your bad start behind you. You must have realized it yourself, but I feel I should try and convince you for friendship's sake. You must forgive me, if I am doing you an injustice. And now, if it is all the same to you, I am going to concoct a little potion for myself of eau-de-Cologne that my rich cousin Gumpel gave me

and a mere drop of ether ... By the way, I hope you are not taking too much of that drug these days? Beware of Pigeard and his gifts ... What are you painting at present?'

'I've begun a nude, but I don't know when my model is coming back. I don't even know if she will come back.'

'You should try doing a still life, if only to get your hand in. A smoked herring is a good subject, or a boiled egg, and a chicken is satisfactory if it is well plucked ... Who is your model? Some Montmartre girl? In that case you will find her again easily enough.'

'I don't know where she's from. She is very beautiful. I saw her one day in front of the Lapin Agile and I wondered whether she was going into the café or had just come out of her shop. She was with an actor who sometimes recites poetry at the Lapin for his own amusement and that non-commissioned cavalry officer, the brother of the painter who sleeps with Zina. Do you know them?'

'Yes, I know them. I am not surprised that she dropped her cheap actor and the cavalryman for you. Your eloquence is in your eyes, my boy, which at least saves you from having to indulge in cheap flattery. Has your nude started well?'

'I think so, but I'd like to finish it before talking about it. I can't judge anything until it's finished. I should like to be able to paint quickly, but in fact I work rather slowly, Besides, as I told you, I don't know whether she'll come back.'

'She would do better not to. She is a light woman, and they are not suitable for serious posing. I suppose you made love to her first — a fatal error. Afterwards, yes — but only if you must. And if I say that I hope she doesn't come back, it is for other reasons as well: not even Picasso, for all his genius, was able to resist the charm of my dear friend Fernande Olivier.'

'You know very well, Max, there's no room in my place for a woman.'

'One always says that. But women are so clever at making a place for themselves. You made a big mistake in not getting

your elegant woman from God-knows-where to pose for you first. You could have washed in your canvas quickly and then worked on it again as long as you liked after the creature was gone and mercifully forgotten. You would have had nothing to worry about except the drawing, the colour, and the construction.'

The two men raised their glasses and drank.

'Do you remember,' Jacob asked, 'how when we first met you told me that you had found, or believed you had found, the primrose path of the Pre-Raphaelites? I don't like the sound of that very much. Take care! Ardengo Soffici and Giovanni Papini, whom I once had the pleasure of meeting, were quite right in advising you not to tread it, but I wonder if they really cured you of that youthful folly? I don't know what they said to you, of course, but — speaking for myself — I must warn you that Pre-Raphaelitism is a poetic invention of a bad period — the very worst. It is one which my friends and I, as its heirs, are determined to repudiate.

'You are gifted, Amedeo, so you must avoid Pre-Raphaelitism. What will save you, I hope, is your relative poverty. I mean that Pre-Raphaelitism ended up with rings and jewellery — fingers loaded with rings. Do you see what I am getting at? The Oscar Wilde type. Dreadful ... The poor fellow was only saved by prison and misfortune. There he was, the society man, the darling of the drawing-rooms; then the jailbird, and so finding his way back to Dostoevsky. That is what you should be thinking of when you are working on a canvas, more even than the problems of painting. I am speaking of painting in general, of course: the *métier* which Derain has already discussed with you.'

'You always like to play the mentor, Max. You certainly give good advice, but you can be sure that I — '

'Nonsense! One never tries hard enough to overcome the follies of early youth. But we will pass over that. What I meant to say is that Derain, for instance, is so intelligent that he

75

thinks over other problems besides technical ones when he is painting. Remember that; and remember at the same time to be on your guard against that sort of intelligence because it can so easily be fatal to an artist.'

'Do you maintain that intelligence — '

'I don't maintain anything. I say and state things that are supposedly important, and they may contain an element of truth. Truth is made up of bits and pieces; the problem is to know how to assemble them into an enlightening whole. It is terribly difficult, enough to make you weep ... I'm not going to talk to you about Picasso, since despite your anxiety to know him, you seem to have dropped him very thoroughly. People must have told you that your latest drawings show traces of Negro influence, but Picasso would be right if he told you that he does not know Negro art well. It is rather the Etruscans who have made you more sensitive to Negro art. Why don't you leave Montmartre and go over to Montparnasse? There is not enough for you here. To the right is Derain: Intelligence made Man. "And the Word was made flesh" — you follow me? To the left is Utrillo, your companion in drinking-bouts, the innocent angel unawares.'

'It is his very unawareness that consoles me. He says he doesn't particularly like painting, that he would much rather be a vagabond and drink. But he reaches for a palette as he does for a bottle, and the fact is that he paints with only a vague awareness — '

'No awareness at all.'

' — a vague awareness of what he is painting. Painting has had geniuses of all kinds. It needed an innocent as well.'

'What about the Douanier Rousseau?'

'You must have the same opinion of him as I have, Max. Rousseau's innocence is of another kind. He is not really an innocent at all, since he instinctively possesses a masterly sense of composition which even the best of us strive for and which, speaking for myself, I have little hope of ever developing ... I

paint, and when I paint — which I do rarely now — it's always faces, heads, figures. But I dream of doing pictures, huge pictures ... I have thought of nothing else since leaving Florence.'

'I have been thinking about your case. Burne-Jones — what a name! — has given you back to Botticelli. But have you ever realized what a danger this Monsieur Jones, who never spotted his fine tweed coat with paint, has been and is for you? You don't know what tweed is, but I do because my father is a tailor, whereas your father had a shop in Leghorn, didn't he, and Derain's father made a fortune in the dairy business.'

'The middle classes have always kept the flag of art flying, especially in France. The painters of the eighteen-forties were wrong to scoff at the middle classes.'

'Yet it was the Paris toll-office that gave us the Douanier Rousseau.'

'A fluke. I don't believe in so-called "popular" painting.'

'What about your friend Utrillo?'

'His art is not popular in that sense: it is childlike. It's a unique case. Maurice began by daubing, as all children do, and still does, or thinks he does. Most youngsters stop painting before they are twelve, whereas Maurice, who will never be more than ten, has nevertheless developed a sort of painting of his own.'

'And Lautrec? Count Henri de Toulouse-Lautrec, the Botticelli of the Moulin Rouge, the master who did a cabaret "Primavera" and a "Birth of Venus" or "La Goulue" rising from a double-bass in the foam of her petticoats?'

'Lautrec's physical disability enabled him to transcend class.'

'Art ...' Jacob paused a moment. 'How impossible it is to define it! Aesthetes must understand something about it, but it weighs on them so heavily that they are unreadable. As for the literary crowd, what can you expect from them but "literature"? Whereas I, who began by being a professed aesthete

and am now a literary man, I am an amateur interpreter because I have watched the painter at work through the keyhole, so to speak.'

'Botticelli — '

'Botticelli's composition is excellent. He did too many processional scenes for my taste, but he composed them all right. If he has given you a feeling for composition, bravo and all honour to him.'

'I'm no good at composition.'

'Not yet, certainly, but it may come — if it is ever necessary.

'You mentioned processional scenes. I should so much like to be able to compose them.'

'You should be able to do better than that. But will you? You don't seem sure of yourself when you do single, isolated figures. Dare everything: then you will achieve something better than insipid processions. Picasso composes, and his groupings never turn into processional patterns. Study Seurat a bit: "Summer Sunday on the Grande Jatte", "Poseuses", and "Chahut". People will realize some day that Seurat even more than Cézanne was the leader of the modern movement. It is curious how the critics neglect to point that out about Seurat ... But only Picasso can understand Seurat, and that is why he is able to follow him without imitating him. Picasso understands everything; but you are not stupid, either ... Are you sure you wouldn't like a cup of coffee?

'No? Well, one last bit of advice, since you don't want coffee and advice is what you came for, just as everybody does. You don't have to follow it, of course, but listen all the same. You are as Italian as I am Breton, and you are as proud of it as I am. But an Italian always has a tendency to artiness for the sake of artiness, and the kind of art you are after has nothing to do with artiness. Save yourself by remembering that you are also a Jew. The Jews don't go in for that kind of thing, but we have given the world composers who were masters of counterpoint: Mendelssohn, Meyerbeer, Halévy, Hérold ... Counterpoint is

the harmony between several different parts. You should keep that in mind.

'We have also given the world excellent pianists. The piano is a whole orchestra under the control of ten fingers. And so is the palette. One more thing, very important: you must learn to laugh a little. And now let us go and see Derain in the Rue Tourlaque.'

The Rue Tourlaque is not particularly characteristic of Montmartre. It is a short street, narrow and forlorn, forming a kind of spur to the Rue Caulaincourt. It consists of middle-class houses, a police-station, and a small group of artists' studios. Derain's studio was on the ground floor at the back of a bare court.

When Jacob knocked at the entrance a voice called out: 'Who is it?'

'Max Jacob, with Modigliani.'

'Come in.'

Derain was tall and had not yet run to fat. He was standing at his easel, putting the finishing touches to a small canvas, a still life, painting with the deliberation of a careful amateur yet managing to spatter different-coloured paints on his conventional blue suit. He owned six of these suits, all identical, and he hung them in his wardrobe "in order of cleanliness", as he liked to say with a laugh.

'Sit down,' he said. 'I'm just finishing and then we'll go and have a drink at Manière's in the Rue Caulaincourt.'

'Modigliani,' Jacob informed him, 'is longing to see the large canvases you've got turned to the wall there. May he?'

'Of course. But they're some of my failures — big jobs I've bungled. That's why they're face to the wall.'

'I throw my unsuccessful poems into an old servant's trunk,' said Jacob. 'I often wonder if I'll ever fish anything decent out

of the lot. And what about you, André: will you go back to one
of those canvases some day and try working on it again?'

'I don't think so, though I may wish to do one of them afresh
after the wild enthusiasm of youth has calmed down a little.'

Although he did not know Derain well, Modigliani felt
more at ease with him than he did with Jacob. 'You are a
seeker, M. Derain?'

'Of course. Aren't you?'

'Everyone is.'

'The difficulty for most people is to recognize what they seek.
Is that your trouble?'

'I'd rather not talk about my own case yet.'

'You seek what you need to find. Picasso is fond of saying
that he finds but does not seek. If he were to make a collection
of aphorisms the book would have to begin with that. Why did
you ask me if I seek, Modigliani? What did you mean by such a
question?'

'I asked because you have allowed me to see some of your
larger canvases, which to me seem very fine. Yet they remain
unfinished, dust-covered, face to the wall, whereas I think — '

'Go on.'

' — I think you ought to work on them some more, get down
to them right away instead of taking such a devil of a lot of
trouble to finish that small still life of a clay pipe and a green
pear on a brown dish.'

The ice was broken and they were now talking easily.

'You're confusing quantity with quality,' Derain remarked.
'I must tell you a little story on that subject. When I was
doing my military service in the east of France I met the most
amazing captain. Whenever he was on horseback he was simply
magnificent, awesome, stupendous, absolutely sublime. But
once he dismounted you could hardly see him. He was absolutely
pitiful. You almost expected his orderly to sling him over his
shoulder and carry him home. I had never told anyone that I
was a painter because I was only too glad to have an easy billet

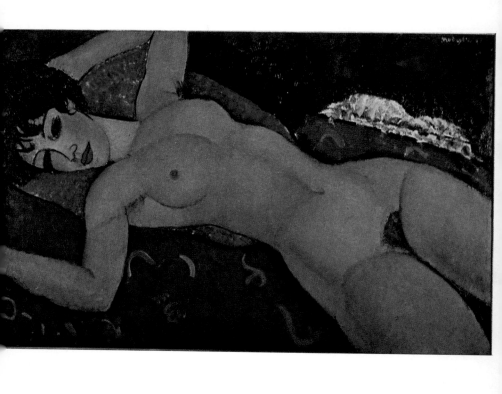

as the colonel's dispatch-rider, but I was betrayed by some drawings I had done in my quarters, and so the captain asked me to do an oil portrait of him.'

'On horseback?'

'No, not on horseback. It was for his sitting-room and his wife said there wasn't enough room for the horse.'

'So you did a successful portrait of him standing up?'

'No, I painted him sitting down. In other words I cheated. You often have to cheat in life, but you shouldn't, ever ... Now let's go out and have that drink at Manière's.'

11 From Montmartre to the Louvre

HE was one of those ragged waifs with hollow cheeks and legs that turned blue in the first cold autumn wind: one of those poor little wretches who were unlucky enough to have been born in Montmartre. Not all the children were natives of the Butte, but wherever they came from, they all climbed up to the Place du Tertre in the hope of earning an odd sou somehow, or else of cadging half a croissant or a cigarette-end from some customer sitting in a café.

To earn their sous or their bit of roll they would put on a show in the square, or play the fool for the entertainment of the pseudo-artists who infested the neighbourhood. They did not look so different from the would-be daubers for that matter, except for their short, ragged breeches. Some of them brought along their sisters, whose methods of attracting public sympathy often proved embarrassing. As a rule they would begin their foolery at about the age of seven, and they worked hard to startle passers-by with their vulgar talk, which was a mixture of artists' slang and the lingo of ordinary toughs. It was one of these gamins, a wistful child with an old man's face, a tubercular little monkey in pitiful physical condition, who one day caught Modigliani's eye because, though he never spoke of it, he knew well enough that he suffered from the same disease.

The young Italian had just entered Mère Catherine's establishment, where André Utter and a number of other acquaintances were drinking together, and he tossed two coins on to the counter and ordered 'the usual' for himself. Then, as the proprietress was about to reach for a bottle of red wine, he suddenly changed his mind and said, 'Give me back my money, Madame, and don't bother to pour out my drink.'

'What do you plan to do with your money?' inquired Utter. 'Are you going to turn over a new leaf?'

Modigliani did not deign to reply, but stepped out into the square and put the money into the small boy's dirty paw. Then he returned to the café, though the sacrifice meant that he could no longer afford a drink.

At that moment a fantastic character, looking like something out of a bad dream, came up to him. The stranger was almost as pale and emaciated as the forlorn children playing outside. He wore a formal frock-coat and frayed carpet slippers on his feet. It was the cartoonist and illustrator, Jules Depaquit, one of the most arresting personalities on the Butte. He was not only an artist; he was also a writer, and in both media made as much fun of himself as he did of others.

'Monsieur,' he began, 'allow me to introduce myself: my name is Jules Depaquit, and you, I believe, are M. Amedeo Modigliani. I am surprised we have never met before. Chance is all-powerful but often malevolent. I was greatly moved by what you did for that little street arab just now. Would you care to have a drink with me? What about a glass of that red wine which our dear Mme La Bille would be only too happy to serve you? Madame: a full glass of red for M. Modigliani and a *mominette* for me. The absinthe served in *mominettes* contains potato alcohol, but why don't we have fried potatoes with alcohol in them? Your health, M. Modigliani. After that generous gesture of yours — '

'I'm not that generous, but the sight of misery disgusts me.'

'Gentlemen, a prince is speaking to you,' proclaimed Depaquit, giving a quick glance at those nearest him.

'You don't know how true that is,' remarked a voice from the door of the café.

It was Pierre Mac Orlan the novelist, who, chancing to pass that way, had seen several familiar faces among those lined up at Mère Catherine's bar. He came in, prompted not so much by

the desire for a drink as by the need for the applause of as many listeners as he could gather around him.

Utter stared at this habitué of Montmartre, who was dressed like a jockey and carried a large bundle of papers under his arm. 'What's that you've got there?' he asked. 'A complete set of your celebrated works?'

'No, unfortunately; not complete at all. Would you believe it, I have found a publisher at last. Yes, I am writing again. I have just been commissioned to do a novel, and for the first time in my life I have been given an advance. I was determined to write because I had had enough of painting fox-hunting and steeplechasing scenes and all those sporting water-colours in typically British style that I used to do. It was the British style that made me choose the pseudonym of Mac Orlan. I don't mind telling you that the novel is not for Fasquelle, or the *Mercure de France* either, but for a very decent fellow in the Rue du Faubourg Poissonnière ... What are you sniggering about, Utter?'

'If the new novel is anything like the first, it ought to be a choice piece of smut.'

'Are you saying that to make Modigliani dislike me? You are wrong to try, because in the first place you ought not to despise people, and in the second there is nothing despicable about my writing since it enables me to earn a living, however wretched, and so to indulge my artistic ambitions — which I seldom speak of. Do I, Modigliani?'

'No, he never mentions them.'

'Any more than Modigliani does his.'

'And we are both wise not to.'

'I may add that books which should be condemned (and often are) have at least the virtue of helping their readers to forget their troubles, if they have any, and carrying them off into a world of fantasy and fable. The world of fable! I keep thinking of the description a man blind from birth might give of the physical universe. And what kind of universe would he

portray if, thanks to some mechanical device, he were able to paint it? What do you think, Modigliani?'

'He wouldn't need a mechanical device. You can find that kind of painting anywhere. Dante, on the other hand, depicted Hell itself where Virgil led him in a dream.'

'Dante! That was a long time ago ... '

'You would do well to read him, Utter, and let Modigliani do the talking.'

'Mac Orlan is taking us too far afield.'

'Farther than Hell?'

'I wouldn't care to illustrate a book which was condemned in advance by its author.'

'You'd rather die of starvation?'

'We all have to croak sooner or later, Utter. I want a short life and a full one.'

'None of this is much help to me,' said Mac Orlan. 'I have only written the first chapter of my novel so far, and it isn't enough to show my publisher as I intend to ask him for an advance of two hundred francs.'

'I can lend you the outline of a long novel I am doing from a short one I once wrote,' Depaquit suggested. 'I am working on the illustrations for the long version now, and when I have finished with it the whole thing will make *Quo Vadis* seem like a Sunday-school story.'

'Which it is — and since my novel is the story of a noted Roman courtesan, perhaps M. Modigliani will be kind enough to give me some information on the subject of ancient Rome, which I have never had a chance to visit.'

'My dear M. Modigliani,' Depaquit broke in, 'I must repeat that your generous gesture a while ago moved me deeply, but what touched me even more was your statement to the effect that the sight of misery disgusted you. That was well said. Misfortune takes so many forms. Thanks to my unusual strength of character, I can defy it, although, if I may say so, you behold in me misfortune personified ... You'll have

another drink with me, won't you? Madame, please: the same again for this gentleman and myself! ... Misfortune, M. Modigliani, is not a question of age, as these poor little waifs out there prove, but the rich children of stupid parents are even more unfortunate. I recall a little boy in my native town of Sedan whose parents made him wear a Scotch kilt until he was thirteen. The result was that everyone took him for a little girl, and the consequences may be imagined.'

'What about the plot you promised me for my manuscript?' Mac Orlan interrupted.

'Come along to my place and I'll give it to you. That will put me in the mood to get back to work on my long novel.' Then, turning to Modigliani, he remarked: 'When I see our painter and novelist Mac Orlan wearing a cricket cap and riding-breeches, I find myself wondering if he does it to please his mother or some wealthy female relative with a passion for British chic.'

But Modigliani was not amused by Depaquit's laboured irony. Though highly intelligent and capable of being cruelly caustic at times, he had no trace of what in Paris passed for wit and made no attempt to acquire it. In fact he detested it. 'Shut up!' he said abruptly.

'Have I displeased you, M. Modigliani?' Depaquit inquired. 'That is exactly what I was trying to do. I must apologize for having tried you so sorely. I now know your true worth. You have a natural pride and nobility, a rich nature, and a nasty character — but at least you have character. I, on the other hand, have no character, or rather, I have never been able to "characterize" my character, if I may so express myself. You are, or will be, a great artist, lacking only the patronage of a Medici or a pope. Happy is he who is able to escape the dismal snare of caricature ... No, gentlemen: do not restrain Modigliani. He is furious and we need furious men, especially among artists, and above all since the Renaissance ... '

'Merde!' Modigliani cried, and walked towards the door.

Before going out, he turned round and declaimed in Italian a tercet of Dante's, ending with the words 'this bitter land'. He repeated them three times, as if echoing himself: 'Bitter ... bitter ... bitter.'

'Who wrote that?' Depaquit asked Mac Orlan slyly, though he had heard enough about Modigliani to know that the quotation could only be from Dante.

Modigliani walked a long way that day.

The clock in the tower of the near-by church of Saint-Jean Baptiste struck noon, but the wine Depaquit had treated him to was all he was to have for lunch. He went on and on aimlessly, wanting only to be alone. Though outwardly calm, he was still furious; but now his fury turned against himself, that other entity which accompanied him but could not answer his terrifying questions.

Depaquit in his self-appointed role of cold-hearted buffoon had mockingly called him a great artist. Modigliani knew well enough what one should *not* be, what one should *not* do. But how to become what one ought to be, what one had sworn to be? He was alone and without a single friend in Paris; he was far from his native land and its beneficial influence; and he was uneasy about what people in France might think of him. So he strode through the streets of Paris, a man whose inner flame consumed rather than enlightened him.

He had been so absorbed that when he finally became conscious of his surroundings after a taxi-driver had hooted at him angrily, he found himself in front of the Galeries Lafayette, where the sight of a pretty girl put an end to his dour meditations. He watched her enter the store and followed her, but soon lost track of her among the crowds.

Another girl emerged, less classically beautiful but with a supple figure that reminded him of some of his drawings. He watched her trying on some gloves, and all at once he was lost

in an erotic dream. He hurried out of the Galeries so fast that he aroused the suspicions of a floor-detective, who took him for a shop-lifter. But Modigliani had done no wrong; his aberrations, the little latent crimes he might commit, were beyond the comprehension of a detective policing a fashionable establishment.

Modigliani went down the Avenue de l'Opéra and arrived at the Louvre, a place he had had no notion of visiting when he set out from Montmartre.

They were changing guard in front of the Ministry of Finance, and a corporal waited while one soldier took over from the other with a great show of saluting and presenting arms. The ceremony was brief, but it was long enough to twist Modigliani's handsome features into a grimace of the hatred he felt for everything connected with the military.

He wandered into the Louvre gardens and presently reached the Carrousel, where Napoleon had once reviewed his Old Guard — Napoleon, the Emperor who had been called the Little Corporal after the kind of little corporal he had just seen outside the Ministry of Finance; Napoleon, whose name still sent a shiver of unease through all the foreigners in Paris, Modigliani among them. He had studiously avoided the tomb in Les Invalides, but he could not help remembering Bonaparte, lord of the rich lands of Lombardy, whose son had been called the King of Rome. Was Napoleon an artist also? Perhaps. He certainly understood processional scenes. Balzac had described one of his reviews in *La Femme de Trente Ans*, vividly evoking the Corsican's love of pageantry ... Corsica ... Corsica and the island of Elba, just across from Leghorn. Yet without Balzac's descriptive genius, who now would recall the Emperor's glory? It was only art that endured.

Balzac's art was like fresco painting. And what were frescoes but huge compositions? Yet the art of Amedeo Modigliani, who had been stimulated by the Etruscans and had rediscovered Botticelli by way of the English Pre-Raphaelites, amounted to

just two portfolios and an album of rather tentative drawings.
And drawings of what? Nothing but one face, a single face that
seemed as if lost in the universe. It was a woman's face, but
always the same.

He was tired now, but there was nowhere to sit, nor had he
any idea how long he had been walking. His steps brought
him, still in a dream, to the main entrance of the museum.
Several men were grouped on the front steps and, being
familiar with museums in Italy, Modigliani recognized them
at once as professional guides.

Seeing Modigliani, one of them, whom his friends and
rivals called Fritz, hurried forward to offer his services, but the
young Italian brusquely waved him away. The man withdrew
at once, perhaps because the visitor did not look like very
promising prey. He was shabbily dressed and dishevelled, yet
there was something familiar about his face, and as he turned
away the guide wondered if he could have seen him some
evening in Montmartre in company with Max Jacob or
Maurice Utrillo.

Modigliani might not have dismissed the other so peremp-
torily had he known who he was, for the guide was none other
than Fritz Vanderpuyl, the French poet of Dutch origin who
lived in a garret in the Rue des Écoles, where Soffici and
Papini had visited him several times when they were in Paris.
But Modigliani was unaware of this and went on into the
museum. Evidently fate never intended him and Vanderpuyl
to meet. Later on, when the poet was at last able to escape
from being a guide at the Louvre, he became an art critic of
some standing, though apparently incapable of appreciating
Modigliani's work. Twenty years after the artist's death,
Vanderpuyl wrote a book for the express purpose of denying
that the latter had any talent or his painting any lasting value.

Another critic who disregarded Modigliani was Maurice
Raynal, who almost from the beginning confined his critical
writing to a dogmatic interpretation of Cubism. As for

Modigliani: A Memoir

Guillaume Apollinaire, since I could not recall ever having seen a line of his on the subject of Modigliani or heard of his associating with him in any way, I decided to ask my old friend Jean Mollet if he could throw any light on the matter. He had been one of Apollinaire's intimates, but when I asked him the reason for the Symbolist poet's attitude he merely replied: 'Guillaume had other interests.' I naturally respect every individual's convictions and point of view, but for my own part I am glad that my interests have not been so exclusive.

12 The Etruscans of the Rue Turgot

I SHALL soon have related the essential facts concerning
Modigliani's Montmartre period, but to confirm my own
recollections I have drawn on those of an old and tried friend,
a compatriot of Modigliani's who came to France at about the
same time. He was among the painter's first friends, and
one of the few in whom the unsociable and reticent Amedeo
ever confided. I refer to the distinguished Italian painter,
Gino Severini, who had met Modigliani in October 1906, a
month after they had both arrived in Paris.

Whereas Modigliani was from the bustling commercial
port of Leghorn, Severini was a Tuscan of quite different back-
ground. He came from Cortona, perched high on the side of a
steep hill on the site of an ancient Etruscan city and over-
looking the main road between Florence and Rome. Modig-
liani had visited it and must have been very much excited to
see that famous stronghold of the Etruscans. It was also the
birth-place of Luca Signorelli, the master who had painted the
wonderful 'Last Judgment' in the cathedral at Orvieto, a
composition which must have doubly inspired the young man
who worshipped Dante and aspired to become a great artist
himself.

When I visited Severini a few years ago, he welcomed me
to his mountain retreat near Bolzano and we talked of many
things together and recalled the past. Reminiscing about
Modigliani, Severini said:

'Do you remember that first place Modigliani lived in on
the edge of the Maquis? I can still see that sort of "glass cage"
or veranda it had. It was next to the Moulin de la Galette and
not far from the Lapin Agile, which he found for himself. He
wanted to take me to the Lapin right away, although in fact
he went there very seldom.

'Modigliani and I got along well from the first, perhaps because we were both Tuscans of about the same age and both rich — our only riches! — in that we were full of ambition, aspirations, and vague, unformed plans. Financially Modigliani was as badly off as I was. He probably received a little help from home from time to time, but it was not enough. I had nothing at all. What were we to do except resort to any expedient we could think of? I had made friends with a champagne-merchant whose wife owned a hat-shop in the Rue Damrémont on the corner of the Rue Tourlaque where Derain and Bonnard had their studios. Their conversation was perhaps not very stimulating but I was glad enough to go and dine with people who were so generous and hospitable that they saw nothing odd in my turning up with a friend as starving as I was. The friend was usually Modigliani. They made quite a fuss of him. The milliner in particular appreciated his tact and good manners, not to mention the charm and gaiety which he showed when with young women. But we did not often have the chance to associate with middle-class people as casual and unconventional as they were.'

I reflected on what Severini had just told me of Modigliani's amiability and courtesy in a social setting so different from ours, which merely brought out his tendency to aggressiveness and turbulence.

'One summer evening,' Severini resumed, 'Modigliani and I were involved in an incident which almost ended in disaster. At that time I was living at 22 Rue Turgot, next door to the offices of the Théâtre de l'Œuvre, and just across the street was a café-restaurant run by an Italian from Florence. When I think of the state of my finances in those days, it seems to me miraculous that I was able to persuade the brute who owned the place to allow me to eat there on credit. That evening I was having my dinner out on the terrace. I had just begun eating my skimpy portion when I looked up and saw Modigliani, who was obviously on his way to or from Montmartre.

He had caught sight of me first, and when I saw him I was struck by the look in his eyes. It was the disconcerting gaze of a man who envies a friend, knowing quite well that he cannot afford any dinner himself. You can picture the situation.

'Naturally I invited Modigliani to join me. I would have done so in any case, but unfortunately I already had two guests, a close friend of mine and his wife, so that the famished Modigliani was staring at not one person eating, but three ... Many people wouldn't understand what I mean, but you will because you have known hard times too.

'There were now four of us dependent on the good-will of the proprietor. But his good-will was only superficial, for at bottom he was a thoroughly unsympathetic individual, not at all accommodating. The credit he grudgingly allowed me did not extend to guests. It was to be expected, therefore, that he would kick up a row when the time came to settle the bill, because — as you've guessed — I hadn't a sou in my pocket, nor had any of the others.

'I think Modigliani had ordered *antipasti misti*, a portion of rabbit, and a sweet. I had asked the waiter for a carafe of red wine. Shortly before the dessert Modigliani, who by now had caught on to the situation, discreetly passed me a pill in the hope of bolstering up my courage. He took one too. To make the drug act more quickly I ordered one of those strong coffees which Italians make so well, even in the smallest cafés. The immediate effect went beyond my expectations. In a burst of crazy laughter I told the *patron* to add the other bills to mine — which was already large enough, God knows.

'The rage he flew into was something Homeric, or else Modigliani might have imagined him howling with rage and despair in some infernal region more terrible than Dante ever described, a pit of torment reserved especially for heartless bistrot-owners. I can still hear him roaring that he would call the police and that it was people like us who gave the immigrants a bad name.'

Severini's anecdotes, however, were not confined to Rabelaisian stories, and he went into some detail concerning his compatriot's artistic development and activities in general during those early years of their acquaintance.

'When we first met in Paris,' he went on, 'Modigliani's ambitions were much more vague and wavering than mine. I at least was determined to get some enlightenment on Neo-Impressionism, or Divisionism, about which I had not been able to obtain as much information as I needed in Italy.

'In 1906 Modigliani was chiefly interested in Toulouse-Lautrec, Matisse, and Bonnard, the three outstanding artists who had a certain influence on him at the beginning of his career. I did not have an opportunity to see much of his work, and I never saw any of the numerous nudes for which obliging young ladies of the Butte Montmartre had posed. What I saw were sketches of various friends and acquaintances. To the end of his life he retained a taste for sketching people in cafés with an extremely sharp pencil. Most of his drawings were charming enough but they were in no way distinctive.

'Of course, like me, Modigliani had still to prove himself. But then, all those with whom we drank and talked at the Lapin Agile had still to produce the painting and poetry they aspired to. The question was where and how to find what we needed to guide us in the right direction.'

Severini went on to talk of some of the artists who had formed that circle, and asserted quite correctly that Modigliani did not get on well with everyone.

'From his Tuscan side Modigliani got his critical sense and his irony, and — another very Tuscan trait — his acute sensibility. I may say in passing that although Picasso was the first artist he wanted to know in Paris, Modigliani not only did not follow up the acquaintance, but he never cared a great deal for Picasso. The feeling was mutual, I believe.

'As time went on, Picasso, Derain and Braque began to use geometrical forms more and more, and Cubism took on a more

distinctive character. The new movement left Modigliani quite untouched. Nor did he share my enthusiasm for Seurat or for total Divisionism in form and colour, by means of which I hoped to achieve a more dynamic style of art. He did not appear to have remembered Jacob's advice to follow Seurat's example, at least in so far as the importance of the composition was concerned. Cubism, however, remained his bête noire. I can still hear him growling, "I'm not having any of Picasso's little tricks." Nevertheless, he must have thought about it enough to take an interest in Derain's experiments, even though he refused to follow Picasso.

'What arguments we used to have in those days! Modigliani was impatient by nature but he never took offence, not even when I went so far as to accuse him of academic leanings and of being too much influenced by his recollections of the paintings in Italian museums. This was at the time when he was so taken with Jacob's gouaches and also with those of the colourful Manuel Ugue, otherwise known as Manolo. Manolo's abstract gouaches were what you might call the last resort of a sculptor who hadn't enough money to buy stone, or even modelling clay, much less a revolving stand and all the necessary tools. It is possible that Manolo had discussed his sculpture projects with Modigliani, for Amedeo was tempted to try his own experiments in that medium shortly afterwards. Whatever the case, the fact remains that Modigliani seemed to awaken to a more acute sense of colour and its harmonies at about that time.'

Severini broke off once more for a moment, and then re-counted some of the incidents of his own career during that period.

'It was later on,' he said, 'in 1909 to be exact, that Boccioni, my great friend during my first years in Rome, met the poet Marinetti and immediately conceived the idea of trying to link up painting with the poetic movement which Marinetti called Futurism. I became acquainted with the Milanese poet

in Paris, and he lost no time in telling me all about Boccioni's novel and startling project, so that when Boccioni himself arrived and we were able to renew our friendship, I immediately undertook to try and indoctrinate Modigliani. I used all the arguments I could think of, including those I had borrowed from Nietzsche, who greatly influenced me just then. Modigliani was also influenced by the German philosopher's dramatic doctrines, and Nietzsche brought us into agreement about what seemed to us the necessity for breaking down the forms of the past in order to construct something really new. We began to search for some source of inspiration in this fresh view of life. We thought we understood each other, whereas in reality it was our passion for colour that made it relatively easy for us to agree about technique.

'During the period I speak of Boccioni remained faithful to the Italian concept of Divisionism in its 1906 form, and although I was more drawn to Seurat and was more interested in working out my ideas in that direction, it was inevitable that we should decide to draw up and issue a manifesto together. Boccioni asked me to round up all the artists in Montmartre and Montparnasse who were sufficiently in sympathy with us to be willing to add their names to ours at the bottom of the document. I was particularly anxious to get Modigliani's signature. However, I had no sooner broached the subject than he replied, "I don't want anything to do with it," and refused to listen to another word.

'He was very taken with Nietzsche's ideas, but if museums had to be destroyed in order to create something new, then he was definitely against it. He not only said so emphatically; he fairly shouted it from the house-tops. As for Divisionism, he could tolerate it still less. He had a totally different concept of colour. I think that deep within himself he felt an obscure desire for some kind of union between dynamic life and culture and for that reason our controversial position seemed unacceptable to him. He and I had many intense and even violent

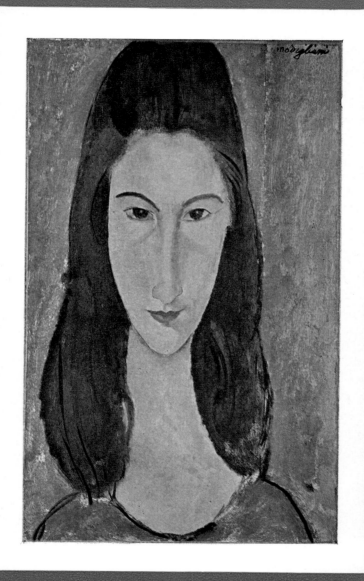

arguments on all these questions, but they never interfered with our friendship.'

Severini then touched on the field of satire and caricature, and in this connection remarked:

'Modigliani never put his name to any caricature that I know of, but he was quite in sympathy with these "minor" productions of his Montmartre friends. Minor works they were, no doubt, but they exercised a certain Expressionist influence, comparable to that which Steinlen and Forain had on Picasso at one time. Guillaume Apollinaire once said to me: "The spirit of caricature has played an important part in the development of modern art; you will realize that later on." I have always thought he was right, although it would be hard to say to what extent the spirit of caricature interested Modigliani. But I am sure that he was not indifferent to it.

'We in Montmartre discussed so many subjects, argued so many problems. There wasn't one of us who didn't have his little theory or doctrine. It may be that Modigliani got tired of it all because he clung to the hope of being able to do his own thinking and searching in some other environment — which may explain his decision to move elsewhere. One fine day he disappeared from our midst. From then on I saw him only rarely until 1913, when I got married. For his Montparnasse period you must seek elsewhere for information.'

13 *The Call of Montparnasse*

IT was one of the last evenings Modigliani was to spend on the Butte and the incident occurred at the Lapin, where he did not choose to go very often.

Frédé, the owner, could have closed the shutters much earlier — at any time, in fact, after the departure of the regulars or after the crew of raffish would-be art students had left. But he wanted to keep the café open a little longer because several of his intimates were there, men such as Pierre Mac Orlan and Julien Callé, whose sly humour was considerably exploited by a whole generation of professional humorists, and, sitting opposite them, Pajol, the oldest of those present, a somewhat shady character who had earned his living by various means from poker-playing to fortune-telling. Pajol wore a corduroy suit and an enormous bowler hat which entirely covered his ugly bullet head. He remained silent most of the time, listening to the conversation, whose best bits usually escaped him.

All at once Callé interrupted the talk: 'There's Modigliani!'

'Is he coming here?' Frédé demanded, frowning.

'Why shouldn't he? He's an artist, a painter like any other,' Callé observed indulgently.

'If he's drunk,' Frédé said firmly, 'I refuse to give him a drop more.'

'He looks as if he'd had a drink or two,' Mac Orlan commented, peering out of the window.

'Are you sure he's coming here?'

'He seems to be waiting for someone.'

'If it's Utrillo, then God help us.'

'Some people,' Callé said ironically, 'assert that that young alcoholic has a brilliant future ahead of him.'

'So they say,' Frédé agreed. 'Do you believe it? It would be

funny if it made the dauber's canvases go up in value. I've got two of them. One I acquired when I bought the place, because naturally I got everything that was hanging on the walls; the other is a picture he did of the Lapin itself. I paid him fifty francs for that, but only to get him to clear out when he was pestering the devil out of me — though I did feel sorry for him. Ah, here he is, and without Utrillo. Thank God for that!'

Modigliani made a magnificent entrance into the Lapin. He was slightly drunk, judging by the dull flame in his eyes. He looked troubled, yet his gaze was proud and direct. He had recently been obliged to buy himself some new clothes, and he had chosen a corduroy suit, which from then on he was to wear for work as well as for gala occasions. He tossed his felt hat on to a table and greeted us all.

'Good evening.'

'Good evening,' Frédé replied with studied nonchalance.

The rest of the company nodded.

'I want a drink,' Modigliani announced.

'We're closed now,' Frédé said.

'Do you mind?' Pajol interrupted, feeling Modigliani's corduroy. 'You haven't been done, anyhow,' he pronounced. 'That's the real stuff. It's the best there is and it'll last you all your life.'

He did not know how prophetically he spoke.

'Take a look at mine,' he went on. 'It's the same sort, and I've been wearing it for the last twelve years.'

Modigliani appeared highly pleased with Pajol's testimonial. He was never to abandon his corduroy except for his pauper's shroud.

After a pause, as if he were ruminating over some problem, Modigliani decided to speak again.

'Give me a drink,' he said, enunciating slowly and distinctly. 'I can pay for it.'

'I've already told you that we're closed for the night.

Anyway, this is not a bistrot. People don't come here to drink; they come here to talk about art.'

'Art? Of course — but over a drink. I need a drink.'

It was true: he did need it. He was possessed by the craving for drink. His fine eyes, so clouded by alcohol, closed for an instant. Suddenly he opened them wide and scowled; then, just as quickly, he seemed to come to his senses and try to restrain himself.

'Perhaps you think I haven't any money, Frédé. Well I have. Plenty. I've sold some pictures.'

'That's all right, but we're closed, I tell you.'

'Closed? What do you mean, closed? You're open, aren't you? Closed to whom? Not to me. Everybody who had to go has gone, but I've just come. And I want a drink. I told you I had plenty of money. Here: look at it.'

With the air of a gentleman inclined to be quarrelsome, Modigliani reached into the inside pocket of his new jacket and drew out three notes, which he let fall one by one on to the tiled floor. They were only for fifty francs each, but they were still bank-notes.

'If you want change,' Frédé said coldly, 'I can give you all you want. But you'd better pick up your billets-doux first.'

The bank-notes remained lying on the floor, stirring slightly in the draught. No one made a move to pick them up. In the electric silence Pajol's wall eye, which seemed to see nothing but took in everything, shifted once more from the haughty Modigliani to the bank-notes and back again. Then he rose casually from his chair, shuffled forward a few steps, bent down, and without a trace of humility, much less of servility, scooped up the three notes. He looked Modigliani squarely in the eye, winked at him fraternally, and slipped two of the notes back into the artist's pocket. Then he placed the remaining one carefully on one of the long wooden tables and said: 'Give us a bottle of Mercurey, Frédé. Modigliani is standing treat.'

Frédé got up without a word and went off to fetch the bottle and some glasses. Mac Orlan abstained for once from making one of his characteristic comments. Even Callé spared us a sample of his wit.

Meanwhile everyone was asking himself if the theatrical scene which Pajol had just staged had sobered Modigliani. They were soon enlightened, for Modigliani spoke for the first time since Frédé had taunted him about the money:

'I sold two pictures,' he said, 'to a fellow I didn't know. I had already sold a few to that old boy in Montmartre who buys anything and everything and sticks it up on the wall. He's an old man. He still buys, though he complains that he isn't able to enjoy his collection as much as he used to because his eyes are giving out. What happens to people's eyes when they can't see any more? Who knows but that this old fellow doesn't see far more beautiful things than the canvases he buys? At any rate, up till tonight I've had only one collector — and he's half blind. Now let's have a drink. Let's empty the bottle!' Glass in hand, he began to recite some of his favourite Italian verses: '*Io mi son' Pargoletta, bella e nuova. Pargoletta! Bella e nuova* ... That's what I sold ... A head — a portrait — a café-waitress: a servant of the poor ... *Bella e nuova* — young and beautiful ... A hundred and fifty francs!'

Finally becoming articulate, Frédé growled: 'It's been a long time since you trotted out your *Divine Comedy* for us. Good. All the better. Now give us your *Inferno*.'

'That's not *The Divine Comedy*. That's one of Dante's ballades. You people in France don't know his ballades, and your absurd love of D'Annunzio keeps you from understanding the meaning of real Italian poetry.'

'Abasso D'Annunzio! Your health!'

'I was reciting a ballade without an *entrata* — what you call the *envoi* — which Italian poets put at the beginning.'

'So it's hors d'œuvres on one side of the Alps and dessert on the other. Go on: we're listening.'

Everyone wondered if Modigliani was drunk, but if so, he had not drunk in vain. And what did it matter if his interpretation of the Italian soul, at once tender and fiery, was interrupted now and then by drunken hiccups?

> 'Io fúi del cielo, e torneròvvi ancora,
> Per dar della mia luce altrui diletto,
> E chi mi vede, e non se ne innamora,
> D'amor non averà mai intelletto.

'Listen:

> 'I lived in heaven, and shall return there surely
> To give delight to others with my light ... '
> 'With my light ... Luce!'
> ' — And whoso sees and does not love me purely,
> Knows naught of love and will not learn aright.

Bella e nuova! The waitress in the bistrot in the Rue de l'Abreuvoir ... What did I say she was? She's not even the waitress ... She only washes the glasses. *Bella e nuova.* A hundred and fifty francs!' He collapsed on to a chair, howling with laughter.

While everyone was looking at him the last customer of the evening entered. It was Roland Dorgelès, who was at that time a reporter and had just come from the press-room of his paper.

'Evening all,' Dorgelès cried. 'Modigliani, have you seen *L'Intransigeant?*'

'I don't give a damn for newspapers.'

'You're right as a rule, but tonight it's different.'

'Why?'

'Because there's an article about you in *L'Intran.*'

'They don't know me.'

'There's an article on your painting — on the picture you sent to the Salon des Indépendants, the one called

"The 'Cellist". It is yours, isn't it? There can't be two Modiglianis.'

'Is it a piece of art criticism?'

'You can change me into a chamber-pot if it isn't.'

'There's no such thing as art criticism. You don't write about a picture; or if you do, you write a poem.'

'Precisely. I'll be hanged if there isn't a poem in it as well. You should be pleased that you inspired it, and your friends should be pleased too. It's been a good day for the painters who won't conform. Do you know Salmon? He's the one who wrote the article. The joke is that they asked him to do a paper on the Indépendants in the hope of making everybody laugh at the avant-garde painters. But Salmon risked his job for the pleasure of giving the outlawed artists some publicity at last, and I'll be damned if he hasn't succeeded. Listen to this: "Taken as sheer ugliness, the excessive clumsiness of some of the Indépendants is less irritating than that of certain enlarged photographs which official bodies take for works of art." Don't you worry about the ugliness, Modigliani. Salmon speaks in the highest terms of the dignity of your model, though he doesn't hide the fact that in his view it is the first time you have shown real talent. He places you in the category of Vlaminck and Van Dongen. Here, take this copy; you can read it in bed. When the paper was sold at the entrance to the Salon it had such a wild success that the news-vendors had to keep sending for more and more copies.'

'There's luck for you!' exclaimed Callé. 'If it had not been for Vlaminck and Van Dongen, our friend Salmon would have got the sack.'

'I don't think so,' Dorgelès replied. 'Léon Bailby who owns *L'Intran* is an intelligent man. He understood what Salmon was driving at, and though he loathes the kind of art his young employee defends, he keeps an eye on his *Intran*, which is a paper with a future. As a result we now have Modigliani a "star" and Salmon an art critic for life, thanks to an error on

the part of some head of the news department and the leniency of a proprietor who personally likes only eighteenth-century painting but isn't above extending his circulation. Don't you think Montmartre ought to give Modigliani a banquet?'

'Or a drinking party at least,' Mac Orlan suggested.

'Don't you try to make a fool of me,' Modigliani retorted. 'In any case, I'm leaving Montmartre.' He seemed perfectly sober.

'Would you mind telling us on what hill or in which dale you are planning to pitch your tent?'

'In Montparnasse.'

After that he uttered only one more word during the rest of the evening.

'Montparnasse is a very nice quarter,' Mac Orlan said, glancing at Pajol, who seemed to want to stay on in spite of the fact that all this talk was beyond him, 'and I may add that it is just beginning to come into its own. You won't find anything like the Lapin over there, of course, but our friend Frédé won't hold it against me if I say that that's its best feature. Besides, what have we accomplished in Montmartre? We're only a lot of poor devils whom people call "intellectuals". Our chief preoccupation has always been to find some way of getting something to eat, just like savages and wild animals, even though we flatter ourselves that we are leading a bohemian life. But when we go sneaking out to get a bag of fried potatoes or a bite of cold meat, avoiding all the eating-joints where we've run up a bill, we don't feel very proud of ourselves, do we?'

'Do you suppose that living is any easier in Montparnasse?'

'In Montparnasse at least you don't have to worry about idiotic traditions, because everything is new and there are no traditions: whereas we've exhausted ourselves with trying to go against the local customs here — the Montmartre style of dress, for instance, with its flat-brimmed top hats, caped

greatcoats, over-large soft felt hats, Spanish capes, and clay pipes with bowls in the form of a skull.'

'There's some truth in what you say,' Dorgelès admitted. 'There's always truth in what you say. Modigliani will find himself on virgin soil in Montparnasse.'

'It is certainly a quarter with a future.'

By now Modigliani had fallen fast asleep on his chair.

Dorgelès took the floor again. 'What artistic life is there in Paris outside Montmartre?' he began. 'There is the Dôme, where four or five German painters who are pupils of Matisse forgather regularly. There are two or three eating-places where various English and American misses who paint pretty little water-colours meet together. Oh, yes: there's a Scottish artist in the Rue Boissonnade who has set up a Manichean temple on one side of his studio, admission free Sunday mornings. Farther on, out towards Vaugirard and Plaisance, Modigliani will come across some handsome specimens of humanity from such impossible places as Mohilev, Zagreb, and Baffin Island. He can take his pick. Whatever the case, I hope he'll come back to the Butte and give us a few of his impressions.'

Mac Orlan sighed. 'They're all leaving Montmartre. Even Salmon is getting married and going back to Montparnasse.'

'Taking the Left Bank road to get on the right one. What about you?'

'I am going to move my goods and chattels into Salmon's old studio in the basement of the "Bateau-Lavoir", looking out on to the court.'

'An excellent preparation for the peasant life you've always said you long for!'

Modigliani woke up. He finished off his glass and put on his felt hat, impressing everyone by his unaccustomed calm after so much drink.

'Good night,' he said abruptly, and went out into the darkness.

Part Two
The Palette and the Guitar

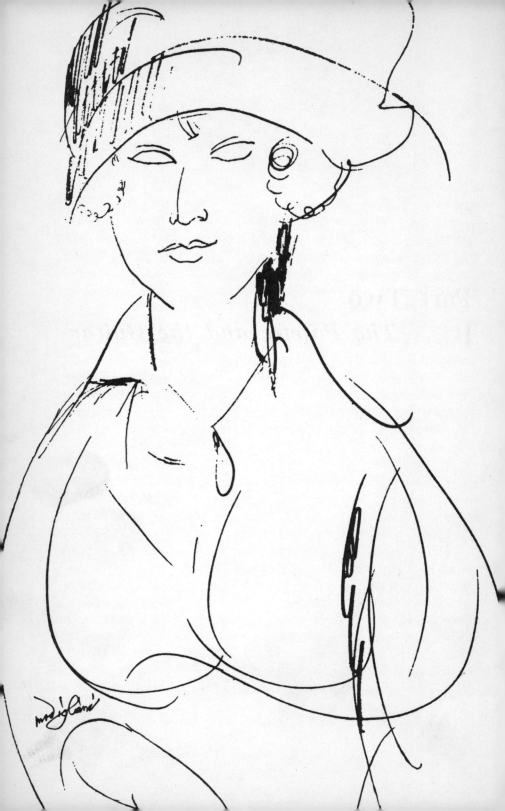

1 *The Palette and the Guitar*

AT first Modigliani showed few signs of being anything more than an odd young man who was part of a little world so odd in itself that there was small chance in Montparnasse of his behaviour being noticeably different from anyone else's. Of course his aggressiveness and, it must be admitted, his turbulence, made him conspicuous, but he was hardly more aggressive or turbulent than many others, and no one could have foreseen that he would one day make a name for himself as an artist of the first rank.

Modigliani never had any other ambition than to become a great artist. He never wanted to gamble on his luck. As he had tired of Montmartre, where he felt as if he were slowly sinking into a bog, he was attracted to Montparnasse, perhaps by the hope that he might start a new life there in an atmosphere more congenial to his active mind. Since the Butte remained under the spell of the past, only Montparnasse could offer the prospect of something new.

When Modigliani left Montmartre, the new part of the town he had elected to live in was only in a tentative stage of evolution. The two chief meeting-places were the Dôme café and the Rotonde bar on the corner of the Boulevard Montparnasse and the Boulevard Raspail.

All sorts and conditions were to be seen at the Rotonde, where Modigliani was to feel more at home than anywhere else. Artists were not the only customers: there were various workmen, butchers' assistants, and oddly enough numerous removal men, who were very plentiful in the Paris of that era when nothing was easier than to move house or studio. In addition, there were two not very conspicuous gentlemen with goatee beards who came there quite often. They were both nondescript, and they had a habit of passing their newspapers,

mostly foreign, to each other, while commenting on what they had read. One of the removal men, more perceptive than his fellows, took a careful look at them one day and remarked: 'I've got an idea that they're Russian.' He was right. The two foreigners were none other than Lenin and Trotsky, though no one then dreamed that they would one day be figures of history.

Modigliani soon formed the habit of calling in at the Dôme or the Rotonde at any and all times. Naturally he went to both places to drink, but he also went to make sketches and could be seen there night after night, armed with a stubby pencil and his big sketch-book with its sky-blue covers.

It was at the Rotonde that Vlaminck and Modigliani first made each other's acquaintance. It is often difficult to quote Vlaminck, because his very candour tended to make him seem rather unjust at times. Imagining himself to be a libertarian — though no real anarchists would have tolerated him for long — Vlaminck was proud of his Fauvism, and asserted that the revolutionary criminal, Ravachol, was its 'patron saint'. On the other hand, owing to the fact that he saw in Cubism, which he was probably unable to understand, nothing but a scandalous fraud, he was later to declare that its patron saint was the political swindler, Stavisky.

Vlaminck was a violent man, but he had a peculiar innocence about him, and he was somehow touched by a similar streak of innocence in the young Italian. The only puzzle is why Vlaminck waited until Modigliani died before giving us a description of the artist in the pages of his book entitled *Portraits Avant Décès* ('Portraits Before Death'). At any rate, the 'portrait' is excellent, and, as Vlaminck himself would have said, 'it is worth ten by anyone else.'

'I can see Modigliani now, with his imperious gaze, sitting at a table at the Rotonde, the nervous fingers of his intelligent hand tracing the features of one of his friends without pause and in a single unbroken line. When he had finished the sketch he would present it as a reward to the subject.'

It is worth noting that he drew without pause and in a single continuous line. Vlaminck was astounded by this facility, which Picasso also possessed, but though in his description he shows his admiration for the apparent spontaneity underlying Modigliani's gift and his sure instinct, he failed to realize that both were the result of persistent study and experiment. He goes on:

'With a grand gesture, as if he were some millionaire distributing largesse, he would hold out the drawing, which he would sometimes sign, as though he were paying with a large bank-note for the glass of whisky he had just been treated to.'

Vlaminck wrote contemptuously, yet he once claimed in Modigliani's presence that his own pictures were as stable in value as bank-notes and could be used as such. Whether Modigliani was pleased or annoyed by this announcement it was hard to say, for his expression did not alter. There were times when he could remain cool and collected, if he chose. Vlaminck had a proof of that one day when Modigliani offered an American girl a sketch he had just done of her. Vlaminck described the incident thus: 'He wanted to make her a present of it. As she kept insisting that he sign it, he became provoked by her venality (*sic*), and wrote his name across the face of the picture in huge letters as large as those used in "Flat to let" signs.'

Vlaminck's portrait of Modigliani concludes as follows: 'I knew Modigliani well. I knew him when he was hungry. I have seen him drunk. I have seen him when he had money in his pocket. But in no instance did I ever find him lacking in nobility or generosity. I never knew him to be guilty of the least baseness, although I have seen him irascible and irritated at having to admit the power of money, which he scorned but which could so hamper him and hurt his pride.'

Since Vlaminck described Modigliani only as he saw him

at the Rotonde, he failed to make a study of him in any other setting: in his studio, for instance, or in some of his friends' studios. Modigliani liked to visit his friends, especially in those days when he still did not have many. One of them was Manuel Ortiz de Zarate, who had installed himself in the centre of Montparnasse in lodgings which were half bourgeois and half bohemian. The fact that the windows looked out on a blank wall was immaterial to Zarate. He was hardly aware that the wall was there. His only interest was in what he was painting. He cared nothing for landscapes, but concentrated on such subjects as flower pieces or still lifes composed of fruits and vegetables which could be used for a meal later on. Zarate owed the attractive atmosphere of his studio-home to his wife, who was an ideal companion. Since Modigliani was never more dignified or reserved than when he knew that he had to be, he was careful not to come to his friend's house drunk, out of respect for Mme Zarate.

One afternoon when Modigliani went to call on Zarate the latter seemed to give him a warmer welcome than usual. He soon realized why. The Chilean artist was in one of his despondent moods and, after telling Modigliani to rest on the couch, he himself resumed his seat on his work-stool, his eyes mournful, his arms hanging listlessly at his sides, and stared vacantly at the large white canvas in front of him. He had been trying ever since morning to start a still life for which his wife had lovingly prepared the materials, but a feeling of helplessness had come over him and he had not been able to apply even the first brush-stroke. He was therefore only too delighted to have a valid reason for not working.

Modigliani was always puzzled by the relative comfort of his friend's home.

'Don't you mind not having a studio?' he asked.

'This *is* a studio.'

'Yes, I suppose you could call it that. It has the look of one. But then, it has a linen-cupboard in it and a sewing-machine,

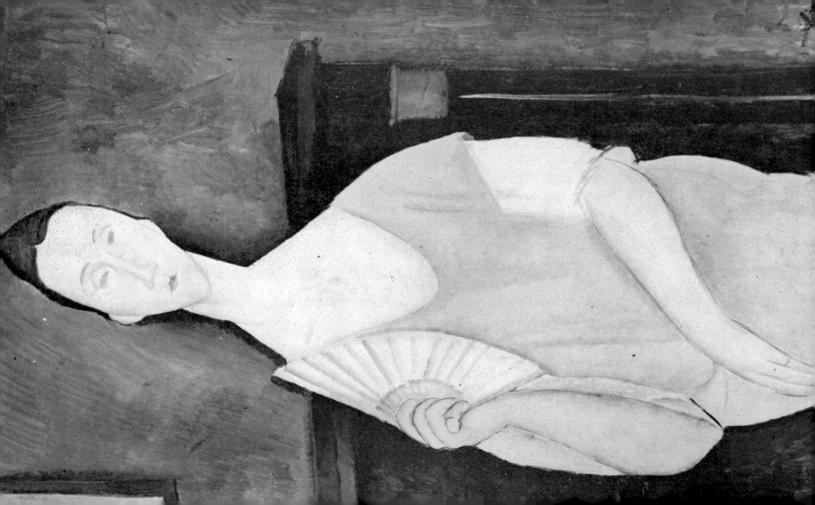

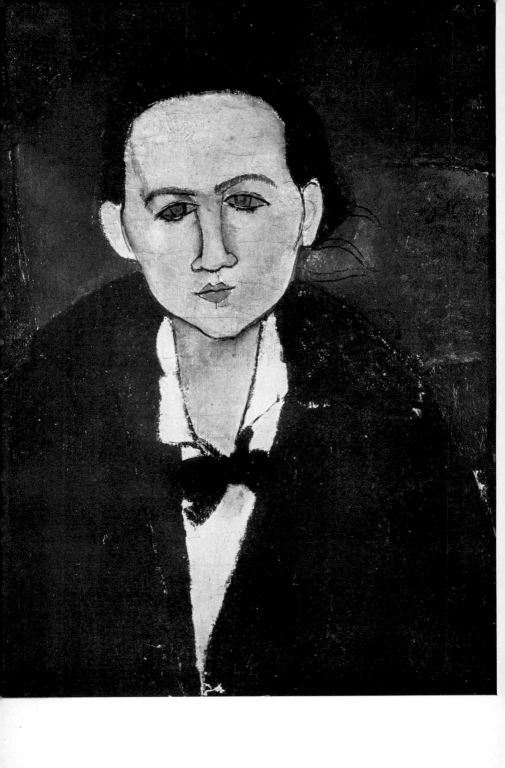

and that spoils the whole effect. I haven't even got a screen in my studio, and luckily there are a good many other things it hasn't got either. The women who come and pose for me don't give a damn because there's no screen to hide behind while they're undressing. When they're stripped and I'm ready to start work, I throw a piece of cloth or a newspaper over their dress and underclothes so that the place won't look like a bedroom. Women ought not to clutter up a man's studio in any way. The best studios are empty ... You say you don't mind not having one?'

'Not in the least.'

'That's terrible.'

'Terrible? You're pitching it rather strong.'

'I've got to have a studio, a regular studio — my own or else a friend's. If you had a studio, I should come and work in it because I know it wouldn't bother you.'

'I can paint here — not today, perhaps, because I have my bad days just as you have yours — but I can paint quite comfortably here. The great Odilon Redon does all his painting in his wife's drawing-room. Do you like his work?'

'He's a fine painter, but I'd rather you liked him for the quality of his painting than for those nightmarish compositions that he does so marvellously.'

'Don't say that, Modi. Redon does not paint nightmares. It is not fair to call them nightmares. They are the apotheoses of Nirvana. Nirvana! ... Would you like a pill?'

'No, not now. And don't you take one either. I want to talk with you quietly. I want to be calm.'

'Nirvana, Modi!'

Zarate was one of the first friends Modigliani made in Montparnasse and he became one of the best, remaining devoted to him until Amedeo's death. Had it been in anyone's power to save Modigliani, Zarate would have done it. Unfortunately there was no one who could save Zarate from himself, for although he never drank as much as Modigliani, he indulged

facing: Madame Hélène Povolotzka, 1917 113

freely in hashish, with the result that he was often compelled to go into strict retirement.

Now, however, he was talking animatedly: 'I repeat that you do not need the traditional type of studio. One can get along quite well without it.'

'And you really like it here?' Modigliani queried, strolling over to the window and gazing out at the blank wall.

'It doesn't matter all that much whether I like it. I'm quite content, and it suits my wife for her work.'

'Does she still make those dolls?'

'Yes.'

Modigliani stubbornly returned to the previous subject: 'I simply have to have a studio of some sort. I don't care if it's a slum so long as it is a studio. I haven't always been able to have one. I was obliged to live — for as short a time as I could make it — in one room, a single room. It was impossible to set up my easel in it, so do you know what I did? As I could not keep from painting, in spite of the difficulties, I began decorating the walls and even the door. The landlord was furious and ordered me to paint it over at once. He showed me the door all right — my own door. I think the things I did there were not so bad either, but they had to be painted out with some filthy whitewash.'

'What fools landlords are. You left yours an absolute fortune.'

'Listen: I once had a room in the Mouffetard quarter. I learned in one of the bistrots near by that a crime had been committed in that room. A woman who had been deserted had given birth to a child there and killed it.'

'So — ?'

'So I wanted to paint a "Maternity". A "Maternity", do you understand? But I had to have a model, so I found one right away: a woman from the Rue Mouffetard. She was very beautiful. She posed for me while I did a painting of her on the door of my room.'

'And then you got her with child! That's rich!' Zarate began to laugh uncontrollably.

'Stop that laughing! Did you take one of those pills, after all? I told you not to. It was for tonight. Oh, well, give me one: then we can laugh together — at me, you, everything.'

'I swear I didn't take a pill, Modi. It's a side-effect of the one I took yesterday. Don't be angry, Modi, you're my only friend.'

Zarate's young wife came in, carrying a tray with teacups and a steaming pot of tea. Modigliani had stretched himself out on the couch, but he was on his feet the moment he saw her — in marked contrast to the Modigliani who raged about after having a drop too much at the Rotonde, or roared up and down the Montparnasse streets, or got into trouble with the local police, just as he had done up in Montmartre. Now, as Mme Zarate put down the tray, he gave a little bow in her direction. He looked handsomer than ever in his corduroy suit which caught the light.

'I made some tea for you,' Mme Zarate said simply, as though her only pleasure in life was to serve them.

'Get us some rum to put in it,' her husband said.

She knew only too well that it would be better for him not to take any rum. She also knew that if she refused to give it to him, he would fly into one of his ugly tempers; or else he would suppress his anger out of his very real love for her and relapse into a state of apathy which would last for days. Moreover, Zarate's tone was, as usual, ambiguous, so that it was never possible to be sure whether he was entreating or commanding. Modigliani had already noticed it, and he was struck by the incongruity of this domestic comedy in a so-called artistic atmosphere. 'Thank God I live alone!' he said to himself with fervent satisfaction.

Mme Zarate soon reappeared with a half-full bottle of rum, and as she placed it on the tray she invited Modigliani to dinner.

'No!' he replied violently, but softened it a moment later

by adding: 'I should like to very much, but I really can't this evening.'

Mme Zarate was hurt and disappointed. She was convinced that Modigliani was good for her husband's morale — at least when the young Italian was not drunk, but calm and reasonable as he was when he came to see them. Even when he was drunk outside, his erratic outbursts often helped to rouse Zarate from his lethargy and rid him of his temporary artistic impotence.

As soon as she had poured the tea for the two men, Zarate's flabby hand motioned her to leave them and the bottle of rum as well. She went out obediently, closing the door tightly behind her.

Once he and Modigliani were alone, Zarate gradually came to and presently got off his work-stool on which he had been moping for so long. He took the two cups of tea, walked over to the window, and threw out the contents. From below came the yelp of a dog who had received the hot liquid on his tail. Zarate replaced the cups on the tray, closed the window, and, well pleased with this little stratagem, filled the cups to the brim with rum.

'You said your wife was still making dolls, didn't you?' Modigliani asked as they drank.

'Yes.'

'Does she sell any?'

'A few.'

'To whom?'

'To collectors.'

'Do you mean to say that people collect dolls? What are they — freaks or fools?'

'I don't know. I can't be bothered with such matters. All I know is that she has customers.'

'Doesn't she make dolls for little girls?'

'I tell you she makes them for collectors; for doll-fanciers.'

'Doll-fanciers! Dolls ought to be for children, beautiful

dolls, but terrifying ... The dolls should be given to little boys and tin soldiers to little girls. Perhaps that would save the world from wars — and love.' He rose abruptly. 'I must go now.'

'Can't you really stay to dinner with us?'

'No.'

'Why not? We could go out together afterwards. We could take another pill ... '

'I have an appointment.'

'I don't believe it. Stay.'

'You're right. I haven't an appointment. I just want to be alone.'

'All right. I can understand that. I have often felt the need to be alone, and I know that I shall feel that way again in spite of my attachment to my wife. Yet if I were really alone, I should die immediately.'

'Immediately? I have an idea that it takes a long time to die.' Modigliani finished his rum, and then admonished his friend: 'Don't go on sitting there like that. It's frightful to see you crouching in front of that blank canvas like some cringing dog in a circus who's afraid to jump through the hoop. I understand how you feel, of course. If you had a real studio you could work better. Why don't you come along with me and do some sketching at the café?'

'I can't sketch the way you do.'

'Do something, at any rate. Get your guitar and sing me one of those Italian songs you used to sing when you were trying to earn a bite to eat in the Neapolitan cafés and the girls all made eyes at you.'

Zarate took his guitar down from the wall, dusted it, and tightened it up. He had kept it as a memento of his youthful travels in Italy, but it was a long time since he had played it. He came back to his stool and, sitting down again, assumed the musician's classic pose — like a Manet, as Modigliani remarked — struck a few chords, and began to sing. His wife

discreetly opened the door and looked in. Modigliani was just preparing to go. He bowed to her in silence, leaving his friend bent over his guitar, and did not speak again until he reached the door. Glancing back, he announced in a low, penetrating voice: 'I am going to steal some stone.' These mysterious words filled Mme Zarate with consternation and dismay, for she feared that her husband and Modigliani had once again been sharing a dose of the deadly drug.

MODIGLIANI did not regret having refused to dine with the Zarates. He was in no mood for family intimacy and when he had departed, leaving Mme Zarate nonplussed by his strange phrase, it was as though he were trying to hasten the longed-for moment when he would be able to carry out a plan he had for stealing some stone for his sculpture.

But he still had to decide where to dine. He reproached himself for not having kept in touch with the people who had a boarding-house in the Boulevard de Port-Royal, where, though a foreigner, he had once known the authentic atmosphere of French life. It was the Romanian sculptor, Constantin Brancusi, who had first taken him there, and he had liked it because it enabled him to make the acquaintance of a number of middle-class French people who were poor but cultivated and of a kind who compose what is often the best society France has to offer. Indeed, Mme Mollet, the owner of the establishment, was so altruistic that she gave the impression of running it more from generosity than from necessity.

While he was still living in Montmartre Modigliani had often been taken by his friend and compatriot Severini to dine with the hospitable wine-merchant and his milliner wife, and with them he was always the perfect guest. He left an equally good impression at the Mollets' boarding-house. When, years afterwards, I questioned my old friend, Jean Mollet, the son of the household, about the artist, he replied: 'He was very pleasant' — which was saying a good deal in view of the reputation Modigliani subsequently made for himself as a wild character. If I seem to stress this point, it is only because some authorities have been tempted to try and make him more picturesque by describing him as hopelessly undisciplined and given over to every conceivable excess.

Modigliani: A Memoir

With the Mollets Modigliani felt very much at home. He enjoyed talking with Jean, who brought home titbits of news and gossip from all over Paris and in this way gave the artist an insight into French life. Modigliani also developed a great liking for M. Mollet senior, a former industrialist who had become the business associate of a publisher and who consoled himself for the vicissitudes of life by composing waltzes which he played zestfully on an upright piano. At the Mollets' Modigliani felt as far removed from the Rotonde as he did from Leghorn, or for that matter from that rat-trap full of impecunious artists known as the Cité Falguière in the Rue Falguière where he went to live for a while.

Nevertheless, he could hardly go to the Mollets' without Brancusi, and since he knew that the sculptor was engaged that evening Modigliani decided to get his supper, meagre as it would be, at Rosalie's, a forlorn little restaurant for artists in the Rue Campagne Première.

Rosalie claimed that artists were as much at home in her restaurant as they were in their studios, which was one reason why Modigliani preferred to go elsewhere. But it was growing late, he was hungry, and he could think of no better way of spending his present ten francs, the price of ten drawings at one franc each, than on food. As he walked along he thought of some of the places where he had eaten at one time or another. There was Rosalie's, for instance, but he had no special fondness for it, even though its owner was a compatriot of his. Then there was the Zarates' table, which was cheerful enough, and the Mollets' boarding-house, and dozens of others. Last of all he recalled the dining-room at home in Leghorn, and he remembered how the family would gather around it in the evening after each had finished his allotted task. He missed his devoted mother, who did not need to understand him in order to admire him; he could see his father, who did not understand him at all, preoccupied by the eternal market fluctuations and by the myriad figures in his double-entry

ledgers. He pictured his eldest brother, Giuseppe Emmanuel, whose chief interest was in Karl Marx, and Umberto, his other brother, to whom he was one day to send the beautiful drawing he had done in the noise and bustle of the Rotonde and signed 'Dedo', the pet name his family had given him when he was a little boy.

When he reached Rosalie's he pushed open the door and stumbled into the *patronne*, who happened to be chasing a rat which had been making spectacular inroads on a piece of gorgonzola on the dining-room shelf. It was nearly closing-time, and all the regular customers had gone. Modigliani sat down at a marble-topped table which the blowzy Rosalie proceeded to clear, bringing in clean dishes from the cubby-hole of a kitchen in the rear.

'You're late tonight,' she informed him. 'There's not much left. Would you like some minestrone? No? Then what about a bit of stew? I think you like that.'

'I'll have some stew.'

'You're sure you don't want any soup?'

'No, but give me an absinthe.'

'If you prefer it. What about a vegetable?'

'A pint of red wine.'

'Dessert?'

'You can give me what the rat left of the cheese.'

He downed the absinthe in two quick gulps. He tried out the stew but without enthusiasm, and, cancelling the order for cheese, took a second pint of red wine instead. Then the door opened and Thérèse appeared.

Certain chroniclers who have been unable to give the exact date of this meeting which was to prove so fateful for Modigliani, have none the less not hesitated to state that the young lady in question was not Thérèse, but Suzanne. Whatever her name, there was certainly a Suzanne after Thérèse, as well as a variety of others who were fascinated by Modi's good looks. In the present case, however, she shall be known as Thérèse.

Thérèse's character is not easy to explain. The older habitués of Montparnasse dismissed her as the most abject and hysterical of whores, but that is neither fair nor entirely true. Hysterical she was to some extent, but whore she definitely was not. In the days when Thérèse used to take her meals at Rosalie's the great Sigmund Freud had already made considerable progress in his theories, but it is still anticipating somewhat to speak of an 'Isadora complex', Isadora Duncan then being the celebrity of the moment. Yet that is exactly what Thérèse had.

The famous dancer asserted that she never took any lover to bed with her except for the purpose of procreation, and in accordance with her delirious idealism she always insisted on having a partner who was a great man not only in her eyes but also in the eyes of the world. She aspired to nothing less than royal offspring. Thérèse, being only a little Montparnasse model, could hardly hope to beget a child by an illustrious father, but she was undismayed and confident of her ability to win at least a minor triumph. So far she had been unsuccessful, but her judgment was not unsound. She had conceived an ardent liking for Modigliani, who in her opinion was marked for future fame, and without a moment's hesitation she went to his table.

'Good evening, Modi.'

'Evening,' he grunted.

'May I sit here?'

'If you want to.'

Rosalie poked her head out of her tiny kitchen.

'I've hardly anything left,' she told Thérèse. 'Would you like some minestrone?'

'No thanks, I'm not very hungry. Could you give me a cup of hot chocolate and a piece of bread and butter?'

'The rats have eaten all the butter,' Modigliani said. He uttered the words on an impulse and would have liked to repeat them, for they had a kind of nightmarish charm about

them as if they were composed by a lunatic poet. At all events they suited his mood.

Rosalie shrugged. 'Don't listen to him, dearie. He means the cheese, and even that isn't entirely true. I'll go and make the chocolate for you.' Then, turning to Modigliani, she added irritably: 'You can consider yourself lucky you saw a real rat.' She shuffled off, grumbling to herself: 'The way he's drinking now, the other kind of rats will be along soon.'

Thérèse resumed her conversation with Modigliani.

'Are things going well for you these days?'

'No.'

'What's the matter?'

'You wouldn't understand.'

'How do you know I wouldn't? It's not fair of you to treat me like a fool. Since I've been posing, artists have told me some of their troubles and I know a good bit about the way they feel.'

'They were wrong.'

'How were they wrong?'

'To tell you their troubles.'

'Why?'

'Because it's a proof of weak character on their part. Besides, it's foolish to put ideas into your head. They can only do you more harm than good.'

'I'm not such a fool as you think. In the first place, you might as well know that the only reason I've been telling you about those other artists is that I wanted to have a good talk with you. I know very well that what they confided to me was not the whole story, but words aren't so terribly necessary. That interests you, doesn't it? You see, it's the *whole* man who confides in me and I don't need to force anything out of him. It's the way he behaves when I'm around that tells me, to say nothing of how he behaves when he's by himself; his way of working or not working — which can be even more tiring. Take Derain, for instance — '

'I don't want to take Derain or anybody else.'

'All right. Don't get angry.'

'If I got angry you'd be scared to death.'

'I'd like to see it happen — Modi in a temper because of me! I'd weep for joy.'

Rosalie brought the chocolate, and Thérèse went on: 'Modi, will you let me tell you something?'

'Nobody can stop you talking, not even yourself. And the only way I can keep from listening to you is to leave, which I'm going to do straight away.'

'Modi, people are beginning to say you're somebody. I think so too. Some day you'll be famous. You don't need to tell me that an artist mustn't sacrifice himself too much to a woman, but all the same, if you wanted to — '

'If I wanted what you want, is that it? If I were willing — You little fool! I've done with all that. I've thrown it *dopo le spalle*, do you understand?'

'What does that mean?'

'Over my shoulder. "Things temporal fade before the everlasting." '

'I suppose that's more of your beloved Dante. But don't you see, Modi, it's the everlasting things that — '

'Merde! That's just what I'm saying.'

'I'm going to meet some friends at the Rotonde, Modi. Would you like to come along?'

'You want me to come too, and let you take my arm so as to complete the picture and make everybody laugh? Why not? I don't give a damn.'

'You'll come, then?'

'No.'

'You've got another engagement?'

'Yes. With the night. I'm going to steal some stone tonight.'

His statement did not strike Thérèse as being particularly wild. She was not wholly bereft of common sense and she made it a rule to understand only what it suited her to understand.

'Stone that you can't afford to buy? For your sculpture?'

'Yes, for my sculpture. Not for building a house.'

'It wouldn't be such a bad idea if every artist did have a house of his own. But if you had a house you'd probably pull it down stone by stone to use for your sculpture.'

'Probably.'

'You've never been very talkative, Modi, yet you could be so nice, if you wanted. Tell me: when you're pinching your stone, aren't you afraid of getting caught?'

'Yes.'

'It must be hard to carry home. It's so heavy.'

'Very heavy.'

'Where are you going tonight?'

'To a stone-mason's near the Rue Blomet.'

'Wouldn't you like me to help you?'

'To do what?'

'To carry your stone, of course.'

'You're out of your mind.'

'Not particularly. I couldn't carry the stone, because it's heavy even for you, but we might find some way to cart it.'

'What in?'

'In a pram I bought second-hand when — well, it wasn't used, but I kept it just the same. It's under the stairs at my place.'

'The stone would break it.'

'It would hold up all right if we put two planks in the bottom.'

'It's ridiculous. What baby did you get the pram for?'

'A baby I wanted to have. But I didn't have it. I was mistaken.'

'You would have liked to have it?'

'Rather!'

'Were you in love with the father?'

'I admired him.'

'Was he handsome?'

'Handsome enough to produce a fine baby. Yes, he was good-looking — as handsome as you.'

'Did he leave you?'

'No, I left him. He didn't give me a child.'

'Perhaps he hasn't produced any work, either.'

'Don't say that. He's a wonderful man and people will hear more of him yet.' Seeing that Modigliani was beginning to scowl, she changed the subject. 'All right, Modi, shall we go along and get — '

'I don't want you following me with a pram!' he burst out. 'I don't want to listen to you. I want to be alone. You can come and see me with your pram when you've given birth to a stone!'

He got up abruptly, went over to Rosalie, paid for his meal, and strode out of the door without another word.

'You see?' Rosalie said. 'You've known him long enough to know how he'd react. Plenty of others have wasted their time on him, but he doesn't want any woman to stay with him: everybody knows that. Every woman who's tried it has had to give up, and in a hurry too. He's been like it ever since he came down from Montmartre, ever since he came to Paris. He was probably like it before he left Italy.'

'But if I were to stay with him I wouldn't be around all the time. I wouldn't want to be in his way.'

'He'd have a fit if he fathered a child — if I know him.'

'Oh, I should go away and be happy to take the child with me.'

'If you'll take my advice, dearie, you'll stop bothering about Modi, because he's not like other men. He's not like the others even when he's sober, and when he's drunk ... Have you ever seen him really lit?'

'Yes, at the Dôme, the Rotonde, in the street. I wanted to help him home, or take him to my house.'

'You're mad.'

'We'll talk about that some other time,' said Thérèse with dignity.

'With me or with him? With me, it doesn't matter; it's just talk. Perhaps you'll believe me yet.'

'With him.'

'Then I wish you joy of it,' Rosalie retorted.

3 The Great Days of the Cité Falguière

AMONG the many artists who came to know Modigliani well after he had settled in Montparnasse was the sensitive Japanese painter Fujita, who retained the most detailed and vivid recollections of the young Italian. Both lived in the dreary Cité Falguière for a time, and both had to struggle against the same sort of poverty and tribulations during those sordid years.

Fujita, of course, won considerable recognition in the end and was able to move to a spacious studio in the Rue Campagne Première on the edge of Montparnasse, which has now become peaceful and humdrum compared to its more boisterous beginnings. Had Modigliani lived longer, he would always have been welcome to use Fujita's studio, just as he later worked in the far more modest one of his loyal friend Kisling, and by way of showing his appreciation Modigliani would have forced himself to remain sober on such occasions. Even when he had taken a dose of hashish and was likely to go rampaging almost anywhere, he nearly always managed to keep well away from his friends. They rarely saw him at his worst and only heard of his disgraceful behaviour afterwards. The elegant Baron Pigeard was probably the only person who witnessed his frenzies, and he was not really a friend. Indeed, Modigliani regarded the baron as nothing more than a dope-peddler who happened to be better dressed than the others.

Sorting through his memories of those days, Fujita recalled the main incidents of his friendship with the Italian artist and related them to me as follows:

'I met Modigliani for the first time towards the end of 1913. By a coincidence he, Soutine and I lived for a while in the same place: 14 Cité Falguière, which is in that section of the

facing: The Cité Falguière

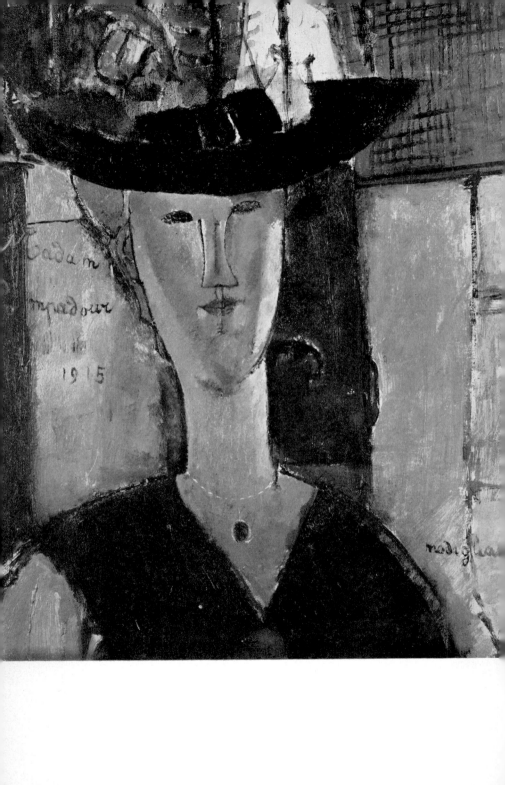

Rue de Vaugirard just beyond the Boulevard Montparnasse. It had a wide entrance on the Rue Falguière and you went through a court to a small door at the back which led to our studios. You had to cross a sort of bridge, like the approach to a medieval fortress, though the building itself was anything but fortress-like. Soutine and Modigliani had studios on the ground floor, opposite each other. Mine was on the first floor, and it looked out on a wall on either side.

'At that period Modigliani was spending most of his time on sculpture; he did no painting and made only pencil drawings. He always dressed in corduroy, and he wore checked shirts and a red belt, like a workman. His thick hair was usually tousled. He drank a great deal of Pernod and often did not have enough money to pay for it. When people invited him to have a drink at their table, he would do sketches of them and then give them the drawings by way of thanks. He had a habit of scowling and grimacing a good deal, and he was always saying "Sans blague!" ("No kidding!") He seemed to like me very much. We were both fond of poetry, and every time he came to see me he recited a poem by Tagore that he had found in a magazine. After we became neighbours he would come and talk to me in my studio about the art of the Far East. He was most interested in the art of China and Japan, but not at all in Negro art, which so many people were talking about at that time.'

As Chaim Soutine was also a neighbour of Modigliani's in the Cité Falguière, it was not long before they became great friends. As a result, Modigliani became involved in an incident connected with an ox carcass which the Russian painter used as a model for one of his most startling canvases. Soutine's idea of doing a painting of such a subject undoubtedly derived from a neurosis for which poverty and undernourishment were partly responsible, but the more he thought about it, the more determined he became to undertake it. He must have subjected himself to endless sacrifices and privations, and it seems

incredible that he finally managed to scrape together enough money to pay the butcher for the carcass. As he worked very slowly, it was inevitable that the meat, which was hanging from the rafters of his studio, should begin to decay long before the picture was finished. The situation became impossible for him, not to mention everyone else within smelling-distance, for the odour spread not only throughout the entire Cité Falguière but also the quarter round about. It was imperative to get rid as soon as possible of the foul object and the hordes of flies it attracted. But how? The huge carcass could not be thrown into the dustbin like a dead cat. The only solution was to get it out of the house at night and dispose of it elsewhere, and the story goes that it was Modigliani who helped to carry it — heaven knows where.

Modigliani went back and forth from the Cité Falguière to the Rotonde and beyond, moving about restlessly in quite a different world from the one he had known in Montmartre. The Butte was relatively small and it still retained something of its village atmosphere. Montparnasse covered a large area, and a considerable number of artists, including Modigliani, lived here and there along its borders. Their favourite meeting-places were the Dôme and the Rotonde. The young Italian felt lost among so many other foreigners. Moreover, none of his paintings had as yet been shown in the galleries, and the one piece of sculpture he had submitted to the Salon d'Automne, never a good place for sculptors, had gone completely unnoticed. He was discouraged, and it is not surprising that he allowed himself to drift from one café to another, sketching portraits of friends and acquaintances, of the pretty girls he met, selling his drawings for a franc apiece, offering them in exchange for a drink, or else simply giving them away.

To most of these foreigners Modigliani was just another artist like themselves, and the only reputation he succeeded in making at the beginning of his Montparnasse career was that of a wastrel and a turbulent eccentric. One evening he

would be howling drunk; the next he would be seen tearing up one of his finest drawings in a fury. It was only first-rate artists like Kisling and Henry Hayden, Metzinger and Soutine, Lipchitz and Fujita, who sensed the possibilities of future greatness in Modigliani, and then took him to task for his apparent laziness and for not producing more.

One night, as he was sketching away at the Rotonde under the benign eye of M. Libion, the proprietor, Derain came in unexpectedly and, on seeing Modigliani, decided to go over and speak to him. The habitués were impressed.

Derain was something of a dandy and at that time sported a bowler hat. The bowler was widely popular just then, even among artists. Apollinaire wore one; Picasso owned one, though he rarely appeared in it; and when Georges Braque returned to Montmartre after a visit to his native town of Le Havre, he brought back a whole cargo of magnificent bowlers which had been refused by the Negro dandies of the Ivory Coast. He had paid only a hundred francs for the lot. They were superb hats, but already out of fashion; nevertheless, everyone in our group was eager to have one. Having bought them for twenty sous apiece, Braque very sensibly sold them at the 'special price' of two francs each, thus netting himself a profit which represented a veritable fortune at that period. If Modigliani had known about them, he would doubtless have wanted one also, provided that he had been allowed to pay for it with a drawing. Sombre as he was by nature, he had his moments of gaiety, which were as brief and unrestrained as his outbursts of rage.

Modigliani had just finished a pencil drawing of a woman's face, and when Derain came up to him he showed it to the older artist, despite the fact that the subject was openly scornful of her portrait.

Derain took the sketch and examined it closely. 'You still draw well,' he remarked, 'but I am surprised and even a little disappointed that you think that sufficient. No, don't take the

picture back. Let me look at it again ... Perhaps you do draw
better than you used to. But where will that lead? You will
probably become very skilful, and then you will be tempted to
base everything on skill. It is inevitable, I suppose — that
is the devilish part of it. But you've got more to you than that.
Why don't you take a few risks? With a nature and temper-
ament like yours, you should risk everything — your whole
self, including your hide.'

Modigliani started, but he managed to answer in an even
voice: 'I am risking a great deal, and my own hide first of all.
Here I am, apparently playing the fool just to try and earn a
franc or two, but I know what I'm doing: I'm not doing a
blasted thing. You haven't seen any of the drawings I really
care about. Those that dissatisfy me are the ones I never
tear up. I keep seeking and seeking ... You tell me to take
risks, but have you ever thought of the pictures I could do,
and don't? I have painted a good deal; now I'm doing sculp-
ture.'

'That's not a bad idea, provided that you keep on seeking,
as I believe you do. Sculpture will give you the fullness of the
forms; you already have the "feel" of them. But you are a
painter, first and foremost. I know sculptors and I know what
their drawings are like. Yours are the drawings of a painter,
not a sculptor ... Now, what will you have to drink?'

When Picasso had a session with Modigliani in the café the
following day, it looked to many as if he had come for no other
reason than to show in public his approval of the younger
artist, despite the fact that the latter had as yet accomplished
so little. Modigliani's stock rose even higher.

'Keep on drawing,' Picasso advised him. 'You are perfectly
right to keep on drawing. One can never draw enough. No
one has done more drawings than I have. When I was a child
I did nothing but draw, but I really wanted to paint. My father
was a painter; he was also the drawing-master in the local
school. He taught drawing to children who didn't want to

paint, or to draw either, for that matter. Nevertheless my father was paid by the government to teach them. As a painter, his favourite subjects were birds — pigeons especially. It is not for me to say whether my father was a great artist or not, but I know that he showed considerable talent in his particular field. You couldn't possibly have mistaken his pigeons for doves, in spite of the fact that the word "*paloma*" is the word for both of them in Spanish.

'I recall my father saying to me: "I am quite willing for you to become a painter, but you must not begin to paint until you are able to draw well, and that is very difficult." Then he gave me a pigeon's foot to practise on. He came round later to look at my work and criticize it. At last the day came when he give me permission to go ahead and draw whatever I liked. "You are doing fairly well now," he said. "You really know how to draw. Now you can try painting. I am going to give you my paints and brushes and the whole outfit. I am not going to paint any more: you can do it for me!" And with that he went off to his class at school as usual. So far as schools go, I am glad to say that I went to a good one. It was so good that by the time I was fifteen I could do faces and figures and even large compositions — often without models — because, simply by practising on pigeons' feet, I had learned how to capture the mystery of lines, even of nudes.'

Modigliani remembered the phrase 'the mystery of lines', and while as an innovator in his own right he disdained Cubism, he kept seeking for an equivalent way to render angles and curves in his effort to develop a sort of elementary nude.

He was preoccupied with all these aesthetic problems when his fellow-sculptor, Ossip Zadkine, was introduced to him by Zarate. Finding each other congenial, Zadkine and Modigliani walked home together to the Cité Falguière. Zadkine later described the walk to me.

'I can see him now, dressed in a freshly-laundered suit of

mouse-grey corduroy. He looked like a young god disguised as a workman out in his Sunday best. His clean-shaven chin had a small cleft in it. His smile was delightful. He talked to me immediately about sculpture and the advantages of direct carving in stone, and he invited me to come to his place to see some of his early pieces, with which he said he was not dissatisfied. He worked in a little court in the Cité Falguière. He showed me a head he had done, solid and oval in form, with eyes the shape of olives.

'All that is important, if you want to understand Modigliani well. He did not explain anything; we did not discuss sculpture in itself. His only response to my comments as a professional sculptor was a pleased laugh which echoed through the shadow of the lean-to he used for an outside studio. There were other carved heads lying about on the hard earth, most of them still in the rough stage.'

With Soutine, Modigliani had been fast friends almost from the day they met. He admired the Russian's vigorous talent, and he enjoyed talking with him in the dreary surroundings of the Cité Falguière. He painted a striking, if disconcerting portrait of Soutine in 1918, showing his subject as a strong and resolute man, but with a bewildered expression on his face. Soutine had in fact large, beautiful eyes, but they were half closed most of the time in a sort of inexplicable somnolence. His nose was prominent and fleshy and had flattened nostrils; his mouth was weak, and his lips thick. The picture was a good enough likeness but it was an improvement on the original, for it must be admitted that in real life Soutine was far from physically prepossessing. He was for many years a living monument to filth. His face was hardly ever washed, especially during the great days of the Cité Falguière; as for his person, the odour it gave off might easily have been compared to that of his rotting ox-carcass.

Chaim Soutine was a man of extremes. He was unperturbed by his lack of cleanliness; on the contrary, he seemed rather

to enjoy it. He was naturally slovenly, and it was the lack of amenities in the Cité Falguière, which his neighbours suffered in silence, that explained his distaste for bodily hygiene. His studio was in such a constant state of disorder that the most energetic charwoman imaginable could have done little with it. Yet in the midst of his squalor he never ceased to dream of comfort and luxury, while avoiding even an occasional bath or the cleaning of his ears and nails.

Modigliani was just the opposite. He was so particular about his person that it would have amazed everyone if he had failed to appear clean-shaven in public. He washed and groomed himself regularly even in the coldest weather, whether hot water was available or not. Yet he was as unconcerned about Soutine's stinking body and lair as their owner was. His friend had enormous talent and he possessed the ability of demonstrating it, so to speak, even in his conversation — something not given to all talented artists. In Modigliani's eyes that made up for all the rest, and he derived the greatest satisfaction from the long talks he and Soutine had together.

Fernand Léger did not belong to the group who lived at the Cité Falguière. He took a huge studio at 86 Rue Notre-Dame-des-Champs, setting himself up there as the 'artistic conscience' of the quarter. He did not exactly visit the Cité Falguière for the purpose of recruiting disciples, but he was anxious to try and indoctrinate his fellow-artists in everything that he claimed to have originated and applied. Speaking in his slow, guttural voice, he once told Modigliani:

'I am a man of my time. I don't aspire to be anything else. I began, of course, the way everyone else does — you've got to learn your A-B-C — but I soon got started with my own experiments. We have to create something original, even out of our mistakes, and a certain kind of strength can be wrung out of weakness, don't you think?'

'I'm not one to talk much,' Modigliani replied.

'Wouldn't it be better if you were? By discussing things you

can sometimes release your ideas and in that way avoid mistakes — at least, that is how I look at it. One day I was watching some workmen putting up the iron girders of a factory. I was fascinated by the metal construction. I realized that the world had become a mechanical wonderland, and I said to myself that that was the kind of thing that should be interpreted and represented. I was amazed that I had been the first to think of it when it ought to have begun in 1889 with the Eiffel Tower, the very time when people were imitating the Impressionists. Painting must be contemporary at all costs.'

'There's some truth in what you say,' Modigliani agreed, 'but you should think of what is lasting and eternal. You admire the machine; you believe in progress. I believe in it too — so much so that I think progress will eventually reduce the machine you worship to nothing.'

'I don't worship it. I just face the fact of its existence. And what about you? Are you working?'

'I sculpt, I draw, and I paint from time to time.'

'You ought to paint more. What about your nudes?'

'Eve — Beatrice — Pargoletta ... '

'Pargoletta? Never heard of her. Not that I've anything against nudes; you'd have to be crazy not to like them; but don't try to tell me that I'm mistaken about the machine just because you think it will be out of date some day. What does "out of date" mean? Look at Rembrandt's portrait of "The Night Watch", and Uccello's battle-scenes with slung shot: they're out of date, but they're still beautiful and they belong to their period. I'm painting my time, my period, just as Rembrandt and Uccello painted theirs, but that doesn't mean I have anything against your female nudes. Anyway, I'm glad you're not filling your head with all this nonsense about Negro art.'

It would be interesting to know whether Modigliani ever discussed Léger's dogmatic theories with Soutine. With Fujita, his other neighbour, it was not art that he discussed most

often, but women. Fujita knew all about his appetite for women, his craving for physical pleasure, though Modigliani was at the same time exceedingly afraid of being dominated by the opposite sex. Fujita may have thought that a woman could play a very helpful role in Modigliani's life, and if he did think so he was certainly proved right, for it was owing to Modigliani's intimacy with two women towards the end of his short career that he was able to achieve the greater part of his finest work. Now, however, it was Thérèse who usually took him home to the Cité Falguière after he had been drinking at the Dôme or the Rotonde. His drinking was his only hope and refuge. Thérèse looked after him, and I was once told that 'he made love with her between hiccups.'

4 *A New Friend*

In the year 1912 something happened which was to be far
more important to Modigliani than the official opening by the
President of France of the Boulevard Raspail, great event
though that was in Montparnasse. In 1912 Kisling arrived
from Poland. Modigliani and Kisling became good friends
almost immediately, and their friendship was to stand them in
good stead more than once.

'Go to Paris,' Panckiewicz, the young Pole's professor at the
Cracow School of Fine Arts, had told him. 'I have nothing
more to teach you now — except how to paint as I do.' He was
an old friend of the Impressionists, and he knew what he was
talking about.

By the time Modigliani got to know him in Montparnasse,
Kisling had already become the authentic Kisling he was to be
from then on. He wore a mechanic's blue overalls, not from
snobbishness nor from any desire to imitate the Picasso of the
'Bateau-Lavoir' days, but simply because the overalls favoured
by the steel-workers and the grey or brown corduroys worn by
labourers were the cheapest clothing Kisling or Modigliani or
any other impecunious artist could buy.

Kisling rapidly installed himself in the studio in the Rue
Joseph Bara where he was to remain for more than thirty
years. He loved life. He loved pleasure — enough to enable
him to snap his fingers at difficulties and hard times. He was
also fond of parties, and at night led a riotous life in Mont-
parnasse. He would either promise himself a night out as a
reward each time he did a successful bit of painting, or else as
a consolation for each exhausting and fruitless struggle with a
blank canvas.

Whenever Modigliani got drunk (and he was always more
violent when drunk than Kisling) it seemed as if it happened

by accident, even though the same thing occurred night after night, whereas Kisling's good-natured drunkenness appeared to exercise a persuasive and calming power over his friend, even when Modigliani went raging about after a debauch of alcohol or hashish.

I recall that once when Modigliani was drunk he suddenly sobered up and smiled affectionately at Kisling, who, having just made a hundred francs, had spent them all on flowers just for the pleasure of tossing bouquets to the women around him. Modigliani marvelled. Imagine throwing flowers away like that! It was not the spending of the hundred francs that astounded him — he might easily have tossed them into the gutter himself had he been so minded; what impressed him was the idea of giving flowers to women without singling out any particular one, bestowing them in a burst of devotion to women in general, all of whom would be forgotten immediately because there were so many.

Afterwards he remarked: 'Kisling is as poor as I am, yet he bought a hundred francs' worth of flowers for the sheer pleasure of wasting both money and flowers. When I saw him the next day he was furious. He was abusing Adolphe Basler, the fellow he calls his dealer, and threatening to break with him, although poor Basler is as poverty-stricken as we are. And all because Basler wasn't able to advance him the fifteen francs needed to buy a pair of high-buttoned boots for a little model who didn't want to leave after posing for him. Kisling isn't afraid of women; he doesn't mind having them around. He's going to be a real strong man.'

The Adolphe Basler whom Modigliani referred to had become an art-dealer because of his very real love of art, and also because he hoped that some day, thanks to his efforts, the name of his forefathers, who had been only second-hand dealers, would be inscribed in letters of gold over the shop he aspired to own in the Rue de la Boétie, or at least in the Rue de Seine. Kisling had advised him to look at Modigliani's work.

Later on, after he had broken with Basler — for Kisling was sometimes as difficult as Modigliani — he recommended his Italian friend to the poet, Léopold Zborowski, a surprising sort of picture-dealer in that he considered the buying and selling of works of art as another form of poetry.

The cordial feelings Kisling had for Modigliani did not prevent him, however, from acting prudently where his friend was concerned. When the young Pole had fully entered into the life of Paris he was ready to fight a duel with anyone, but he would never allow Modigliani to become involved.

'I am going to have a duel tomorrow with Gottlieb, another Polish painter,' he announced one day. 'I don't know why exactly, except that we hate each other. The conditions are very strict: first we shall use pistols — only that's a joke. But if, as is likely, there is no decisive result by that method, then we shall continue with Italian sabres. I don't want Modigliani to know anything about it. This is going to be a risky affair, and you can picture Modigliani getting mixed up in it over there at the Parc des Princes — drunk or sober. Imagine Modi stepping in between Gottlieb and me. And Italian sabres into the bargain! It would send him off his head, and make us look ridiculous.'

On this occasion, however, when Kisling had taken considerable trouble to prevent Modigliani from learning of the encounter until afterwards, he returned home with a few sabre cuts on his nose. Fortunately, when Modigliani arrived at the little banquet given by the witnesses in Kisling's studio, he was in one of his gayer moods and merely observed: 'This makes the fourth time that Poland has been partitioned.'

AUGUST 1914: the height of summer. People wanted only to be happy, but instead, in Montparnasse as everywhere else, they discussed the international situation in a detached way, as if talking to themselves.

'Do you think there'll be a war?' one young man after another would ask his neighbour.

A model from one of the art schools shed a few tears as she said to the artists around her: 'You'll all have to go ... And what will become of us?'

A fishmonger in the Rue Delambre stated the case more bluntly: 'It's only the beginning, I'm telling you, and we don't know how it will end for any of us.'

No more profound utterance was made by anyone.

The German artists departed from Montparnasse. The other foreigners, led by the Poles, began enlisting in the Foreign Legion, and since the Poles made the Rotonde their unofficial headquarters, not so much because they wanted to keep drinking but rather to take advantage of the opportunity to strut about in full dress uniform, it was not very long before Modigliani became involved.

One afternoon Simon Mondzain, Kisling's friend who had come with him from Cracow and who was miraculously to escape death in the war, came into the café and announced: 'I have just signed up with the Legion. Kisling has too.' Then, looking at Modigliani, he said: 'What's going to become of you in all this?'

'I'm going to do as you've done. I'm going to join up.'

'You are?'

'Are you surprised?'

'Rather.'

'Why?'

'Because you've plenty of reasons for not joining up.'

'What are they? First of all, you should realize that any reasons against doing something are the same as those for doing it.'

'Perhaps. Up to a certain point. Still, you're Italian — '

'What if I am?'

'Italy, Austria and Germany are members of the Triple Alliance. Austria started the war, egged on by Germany; therefore Italy will be forced to come in.'

'Italy won't come in.'

'She might.'

'No. You can consider that the Triple Alliance has never existed in practice, since it hasn't lived up to its agreement. If the Triple Alliance were really valid, Italy would have mobilized already. But she won't stir, and she's a perfect right not to.'

'Are you so sure she won't?'

'She hasn't yet.'

'If you've received any inside information through your brother,' put in a French member of the group, 'you might pass it on. It would be a great help to us, because as we are already mobilized we've no need to join up.'

'What brother?'

'Your brother Emmanuel — the Socialist politician.'

'I haven't heard from my brother for over a year. Perhaps you have news of him since you read the papers? I never read the papers, even now. My brother is a politician. I am not. It's already difficult enough just being an ordinary man. I'm not a politician — I'm a revolutionary.'

'Are you going to join up?'

'I don't even know yet what to join.'

'Good. I thought you were anti-militarist.'

'You're a revolutionary, yet you intend to be a soldier?' Mondzain pursued.

'Because I'm a revolutionary. A war can be a revolutionary

war, and carry its soldiers along, and the children of its
soldiers — '

'If the soldiers have had the pleasure of begetting any child-
ren beforehand.'

' — right up to the end of the revolution.'

'And I always thought you were a pacifist!'

'I never said I was a pacifist. A revolutionary is not the same
thing. I'm so much a revolutionary that I'm even willing to
be a soldier and revolt against my own anti-militarist beliefs.
A little contempt for soldiering makes it all the easier.'

'I thought — '

'I've read Nietzsche and I'm through with Tolstoy.'

'What about your Dante?'

' "My" Dante, as you call him, is with me against war and
yet accepts it. He forbids it, but he is ready to take part in it
when the time comes. Nothing can be done without the spirit
of contradiction.'

'Modi, you bewilder me.'

'I spend my life bewildering myself.'

'But Modi — with a disposition like yours — what if a
sergeant should start on you?'

'As he certainly will do.'

'Well — ?'

'Let him yell his head off. He isn't an artist, he's a sergeant;
and there's nothing I can do about a sergeant's foul mouth.'

'Do you think you'd obey him?'

'Yes. But only because I'd be obeying myself first.'

A Frenchman, listening to the conversation, protested.
'That's all very well,' he said, 'but I simply cannot understand
how a man like you — an artist and a revolutionary —
can want to get into the war. No one can force you to
take part.'

'I don't want to take part, but I'm going to just the same.'

'Only because you've got it into your head that this is a
revolutionary war. But it's not certain that it is. You think so,

but one day you'll come back and find you've been fooled again. That is, if you do come back.'

'You don't go off to war with the idea that you'll come back.'

'I agree with you, Modi; but if you do come back, you're glad you did, all the same. Even though you are disillusioned — and show it.'

'Then we're both right.'

'Perhaps. But if I were you, I shouldn't give a damn about Alsace or Lorraine.'

'You've got to pay.'

'Pay for what?'

'You're a Frenchman and you've just reminded me of the fact that I am a foreigner ... You ought to understand.'

'I do understand ... Well, goodbye. I've got my farewells to make — to my mother out at Rambouillet.'

Modigliani shook hands with his French acquaintance, but said no more. He realized that this was a time to keep silent.

Modigliani did not go to the war. The military rejected him. They were not interested in the proper spirit shown by a young man with weak lungs, and so he did not become a soldier. The recruiting officers did not want the hide of an Italian son of a dealer in hides. He was perturbed about it for a long time afterwards, yet it relieved him to feel that he had at least tried to do his duty. Now he would be able to take advantage of the few years remaining to him and achieve his most important work. He could become an uncompromising revolutionary again — much more of a revolutionary than his brother Emmanuel, who, if it had not been for Fascist persecution, could have become a government minister. Modigliani could return with a clear conscience to his basic anti-militarist views. Nevertheless he was distressed by the sufferings of France, for he felt a dedicated and even passionate love for the country of

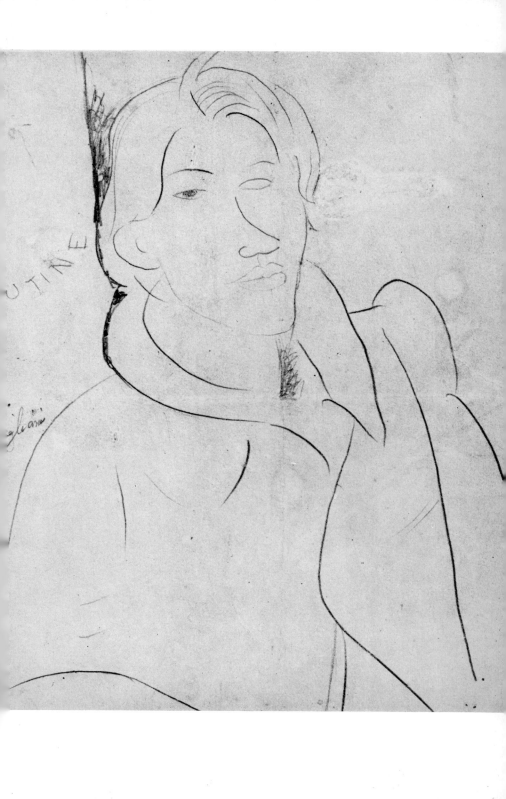

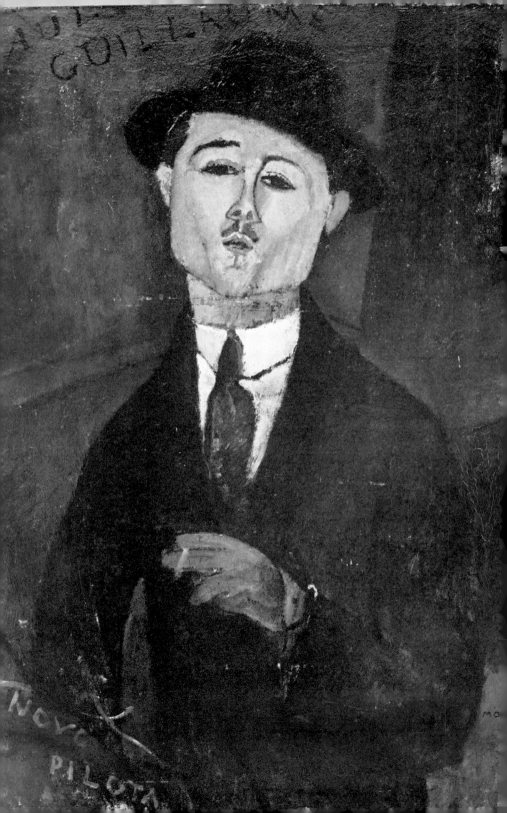

his adoption. He got abominably drunk the night the news of the Charleroi disaster reached Paris.

Generally speaking, Modigliani looked on sorrowfully at the war in which he could take part only vicariously. He was dignified about it even when drunk. Only once did his reserve crack, and that was one night in 1918 when he had taken so much drink that he could no longer control his resentment over the misery caused by this world catastrophe. Chancing to see a Serbian officer strutting across the street from the Dôme to the Rotonde, he shouted: 'It's all because of those blasted fools! The bastards!'

facing: Paul Guillaume *145*

MODIGLIANI was now to begin the life for which he was destined: a life which had been postponed and jeopardized more because of the privations he had had to endure than because of any excesses on his part. Events were coming to a head, and he was shortly to fulfil his great promise as an artist.

He decided to move from the Cité Falguière. Chaim Soutine saw him go without regret, for though Soutine relied a great deal on others' friendship, he contributed little himself. His friends would seek his advice often enough, but he never asked any from them. Now he and Modigliani met only occasionally at the Dôme, since Soutine for some reason always refused to go to the Rotonde.

Modigliani went to live in an artist centre which was not half as large or as populous as the Cité Falguière. It was situated in the Boulevard Raspail between the Rue Huyghens and the Place Denfert-Rochereau, and it consisted of a number of antiquated 'lodges' at the back of a court which had been made over into studios and work-shops for artists and cabinet-makers. Ossip Zadkine, who at that time was one of Modigliani's chief intimates, afterwards recalled his friend in a queer studio 'which was glassed in on all sides and looked like a huge glass cage'.

Reminiscing about Modigliani many years later, Zadkine told me: 'We never argued with each other; we never talked about sculpture; and often, after some remark of mine, he would break out into a clear, ringing laugh. He worked at his sculpture during the day in a shed next to his studio, and at night he sketched in the cafés. The forms of the heads he planned to do in stone were first worked out in his sketches, which he outlined heavily in black or blue. You had the feeling of watching a master-draughtsman who *thought in stone*.

'I would watch his progress, and little by little I would see the oval of the head lengthen and become reduced to sharp angles. The nose took on the shape of a fine blade, bent back at the tip. The lips would practically disappear. The olive-like eyes seemed to protrude more and more, as though they were about to burst from the stone.

'I remember how sorry I felt for him as I studied one of his caryatids which was just emerging from the stone block, for the modelling and volumes were blurred and seemed lost in uncertainty and hesitation. It was as though the initial upsurge of the idea that he was trying to express had escaped him, and in his hesitation he had coarsened the volumes instead of making them purer and finer. Some new problem seemed to have taken hold of Modigliani's tormented mind. It was during this period that I became more and more convinced that his talent as a sculptor was waning, and that he was aware of it.'

Zadkine did not say whether he thought Modigliani suffered as a result of his failure. It hardly matters. What is important is that Modigliani left off working in stone and, as he no longer had any need to go and steal it at night or to fly into a rage when the forms he had conceived eluded his chisel, he concentrated on painting.

Continuing his recollections, Zadkine said: 'The handsome young man to whom Zarate had first introduced me was very much changed by this time. His face was ravaged by the quantities of cheap wine he had drunk and all the hashish he had absorbed. His well-shaped chin often went unshaven now, but his thick hair still hung in curls over his fine forehead, which as yet showed no sign of wrinkles.'

Saddened as Zadkine was to see Modigliani going downhill physically even while his work continued to rise towards perfection, he was heartened by the young Italian's ability to maintain his position as a sort of 'prince-errant' in the motley world of Montparnasse. 'He was more skilled than ever,'

Zadkine concluded, 'in his ability to move all those who gathered around him of an evening at the café-bar, listening to him spellbound as he dramatically declaimed the verses of his beloved Dante, though few could understand the language in which he was reciting. He truly reigned over this little kingdom of young people who had come from the four corners of the earth to take advantage of the marvellous promise which Paris held out to them.'

Part Three

The Lady from London

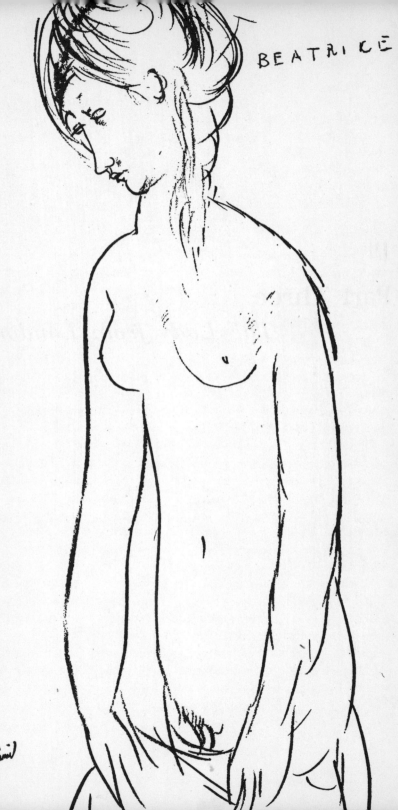

1 *The Lady from London*

MONTPARNASSE is a part of Paris which is relatively neglec-
ted nowadays, but during its best and most spectacular period
it could easily have been compared to a huge international port
to which phantom ships brought many 'passengers', who were
often the strangest of strangers, loaded down with the most
astonishing possessions and paraphernalia. It was a hospitable
port, for it had no Customs, no very conspicuous police, and no
aliens' registration office requiring the inspection of identity
papers. The newcomers could not be distinguished from the
local population as a rule, except by their different and occa-
sionally peculiar deportment.

Among those who attracted attention soon after arriving was
a certain Mrs Beatrice Hastings, who forsook London for
Montparnasse and succeeded in making a place for herself in
the pleasant republic of arts and letters. Modigliani was to link
his destiny with this Englishwoman's for a while.

It was Mrs Hastings who noticed the artist first and was
attracted to him, which perhaps explains the relationship,
because it would never have occurred to anyone in Montpar-
nasse to treat Mrs Hastings with familiarity. It was not so
much her plainness that inclined people to respect her, for
although she was hardly a raving beauty she did not lack a
certain grace and charm, but — since no one could have fore-
seen that she was to become involved in a romantic adventure
— she commanded respect by virtue of her quiet authority and,
until her meeting with Modigliani, her apparent conven-
tionality. As a further protection, she had the reputation of
being a poet, though how and why she came by it was a
mystery, since no one, not even the most anglicized members
of the community, could quote a single one of her poems. She
seemed to have been sent over from London to Paris by some

Modigliani: A Memoir

supernatural power for the sole purpose of meeting Modigliani. Modigliani had always needed some sort of miracle to happen to him. Unassuming and modest as he was in his attitude towards his art, he seemed utterly unaware of the greatness that awaited him. And he was so slow in fulfilling himself that, from the day he abandoned himself to various kinds of debauchery, people began to wonder if he had not made a pact with the devil.

Modigliani's many admirers will doubtless be willing to give due credit to Beatrice Hastings, the poetess who produced no poetry, for having deliberately put all her lyric gifts into her amours. Her pride prevented her from ever experiencing the cruelties of love herself, and her calculating conceit made it possible for her to give in to the passion of a lover who was subject to dangerous fits of rage: but she yielded only because of the physical pleasure she desired — she never capitulated. Beatrice Hastings did not love Modigliani; she was not capable of loving anyone or anything except a vague conception she had of poetry. She thought Modigliani was handsome; she was attracted to him; she wanted to become his mistress. Moreover, her poet's sensitivity enabled her to divine his genius, which she awakened, or appeared to awaken; and if it was only an illusion, all the more honour to her if on getting out of her bed Modigliani began to create the finest work of his all-too-short career.

When the affair was over, Beatrice, who was a prudent woman except when enjoying the ecstasies of love, said or wrote about her former lover — I do not know to whom or where:

'Modigliani? A complex character. Swine and pearl at the same time. First saw him in 1914 in a little restaurant.'

It must have been Rosalie's.

'I was sitting opposite him. Hashish and brandy.'

That last statement is misleading. Under the influence of hashish Modigliani would wander shouting through the

streets, going from bar to bar, but he was no longer interested in brandy when under the influence of the drug. Nor did he go to Rosalie's at such times to eat the simple dishes she served to more abstemious customers. Beatrice has here confused her recollections of what took place on several different occasions.

'A rather indifferent impression. I did not know who he was. I thought him ugly, ferocious, greedy.'

It is possible that the handsome Modigliani could have given a young woman an impression of ugliness when he started frowning or making one of his frightening grimaces, and by this time he had become slovenly about his appearance, as his friend Zadkine had noted; but as for his alleged ferocity and greed, Beatrice evidently did not know that he did not sit down and attack his food ravenously except after having gone for days without eating anything more than a piece of salt herring and a crust of bread.

In her next note Beatrice is more approving:

'Another encounter. Was introduced to him at the Rotonde. He was shaved and charming.'

Properly shaved and therefore a gentleman. The lady from London was enchanted.

Another of Beatrice's notes tells us that: 'He (Modigliani) blushed to the eyes and invited me to go and see his work.' And she adds courageously and proudly: 'I went.'

Although revealing nothing of what passed that first evening, she records a fact which again must have referred to several different meetings:

'Always with a book in his pocket: Lautréamont's *Maldoror*.'

Maldoror! One wonders whether Modigliani was full of hashish and thought to frighten the self-contained Beatrice with that peculiar work.

'Kisling's portrait was his first painting in oils.'

Here Beatrice is frankly exaggerating, although she may be forgiven since, as I have hinted, Modigliani's career really

began on the day this lady in her London tailor-made kissed him for the first time.

'He despised everyone except Picasso and Max Jacob. He loathed Cocteau.'

Did he really dislike Jean Cocteau who was so kind to him, helping him in various ways and promoting his art, on which he, like so many others, could have speculated? Cocteau himself said of the artist: 'Handsome, grave, romantic, he represented perhaps the last period of elegance in Montparnasse. I posed for three hours in Kisling's studio for both painters. The portrait Modigliani did of me has travelled a good deal since. It has also brought in a fortune.'

Concerning Picasso, Beatrice was correct in saying that her lover praised the Spaniard, of whom, as he confided to others, he had a sort of respectful horror.

Beatrice concludes her notes by saying: 'He never did good work while under the influence of drugs.'

As regards drugs, Modigliani never took anything but pellets of Indian hemp, which he would occasionally swallow between visits to the cafés. He was addicted neither to opium nor to ether, both popular in the Paris of that era. Moreover, I have seen him snatch away a packet of cocaine from an adolescent girl who was already half doped with it in order to keep her from poisoning herself still further. The wretched child screamed with anger and despair at Modigliani, who remained quite impassive. Whatever the case, it was a stupid remark. Few people have been able to do good work while actually dominated by drugs or drink, but who can say whether at certain times Modigliani did not need to imbibe one of his favourite poisons so that he could work well afterwards — from remorse or from relief?

When Beatrice first made Modigliani's acquaintance in 1914 George V was on the throne of England, but her childhood and adolescence were Victorian and she was one of the most carefully-brought-up damsels of her day. In

Montparnasse she was looked upon as 'a real lady'. No one appears to know whether she was born Hastings, or had been joined for better or for worse to a Mr Hastings and had decided to forget him.

On coming to Montparnasse, Beatrice shrank from the prospect of settling in any of those 'barracks for aesthetes' frequented by most of her compatriots who sought in Paris a freedom of manners and morals not yet known in London. Instead she found comfortable quarters at the back of a little court with a flower-garden in it in the Rue du Montparnasse. Montparnasse, which had taken little notice of Beatrice on her arrival, was suddenly startled to find that she had moved in. The surprise was all the greater when, several days later, she appeared at the Dôme, making an entrance which was regarded as sensational for she did not seem at all the artist type. She was a society woman in smart clothes; a society woman who knew how to choose her gowns even if she lacked the income to buy many of them.

It was Zadkine who acted as the instrument of Providence in introducing Modigliani to Beatrice at the Rotonde. Zadkine was a man who could be formal on the most informal occasions. That evening he was having a drink at the Rotonde, although it was only coffee. Beatrice Hastings was keeping him company, but she was sipping a whisky.

Modigliani chanced to wander in, and luckily he was in one of his pleasanter moods and looking handsomer than usual. In fact he was so handsome that even other men were often forced to admit that he was 'a fine-looking fellow', while many women were so affected by his looks that they were struck dumb. For once he had not had a drop to drink. He wore his workman's suit with a regal air, as if dressed in velvet like a prince or a Duke of Tuscany.

Zadkine made the introductions:

'My friend, Amedeo Modigliani. Mrs Beatrice Hastings.'

Beatrice!

Modigliani's piercing eyes scrutinized the young woman. He instantly took in her very real qualities, but instead of judging her as a painter he was hypnotized by her name. With his fixation on Dante, he was intoxicated by the music of the word Beatrice, 'Bice' as Dante called her when speaking of the first meeting with his chaste beloved. He looked at her more closely and realized that she was beautiful in her way, and desirable. At the same time he was agreeably aware that she found him pleasing.

'Sit down, won't you?' said Zadkine.

'Have a whisky?' suggested Beatrice Hastings.

The English poetess and the Italian painter then exchanged glances which others might not have noticed but which were not lost on Zadkine. He withdrew as soon as he could tactfully do so, secretly confident that this Anglo-Italian contact would bear tender and rewarding fruit.

Modigliani was not drunk, and Beatrice was shrewd enough to sense that it would not be advisable for her to encourage him to drink too much whisky, while Modigliani instinctively brought into play all the tactics of seduction and charm which a woman of breeding called forth in him. He became so absorbed in his strategy that when some of his friends passed by the table where he and Beatrice were sitting, he responded to their greetings only by a courteous nod.

From the very moment they met, Modigliani desired Beatrice. Oddly enough, he was shy in his own way, the reverse side of his aggressive and truculent disposition when excited. He may even have reproached himself for appraising this Beatrice, at once reserved and uninhibited, solely from the point of view of an artist and painter and for judging her beauty and grace as if she were some professional model or obliging hussy, willing to strip in the studio without giving it a second thought.

He was thankful that she was not a painter. At least he would never be obliged to face the embarrassment of having

to express an opinion about the imperfect work of a perfect mistress. As for her poetry, there would be ample time for that. For the moment all that mattered was to try and prolong the evening with her to the point where they would decide to spend the night together.

THE war went on relentlessly.

Modigliani had volunteered to risk death as a soldier; having been rejected, he now resolved to abandon himself to love, from which he had hitherto so stubbornly held aloof, although as an artist he could fear a death from love far worse than any which he might have suffered as an anonymous soldier.

He and Beatrice met again by appointment at the Rotonde one evening. Their relationship was ripening better there than it might have done had they become lovers too rapidly.

Since Beatrice was a poet, and an English poet at that, Modigliani talked to her about the early enthusiasms of his youth when he had come across the verses of Dante Gabriel Rossetti at the same time as he discovered the marvels of painting. Beatrice knew several sonnets from 'The House of Life' well enough to repeat them to him unaffectedly and in a low tone, and as he had never read anything by Rossetti except in the French translation by Lemerre, he listened to her enthralled. Though knowing no English, he was delighted by the sound of the lines, and the music of the foreign syllables coming from her lips made him try to hide his pleasure by a dramatic grimace.

After her recitation Beatrice related the history of the sonnet sequence: how Rossetti interred the manuscript with his dead wife, subsequently regretted his impulsive action, and had the body exhumed in order to recover it. Modigliani knew the story, but he was perfectly willing to hear it again, spoken in Beatrice's low voice in that café in the midst of wartime Paris, where men in uniform on leave from the Front rubbed shoulders with the models and artists who formed the usual clientele.

Turbulent member though he was, of the international

republic of Montparnasse, Modigliani was conscious for the first time of being a foreigner among these people who maintained a semblance of gaiety in the midst of catastrophe and laughed in the face of misfortune. The French seemed able to face the terrors of love and the horrors of war with perfect equanimity, and he was ashamed that he had so often behaved disgracefully among them and gone raving and shouting through the streets. But the French had no Dante; they were not haunted by hell, by the Inferno; they could turn even Purgatory into an acceptable Paradise.

'Another whisky?' Beatrice suggested.

Because Beatrice had interrupted him in the midst of his reverie and brought him back to earth with a jolt, Modigliani allowed his temper to flare. This time, at least, drunkenness was not the cause of it.

'No!' he cried. 'I've had enough and so have you!'

Beatrice was unmoved by this outburst and called for another drink.

'No!' roared Modigliani.

'Closing-time,' announced the waiter.

'Bring me my drink all the same,' Beatrice ordered.

At that moment a heavy explosion was heard in the distance.

'Aren't you afraid?' Modigliani asked Beatrice, becoming suddenly calm.

'Afraid? Why? One might be afraid of the war, but not of gunfire.'

'Madame is absolutely right,' asserted an officer who had been at the Battle of the Marne. 'Besides, that wasn't gunfire; that was a distant bomb. You may take my word for it; I know what I'm talking about.'

'Vive la France!' exclaimed a foreigner with a peculiar accent. It was the best he could do, since the major at the Foreign Legion office had refused his services on medical grounds.

Modigliani could not forget how he too had been rejected,

though he was sure that he could have acquitted himself well in action. Yet instead, he had been turned down and told to look after himself; he had been disqualified, as though he had flat feet. But then, army doctors were apt to find all sorts of defects which would not matter in the least when confronting death in a steel helmet.

Beatrice finished her whisky in a gulp.

'Are you leaving?' asked Modigliani.

'Yes, let's go.'

Modigliani was faced with one of those grotesque situations in which the sense of pride, of masculine triumph, of conquest, gave way to such a feeling of mortification that his only thought was to flee, as though it were possible to escape either from himself or from the recollection of his beautiful prey.

Here was Beatrice, a lady, a well-brought-up woman, whose body under her fashionable gown was perfect and appealing: a slim, lithe body surmounted by a well-shaped head. There was nothing of classic beauty about her face, nothing of the pert prettiness of the Parisian girl; hers was more of an 'expressionist mask', though that term was not yet used by artists. She stood now expectantly beside Modigliani, and he did not know where to take her. He could not reasonably ask her to go to his squalid lodging, to the tiny retreat which served him as a studio. For the first time, perhaps, Modigliani regretted that he no longer had his bourgeois studio in the Rue Lepic with its piano draped in a cashmere shawl.

As Beatrice took his arm, he wondered again where they could retire to, where he might be able to find a clean bed for Beatrice to lie in. He thought of an hotel, for naturally there was no need of any hypocritical discretion. They were in Montparnasse, with its cafés and free-and-easy life, and it would not be the first time that the citizens of the artists' republic had seen Beatrice and Modigliani go off together arm in arm, for better or for worse. Montparnasse would hardly worry about so small a matter. Yet the idea of an hotel was

facing: Reclining Nude, 1918

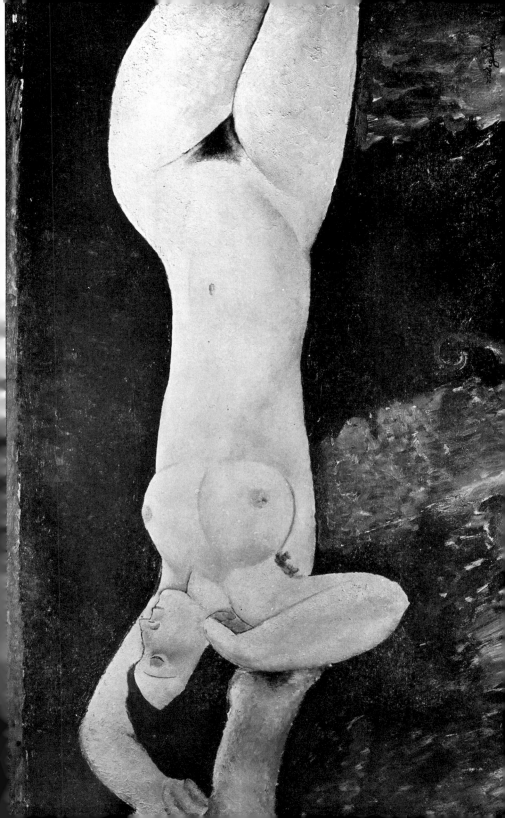

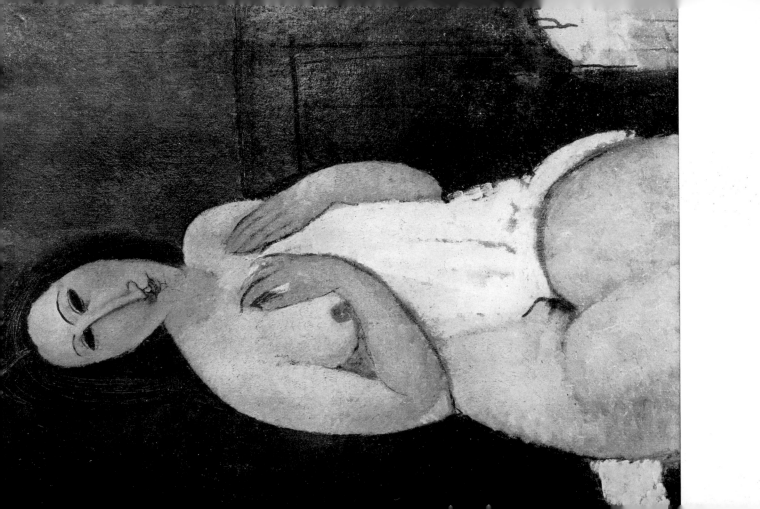

repugnant to Modigliani, who was not at all displeased to have an English lady at his side. The aristocratic side of his nature forbade such a solution, and he was troubled by it even before he remembered that in any case he had not enough money to pay for an hotel room. Fortunately he did not have to decide. It was Beatrice who guided him, and they went straight to her house.

Late the next morning the waiter who had served Beatrice her final whisky that evening brought the couple their breakfast, which consisted of coffee and two tasteless wartime croissants with a mere dab of butter. Montparnasse noted that a new ménage had been set up, and that it was apparently no passing affair. Even so, the event did not affect the temperature of the quarter in the slightest degree. It was just one couple more: another ménage, but a rather odd one.

The Great Works

THE carnal paradise of love, presided over by Beatrice's good taste and manners, proved so delightful for a while that it helped to win Modigliani away from the more artificial paradise to which he had become addicted. Beatrice would not tolerate hashish and, thanks to her influence, he doubtless left off drinking so much wine. But as she was not averse to whisky, he soon began to join her in consuming large quantities of that, and it so heated their brains that though they did not cease to be in love they soon began to quarrel.

Their disputes were due to trivialities for the most part. Even so, their quarrels sometimes became disproportionate and they embarked on the most ridiculous arguments. Modigliani never tired of quoting Dante, and Beatrice set Milton up as a rival. She did not understand Italian, and her French translations exasperated Modigliani far more than the English language which he refused to learn. Beatrice would fill her glass with whisky and soda and declaim Milton; Modigliani would retaliate with Dante; and it was after throwing Dante and Milton at each other and their whisky as well, that they had their first battle.

Inevitably the two lovers had to resolve the problem of how to finance their establishment. As Beatrice had no means of earning money, she was forced to rely solely on an allowance which she received from London, though her cheques did not arrive with much regularity; but nothing could equal Modigliani's naive vanity, now that he had taken up his painting again, when he was able to contribute to the household budget whatever money he could make by selling a picture to some collector or art-dealer who had the perspicacity to recognize the possibilities of his talent and was rash enough to hope that some day that talent would acquire a commercial value.

Modigliani's first 'official' dealer was Léopold Zborowski, the Polish poet who was such an art-lover and idealist that he once pawned his personal library in order to buy at a modest price the work of painters who had never before been able to sell to anyone. The first promising 'colt' that Zbo, as he was called, took on was Kisling, who lost no time in bringing Modigliani to the amateur art-dealer's attention. Amedeo, in turn, recommended Soutine to Zborowski.

While lacking in business acumen, the good-natured Zbo was always ready to share his winnings with his friends after a successful night of gambling, but it sometimes happened that Beatrice and Modigliani would run out of cash entirely at a moment when Zborowski had lost heavily at the tables — and then, with tears in his spaniel-like eyes, the dealer would have to beg his artist friend's forgiveness for the fact that he was not only unable to come to his aid, but had even had to pawn one of Modigliani's own paintings for which he had not found a buyer.

But when money was available, whether it belonged to Beatrice or Modigliani or Zborowski, it disappeared in a flash once the lovers had it; and now that he was working seriously at his painting, Modigliani felt that he might reasonably count on others for help.

Meanwhile, Paul Guillaume, another art-dealer, was soon to take up the young painter after Max Jacob had spoken-to him about Modigliani, and he eventually made a fortune out of the latter's work as a reward for his sincere and fervent interest in it.

Wishing to be the first to break the good news of this new patron to Modigliani, Jacob hurried down from Montmartre in person to tell him about it.

'My dealer,' he explained, 'that is to say *your* dealer, is not officially in business yet, but you can have the same confidence in him as I have in you. I have read the lines in his hand. After I had read his palm I told him that he would either have to

take advantage of the very real taste he had for modern painting or else cheapen it by becoming just an ordinary dealer. He is not yet really established; he hasn't even a shop of his own; but you can have every confidence in him. So you must behave yourself and let me have the pleasure of introducing you to him. I know, of course, that Zborowski has taken you on because of Kisling, but what Zborowski needs is some rich person to back him in his ventures, and also someone to keep him away from the gambling dens. Now you see that I have brought you good luck.'

Modigliani did not interrupt his friend while he was talking, but, growing bored with Jacob's smug satisfaction and patronizing tone, he burst out irritably: 'Sans blague! I know your dealer already. Severini introduced me to him a long time ago. He's a fop ... '

'He is well-dressed, Modi, if that's what you mean, and very polite.'

'He bought a few drawings from me while I was standing on his doorstep.'

'If he did it that way, it was only because you wouldn't go in.'

'He paid me five francs apiece for them.'

'There: you see what he's like. The others only gave you one franc ... Well, I always seem to be going to a great deal of trouble for nothing. I wanted to put you in touch with someone you need as much as he needs you, and then you tell me that you've known him a long time, even before I did. But I'll be proved right in the end. Paul Guillaume will give you more than five francs from now on, if he buys paintings from you; and if he buys your paintings, it will be because you have finally decided to paint again. As for love, you have a strange way of being in love, although I accept that you are if love induces you to return to your art. So it is understood that I am to arrange a meeting with Paul Guillaume? Then I shall do so. Please give my regards to Mrs Hastings.'

'Why should I? You know you loathe her as you loathe all women.'

'I only asked you to give her my regards.'

Despite this stroke of good fortune, however, the little money that Modigliani was able to get for his pictures vanished immediately in his improvident hands, and he never felt his lack of funds so keenly as he did the day that Beatrice wanted to go to a ball.

It was to be just a small affair of the kind that was put on in a studio or in one of the local art schools. The custom of organizing these parties had begun after the first wounded soldiers appeared in Montparnasse on sick leave. These brave fellows did not hesitate to say that since Montparnasse had become such a lugubrious hole it was hardly worth while to leave the Front, where, between attacks, you could at least get drunk during rest periods. People began tentatively to hold late-night parties. They tried giving a few dances. They arranged small banquets and made a great fuss over other returned soldiers, and, as the war dragged on, these entertainments grew more elaborate.

The ball which Beatrice yearned to attend was to be only a little studio gathering. Beatrice smiled to herself as she imagined the sensation she would make when she entered, accompanied by her lover. She could scarcely wait to run over and buy a remnant of rose-coloured material she had seen at a bargain sale. She would be able to make a wonderful gown out of it in less than no time. But where was she to get the money? Her latest cheque had not arrived from London. It was no use applying to Zborowski as he was having more difficulties than he could cope with just then. And Paul Guillaume was apparently in no hurry to buy any more of Modigliani's pictures.

'Leave it to me, Beatrice,' Modigliani promised. 'You shall

be the most beautiful woman at the ball, and everyone will be green with envy.'

Some of the women in the Montparnasse cafés had already complimented Beatrice on a dress of black faille which she wore with the air of a duchess. She had received these compliments only the month before and the gown was still as fashionable as ever, but to Beatrice it was already an old dress. She could not think of wearing it to an evening party. Yet she had nothing else except a tailored suit.

'I am not going to the ball,' she answered Modigliani from the bed. 'You know very well that I have nothing to wear.'

'Didn't you hear what I said? I told you that you would be the most beautiful woman there. I'll show you. Now get up.'

'No.'

Modigliani rushed at her, and Beatrice thought he was going to beat her. It would not have been the first time. He would have had the advantage of her at the beginning, but she was ready to fight back as she had done so often before. However, once she was dragged out of bed, her lover was not as rough with her as usual, and she asked: 'What are you trying to do?'

'Get dressed,' he ordered. 'Put on your black faille dress.'

'But — '

'Do as I tell you.'

More out of curiosity than obedience, Beatrice obeyed. As soon as she had completed her toilet, she came and stood before her imperious lover as if she were a mannequin from some fashionable dressmaking establishment.

He looked her over from head to toe, remembering how he had held her in his arms all night long and dragged her naked out of bed a few minutes ago. Then, fetching his box of pastel crayons, he first took out a piece of white crayon and sketched an arabesque design on the dress to give it the appearance of being décolleté at the line where her breasts curved beneath it. Next he applied all the other colours, embroidering the

entire surface in pastel from top to bottom. He improvised as he went along, and the painter of nudes became a painter of magnificent flowers on the spur of the moment. It was a miracle of inspiration as well as love.

Submissively holding herself as still as a fashion model, Beatrice watched her gifted lover in amazement and delight, while Modigliani covered the dark material with a myriad assorted flowers, and, feeling her firm flesh under the tight gown, he began to breathe heavily with renewed desire. Stooping a little, his burning hand traced on her abdomen a brilliant bouquet which flamed up as far as her small, shapely breasts. He ran the pattern rapidly over her hips, knelt down as if in prayer, gripped her below the knees with his free arm, and finished the design in a foaming display where the skirt swirled around her legs.

'Don't move yet,' he cautioned her.

Finally he stood up again and contemplated his floral master-piece and Beatrice with satisfaction — a satisfaction which remained unshaken when Beatrice, breaking her docile pose, suddenly burst out laughing for some reason which he could not in the least understand.

His hands still stained from the coloured crayons, Modig-liani took up his tin sprayer and covered the dazzling decoration with fixative. 'You can laugh all you like, now,' he said good-humouredly. 'And you can move about a little, but not too much. Only don't you dare to sit down before the liquid is dry. After that, you can take off your dress and cut the neck low with your scissors where I have drawn that white line. Mind your arms, for God's sake! You're just about to smear the rose on your right thigh. There: that's the way. Now, take it off and start cutting. I'll go and see if I can borrow a few francs from a friend so that we can have something to eat at the buffet tonight.'

The ball was a great success. An Italian model did wonders with an accordion, accompanied on an upright piano by a

Modigliani: A Memoir

Slovak pianist who played in the silent cinema. Many of the women had on most attractive dresses, and some of them had even managed to produce elegant shoes. Several artists home on leave from the Front were in uniform, and before the festivities began, M. Libion, proprietor of the Rotonde, had been kind enough to buy a sketch from his petulant customer, Modigliani.

Beatrice and Modigliani made their entrance at the height of the evening. If they did not receive an ovation, it was only because the more astute among the assembled company were aware that any applause might have offended Modigliani and would not have pleased Beatrice either. Everyone seemed to realize that a brief, if cautious, silence would be more suitable, and in fact nothing could have been more flattering to Mrs Hastings, the poetess and perfect lady. The moment of homage over, Beatrice was invited to dance, and to her credit it must be said that she danced well. Modigliani strolled off to the buffet-bar with several friends. Everyone had the impression that he was drinking less these days.

In her painted dress, set off by her graceful bearing, Beatrice was the belle of the ball. Soon she was dancing continually, and she was so imprudent as to flirt discreetly with a tall, blond Scandinavian sculptor, now an officer in the Garde Royale. Led on by Beatrice's coquetry, the sculptor pressed her more closely to him in the intricate steps of the tango. Even so, nothing untoward would have occurred if some onlooker had not made several impertinent remarks which the hypersensitive Modigliani could not fail to overhear. He did not dance himself, but he was quite willing for Beatrice to enjoy herself, and it is probable that he would never have rushed in among the dancers in a fit of rage had not these comments roused him from the day-dreams which he usually preferred to conversation.

The amiable Modigliani of a few minutes before was instantly transformed into a raving maniac, bent on breaking up

the dance and attacking the blond Scandinavian, and it was only Fujita's prompt intervention that saved the situation. The thought of one of the Japanese's ju-jutsu holds was enough to calm Modigliani. Nevertheless, he had to find some outlet for his rage and mortification, and the only recourse left to him was to give Beatrice a good beating. But he could not do such a thing in public. Besides, if he did, Fujita would intervene, and he did not care to have a row with Fujita. He made Beatrice leave the party without more ado, and once outside in the street he gave full rein to his temper. Beatrice escaped from him somehow and ran off, shrieking with terror.

'Ritornerò domani!' he shouted after her. 'I'll be back tomorrow.' But he was too befuddled to pursue her as she fled into the night, holding up the ends of her painted skirt in both hands.

Come back he did, but not until late the next day. No one knew where or how far he had wandered after his preposterous conduct at the ball. There is no telling, either, whether Beatrice regretted taking him back. Their relations were no worse than they had been, but they can hardly have been improved. The neighbours around his dismal studio and those within earshot of Beatrice's more elegant lodgings shook their heads. No one was surprised any longer by the couple's conjugal wrangling. Whenever they became unduly noisy, someone was apt to say, 'The Italian's drunk again,' or 'Now the Englishwoman's having a go.' And to keep the neighbours from becoming too apathetic, the lady poet would cry out from time to time: 'Help! He's murdering me!'

There are those who have reported that for two days and nights after the ball Montparnasse was treated to the spectacle of the disorderly pair shuttling back and forth from Rosalie's to the Dôme and then to the Rotonde, Beatrice still wearing her magnificent torn gown. Even with bare shoulders, she was so proud of the remnants of the painted flowers that she could not be persuaded to put on her old tailored suit again.

Modigliani: A Memoir

The long-awaited cheque arrived only after the last rose had faded.

The artist Henry Hayden, one of the outstanding exponents of Cubism, has thrown a little light on an incident that occurred shortly afterwards. Chancing to go up to the Butte to see a friend one night, he witnessed a shocking scene. It appears that after Beatrice had finally run away from him, Modigliani hunted high and low for her, questioned everyone, left no stone unturned, and at last, as though guided by some occult power, succeeded in discovering her hide-out. Beatrice refused to let him in. Flailing about him in a savage state of drunkenness, he beat upon the door and tried to wreck the shutters behind which his mistress had barred herself. Then, weakened and confused by alcohol and drugs, he gave up the attack and instead, losing what self-control he still possessed, he howled: 'Money! Money! At least give me some money to get drunk with!' Beatrice ignored him.

It was a sordid story — as sordid as their affair had been. Nevertheless, all honour to Beatrice if under her fantastic spell Modigliani was inspired to take up his brush again and launch forth into the period of activity which marked the beginning of his finest work. His pictures now were of such high quality that Zadkine, his companion in poverty in their darkest days, was prompted to say of him afterwards: 'He entered the forest of painting, and beat a private pathway through it.'

Perverse angel and far-seeing demon by turns, Beatrice realized that the time had come for her tempestuous lover to go his way and fulfil his real destiny, which was that of a creative artist. And she bade him farewell in a few cold, simple words, well calculated to revive his wavering flame: 'Paint, my dear boy, paint. After all, you're a painter, aren't you?' After that she returned to England. Montparnasse never heard of her again.

4 *The New Love*

FROM now on Modigliani was to paint steadily to the end of his life. Beatrice Hastings, who had made his existence both a heaven and a hell, had literally ordered him to paint. Yet it may be that at the same time he heard another voice speaking to him, a terrifying and urgent voice: the voice of death, whispering that he was already coughing and spitting blood, and that his days were numbered.

Nevertheless, although he now returned to his painting, Modigliani continued to sketch and draw in public as much as ever. One night, after he had been more riotous than usual, he was marched off to the police-station in the Rue de la Gaîté, and as he sat on a bench alongside a petty thief and a gipsy caravan-driver who were waiting to be questioned, he opened the sketch-book he always carried, took a pencil from the pocket of his corduroy jacket, and quickly made a drawing of a young policeman standing near with a bicycle. When it was finished the picture looked like some sort of Saint George in a messenger-boy's cap. Everyone gathered around to admire it.

'Are you going to give it to him as a present?' asked the police-sergeant, looking up from his pile of official papers.

But when it was offered, the subject of the portrait was distinctly cool. 'What the devil would I want with it?' he growled. 'The mirror's good enough for me.'

No one can say to what extent an incident which occurred in Modigliani's life about this time affected him. Perhaps he was able to throw it *dopo le spalle*, as he himself would have said, but it might well have overwhelmed another personality.

To explain it we must return for a moment to that Thérèse, sometimes known as Suzanne or even Germaine, with whom Modigliani had had an affair before he encountered Beatrice.

It may be remembered that she had often declared openly that she aspired to have a child by a 'great man', and while she was not necessarily fitted for such a role or her acquaintance among the 'great' extensive enough to enable her to play it, she made a number of attempts with those she considered likely candidates. After meeting Modigliani, she was convinced that he belonged to the potentially great and was well on his way to fame, and from then on he became the chief object of her pursuit. As a model, she was perfectly entitled to frequent Montparnasse, and she was constantly preoccupied with the problem of what Modigliani did when alone, when she might be able to find him alone, and how far she could take advantage of his weaknesses.

Nothing very positive has ever been learned about the end of this relationship, and we can only conjecture what actually took place. All that was known of it was through conversations overheard in different cafés and bits of gossip exchanged between Thérèse's women friends. The lying-in hospital was no great distance from the main artist centre, and as soon as they had heard the news from the women, the men lost no time in spreading it around.

'Did you know that Thérèse was in the lying-in hospital? She's just had a baby.'

'You know it all, don't you?'

'Who's the kid's father?'

'Modi, of course. Who else? She's been trying long enough.'

'That's no explanation.'

'You sound like Modi himself.'

'What does he say about it?'

'Not a word to us, but he went for Thérèse all right when she told him she was pregnant.'

'By him?'

'Naturally; otherwise he wouldn't have cared.'

'I suppose he didn't want to hear a word about it.'

'Exactly.'

'He may have had perfectly good reasons for believing that he was not responsible.'

'Possibly, though as far as I am concerned he hasn't.'

'What makes you say that?'

'Everyone knows that Thérèse used to go after Modi. When a man's drunk, after all ... '

'So you think — ?'

'I don't mean that that's the reason Modi threw the poor girl out with her doll still in the top drawer.'

'What's your theory, then?'

'I'd say you'd have to consider the matter from another angle. What could a man like Modi do with a kid, let alone the mother, who's a pest like all women with crazy ideas?'

'Would you have done what Modi did?'

'Don't ask me. I've never been in that kind of fix.'

'But suppose you were?'

'An accident is an accident. You could write a book on the dirty tricks fate plays.'

Thérèse continued to insist that her child was Modigliani's son and seemed haunted by his cruel words 'Come back and see me when you've given birth to a stone', but no one knows the truth. The mother disappeared and the child with her, although it has since been reported that he was adopted by some kindly people. If he has survived, one wonders what he is like today.

Modigliani had first been encouraged to go to Paris by the eloquence of his friends Soffici and Papini that day of their decisive meeting in Venice. Once he arrived in the French capital, he had lived for a while in the centre of the city, with a permanent 'museum of modern art', so to speak, at his very door, and, as we have seen, it was Picasso who had urged him to go up to Montmartre. Yet Picasso had joined with the others in making him realize eventually how futile his life was on

the Butte, where he was degrading himself in the bibulous company of Utrillo without developing his talent and personality in any way. Many painters and writers lived and worked seriously up on the Butte — all of them young men with a sense of irony which helped to preserve their faith in art and their own stoic optimism; but Modigliani, although he had rare qualities, conspicuously lacked this sense of irony. He did not possess the saving grace of humour, which is an excellent defence if used prudently. He quit Montmartre to go and try his luck in Montparnasse because that was the place for new ideas. Those of his friends in Montmartre who urged him to go there were men who had already found themselves, and if it be asked whether they were wise in advising him to move to Montparnasse the answer is that they were, for the quarter was just beginning to be invaded by young people of all types and nationalities, and though his genius was to assert itself slowly and in tragic solitude, Modigliani was nevertheless a man whose mind and heart required him to make contact with society and to antagonize it, even at the risk of being hurt or broken in return.

By now Modigliani, the deserted lover, the alleged father of a child, was no longer an unknown artist. His work was selling a little, which should have enabled him to live better, but instead he went on living just as wretchedly as before. Solicitous souls who never want to help anyone often speak with shamefaced pity of those unfortunates who are 'beyond help'. Such a way of speaking is uncharitable, but not inaccurate. Romanticism has frequently fed upon realism, but Modigliani kept his alive on wine, absinthe, rum, drugs, orgies of delirium, and also by the aid of Zborowski, his picture-dealer friend, the would-be businessman-poet who devoted his days to art and his nights to poker.

Despite this, his art was growing more powerful and harmonious all the time, and as a painter he now began to achieve the fulfilment of all that for which his sculptures and

countless drawings had been the preparation. He had at last found the style he had been seeking, and, though he had done relatively little painting so far, he was proving that he had a manner and style that were emphatically his own. He had learned to deal with colour in the same way that he had, as a sculptor, learned to carve direct in stone. Clay, he always insisted, was simply mud; a palette too was only a heap of mud, unless the artist considered how much paint it was necessary to take on his brush as part of the form he was creating.

During this phase, Modigliani painted 'The Fat Child', which on closer inspection turns out to be a study of a beautiful young woman. Then he did the mysterious 'Madame Pompadour', which might be a likeness of Beatrice. The long neck which was to characterize so many of his female portraits here makes its appearance, and a hat of the period faintly shadows the fine forehead. There is a hint of caricature in the picture: passion does not stifle wit, and the only wit Modigliani lacked was that of the spoken word. He could not translate his visual perceptions into words. He got his friend Kisling to pose for him, in Kisling's own studio, and he did both a drawing and a painting of him. He also painted a portrait of Paul Guillaume, who had begun to take such a kindly interest in him. The picture is a shrewd psychological interpretation of this man who ended by shooting himself. Next came the 'Girl with Plaits', a number of superb nudes, and the 'Bride and Groom', in which caricature is again in evidence, though worked out in a different way. After that came the excellent portraits of Zborowski, Jean Cocteau, and a certain Marguerite.

Modigliani invented new forms especially suited to his personal mode of expression, and he did so with the same skill and simplicity with which he prepared his palette, knowing by instinct two essential things, two truths which are too often disregarded. One is that harmony has its own laws, which, though strict, allow infinite variations. The other is that what is called inspiration — everything, in short, that

constitutes that lyricism whose virtuosity is circumscribed only by underlying good taste — does the rest.

So far as his artistic technique was concerned, Modigliani learned that thoroughly; he had mastered it while still a boy. Everyone goes to art school in his own way, although it should not be taken too seriously. It is better to steal a few blocks of stone ...

In actual fact Modigliani did not 'invent' anything radically new. He was of his time, and it would have been strange if he had not been. On closer scrutiny his nudes and portraits reveal many traits in common with the general run of the art of that period, and that is a sign of his profound humanity. Originality is a virtue only when new use is made of the eternal verities, controlled and imbued with the feeling and spirit of the time.

Modigliani also owed something to Negro art, which at first he did not care for, preferring rather to go back to the Etruscans. But for all his wide artistic culture, he remained firmly wedded to popular taste. He would never make use of the type of model favoured by certain art schools and studios until he had first seen the counterpart among the anonymous Parisian crowds.

All his real, most important work was produced between 1914 and 1920, and within these six years he succeeded in developing his own style and method, creating something so individual as to be inimitable. He never used stock models. Consequently the paintings he did of women could not possibly have been signed by any other hand than his. He deliberately avoided anything approaching a female type which could be used over and over again and debased in all the second-rate art schools. Whether he chose an anonymous model, Rosalie's kitchen-maid, or Zborowski's servant, whether he was painting the concierge's daughter or Paul Guillaume, Modigliani's own personality never failed to dominate.

A somewhat tragic note discernible in his work caused some

of his admirers to label him 'The Painter of Sorrows', and it is undeniable that his direct portrayal with its realistic and sensual overtones has something deeply religious about it, although I should prefer to call him 'The Painter of Purification'. The passionate devotee of Dante dreamed always of a new life, a *vita nuova*, and in that sense he was indeed a revolutionary. He painted with a heavy impasto, using colour lavishly and heightening the colour range that Renoir used in his last years; yet from that thick, vivid *matière* which looks as fresh as if it had just been put on the canvas emerges an astonishing spiritual quality.

Modigliani was now working conscientiously every day. Step by step, as one fine canvas followed another, he was building his stairway to fame, and it was while he was occupied with this achievement that another love came into his life: a young woman by the name of Jeanne Hébuterne.

IT was at the Rotonde that Modigliani spoke to Jeanne for the first time. She had originally attracted his attention as she was sitting quietly on her stool in the sketching class at an art school in the Rue de la Grande Chaumière where he went occasionally because he could sketch in the life class at little cost. That day at the Rotonde she was also sitting quietly on a stool, but it was one of those high seats at the bar and she was sipping an innocent little drink.

Jeanne was the most modest of young girls. She had only recently begun going to the Rotonde, with several friends, after her drawing class at the Grande Chaumière school, where she had acquired the nickname Noix de Coco (Coconut) on account of her oval little head and her light brown hair. Her family was said to be highly respected by the priests of the parish of Saint-Médard. Her brother was an artist, who is still considered a competent landscape-painter and exhibits his work at the Salon d'Automne. Jeanne herself had been one of those children whose parents thought she had 'talent', and, doubtless after due discussion with the curé, it was decided that she was to spend her time preparing for the entrance examinations of the École des Beaux-Arts by studying drawing first at one of the art schools in Montparnasse. Her elder brother, who had never been seen at either the Dôme or the Rotonde, assured his parents that the behaviour of the students at the school in the Rue de la Grande Chaumière was far more seemly than at the great school in the Rue Bonaparte. The former were not given to vicious pranks or roistering or any of those student escapades which could sometimes lead to dangerous incidents. Afterwards, perhaps, if she did not go on to the Beaux-Arts, she could work in one of the shops in the Rue Saint-Sulpice which specialized in prints and paintings of

a religious character, touching up edifying pictures and restoring a wide variety of piously sentimental decorations.

Jeanne had entered the school in the Rue de la Grande Chaumière because students were admitted without having to take an examination: a regular subscription, instead, gave one the right to draw from a live model and to receive a few sketchy lessons and criticisms from a professional artist.

When she first started her course Jeanne felt as timid as she had in the early days of her ordinary schooling, but she quickly found a seat next to a girl of her own age with whom she soon made friends. Her fellow student had already been there several months and had acquired the nickname of Haricot Rouge (Kidney Bean), a humorous tribute to the magnificent mahogany-coloured chignon, arranged in coils worthy of the Second Empire, which dominated her intelligent feline head. Incidentally, certain commentators writing of this period in Montparnasse have had a tendency to confuse Haricot Rouge with Noix de Coco, owing to the unreliability of oral tradition. The error is trifling, but it is worth mentioning if only for the sake of accuracy.

Haricot Rouge was preparing herself for a career as a porcelain-painter, and it was a perfectly innocent impulse which caused her to take Noix de Coco to the Rotonde, however brief the happiness or fatal the disaster that Jeanne was to experience in consequence. Haricot Rouge was sensible and careful in her conduct, but she was not averse to spending an hour or so at the café: there was little conversation in the studio class, whereas in the bistrot the artists would talk endlessly and she was likely to hear a good deal of discussion about the craft she was learning.

Jeanne was shy about talking with anyone at the Rotonde except Haricot Rouge, but she was liked and treated respectfully by everyone. As a student of life as well as art, her opinions on the subject of both were intelligent but modest. The models and the other easy-going girls were always friendly

and considerate towards her. Only at the Grande Chaumière school did anyone take the liberty of calling her Noix de Coco. The models and the other girls addressed her as Mademoiselle while many of the men who were her fellow-students called her Hébuterne as if speaking to a male comrade.

On one occasion when the group Jeanne was with were discussing plans for an excursion the following Sunday, Jeanne said that she would not be able to join the party as she had to go to Mass.

'Bravo!' exclaimed the mistress of one of the artists present.

'Do *you* feel like going to Mass?' retorted another girl. 'You surprise me.'

'I wasn't speaking for myself. It was because of Mademoiselle I said bravo. She's not ashamed to say out loud in front of all you good-for-nothing unbelievers that on Sunday there's nothing else but Mass for her.'

It was in this setting that Modigliani first noticed Jeanne Hébuterne and was attracted by the clear-cut charm of the little mademoiselle who was dressed so plainly and whose hair hung down in two thick plaits over her narrow chest. Fujita was there that evening and several other artists, all listening to the Jewish dealer, Adolphe Basler, holding forth in his strong Polish accent.

Each time Basler turned up at the café his demeanour was carefully observed. If he had succeeded in palming off even a small canvas or a scrap of drawing on a richer competitor, he would lift his head proudly, hold his umbrella in front of him, and wear his bowler thrust well back. Otherwise the bowler would be over one eye and he would carry the umbrella behind his back.

That evening he was at his best. Only Fujita and Modigliani were not listening to him, and from time to time both artists found themselves gazing at the young girl who listened so quietly to Basler's discourse. Modigliani was not usually ill at ease with women, but now, as in his first serious encounter

with Beatrice Hastings, an unaccountable shyness overcame him. The fact that Fujita, uninhibited by any such feelings, found it perfectly easy to converse with Noix de Coco aroused his jealousy, and when later he detected what he believed to be a smile of complicity between the two, he was enraged.

It would not be fair to suspect Jeanne of vulgar coquetry; she was not that kind of girl, any more than Fujita was one to go in for seduction. Jeanne and Fujita might have been smiling at each other or they might simply have happened to be smiling at the same moment, but whatever the case, it roused Modigliani's antagonism. He was so provoked by it that, even while realizing the stupidity of his attitude, he had an impulse to pick a quarrel with his friend.

He was also beset by another emotion just as harassing as the first, for if he were to do anything so preposterous as to attack Fujita for no apparent reason, he might suffer the humiliation of being subdued in an instant by a mere ju-jutsu twist of the wrist. Conscious of his own folly, he thought it wiser to leave without delay; to escape into the night in an effort to flee from what must surely be the torment of nascent love.

The next day Modigliani saw Jeanne again at the school in the Rue de la Grande Chaumière. He had gone there for that purpose. It was love — there was no mistake about it. He was learning to love. He was in love already.

While he was at the school Modigliani could no longer take any interest in his work, which was now no more than a pretext for going there. Instead he feasted his eyes on Jeanne, like a man obsessed by the charm of one whom he is not sure of possessing body and soul. He could not even be confident that he would win from her the glance that alone had power to turn his uncontrolled rages into gentleness; but it was sheer

delight for him to watch Noix de Coco working away so earnestly at her drawing. Pencil in hand, Jeanne applied herself to her task, well aware of the difficulties involved. Each retouching she made constituted a correction or alteration: *repentir*, artists termed it. She always gave vent to her impatience with herself in such a charming way, rubbing out the error with the tip of her rubber as gently as though she were using the tip of her tongue, and then sketching in other lines with infinite care.

One day, in a few gentle, hesitant words, Modigliani brought himself to tell her of his feelings. She lowered her eyes in modesty, no doubt. But it was more than that: she was surrendering to a dream of young love and she did not dare look up for fear of seeing what might be only an illusion. Perhaps this demon of a Modi was teasing her, or merely fooling her. It had not entered her head before to think of him romantically; nevertheless, the idea that he might really love her and wish to tell her so filled her with happiness.

But he was a drinker. He was said to be a trifle mad. He lived a disorderly life. And yet, if he was in love with her? Did not love have a special power and influence of its own?

Jeanne knew little about life. Her knowledge of the world was limited to what she had learned at the art school and in the few evenings she had spent at the Rotonde with Haricot Rouge, and that could hardly be considered an initiation into all the secrets of Montparnasse. It was Modigliani who gave her a deeper understanding of things. Whether or not he knew what hell was, he had confessed his love; and love was the road to heaven.

Now that Modigliani had spoken, Jeanne no longer wished to go to the Rotonde as usual. On leaving the school, she arranged her sheets of drawing-paper neatly in her green-and-black marbled portfolio with its black laces and walked quickly along the boulevard. It was a matter of great moment to her to have made an appointment with Modigliani for the

next day. She was astonished at herself for having dared to accept it. She went straight home to her family, who lived in the Rue de la Montagne-Sainte-Geneviève.

Several weeks at the art school and the Rotonde had not changed Jeanne's habits to any extent. She could be trusted under any and all circumstances. She continued to do her hair in plaits like a little girl, and no one, not even those who had nicknamed her Noix de Coco, had yet informed her that she resembled one of St Ursula's own virgins. She was quite satisfied to wear clothes which a well-dressed working-girl would have been ashamed of, and she also wore flat-heeled shoes. She wore neither powder nor lipstick, and it was in her simple, unadorned state that Modilgiani found her beautiful and desirable.

When Jeanne reached home, she had just time to remove her hat and cape and put her portfolio in the corner of her room before going down to dinner. Her father said grace. Noix de Coco said her own prayers before going to bed as usual, but no one will ever know whether she felt guilty about her love, or whether she asked God to bestow his blessing upon it.

That evening Modigliani did not drink, and the next day the redoubtable Modi waited for her in the state of mind typical of every young man hurrying to his first romantic rendezvous.

It would be impertinent to guess at what precise moment Jeanne gave herself to Modigliani's waiting arms. We know only that the day came when the daughter of the pious parishioners of Saint-Médard, this virgin who resembled the Virgins of the Rhenish Primitives, gave herself to the smouldering-eyed Italian, the handsome Jew from Leghorn, as though she were surrendering to some archangel in human form who had gazed upon the daughters of men and found them fair.

The two young people resolved to join their destinies for

better or for worse, and all Montparnasse was astounded and filled with misgiving, although it would be necessary to wait until the pair had set up house together before coming to any definite conclusions. Besides, Jeanne could not break with her family immediately, and Modigliani — Modigliani was spitting blood.

ONE morning Modigliani undertook to paint a nude on one
of the doors of the dining-room in Zborowski's house in the
Rue Joseph Bara. Mme Zborowska, who valued the young
man's art as much as her husband did, watched with mixed
feelings. There was a conflict on her mind between the picture-
dealer's wife on the one hand and the society woman on the
other. Were nudes, particularly Modigliani's nudes, altogether
suitable for a dining-room? Mme Zborowska was not un-
appreciative, but she had her doubts. Modigliani finally
stopped working and coughed up some blood. He had come to
regard this as casually as if he had a crumb lodged in his throat.

It was lunch time. The artist sat down at table with his
hosts. It was only a cold meal, but it was something. Having
succoured Modigliani to this extent, Zborowski launched forth
into a long conversation. He spoke as if prompted by a sudden
inspiration, but in reality he was airing a matter which had
been on his mind for some time.

'I have been thinking,' he announced to his wife, 'of going
to the Midi with you and Modigliani. Soutine and Fujita are
coming too.'

'It will do us all good,' assented Mme Zborowska, still eye-
ing the nude painted on the dining-room door.

'While it is true,' Zborowski observed, 'that Soutine and
Fujita are in the best of health, they will feel even better after
I have sold their pictures to that rich crowd down on the Côte
d'Azur. I have already made my plans.'

'I have every confidence in you, Léopold,' said Mme
Zborowska.

By a rare stroke of good luck Zborowski had not only sold a
canvas at a fair profit recently, but he had, despite his reckless-
ness, also won at poker the previous evening. He calculated

that after the railway tickets (one way only) had been paid for, he would have enough to keep his group and himself for at least a week. A Polish dreamer like Zborowski never needed more security than that, to enable him to believe that he was a capitalist.

Ahead of them were Nice, Cannes, the whole Riviera, the refuge of princes, of artists like Renoir at Cagnes, Matisse and Friesz at Cassis, Signac at Saint-Tropez. It never entered the head of the insouciant Zborowski that Renoir, Matisse and the rest had gone to the south of France to paint and not to sell their work, to seek motifs rather than collectors or buyers.

Zborowski was undaunted by such considerations. His life as a hard-headed businessman was in fact pure fantasy. His idea of big business was something which only a poker-player could dream of transacting. The poet art-dealer was determined to console himself for a setback he had suffered not long ago, a setback which had left Modigliani quite unmoved although it touched him closely.

In an effort to try and interest the general public in Modigliani's work, Zborowski had arranged an exhibition of his nudes at Berthe Weill's gallery in the Rue Laffitte. He had persuaded her to put in her front window two unusually beautiful nudes by Modigliani, the kind of nudes which would have delighted Théophile Gautier, who had sung the praises of Venus and her sacred mount. The purpose of the display was to catch the eye of the passing crowd. Unfortunately for Berthe, the first person to be attracted hurried off to complain about it to the nearest chief of police, and that august official's reaction was prompt and drastic. He issued an indignant order to remove without delay the two examples of an 'intolerable offence to public morals'. As a result, no one except a few painters from Montparnasse and the Butte had a chance to see the first exhibition of Modigliani's work.

The Warm South

IN 1918 Léopold Zborowski set off for the Riviera, accompanied by his three favourite artists — the Italian Modigliani, the Russian Soutine, and the Japanese Fujita. Soutine seemed keenest about the trip. Though he gave no indication in advance of how he felt, he was looking forward to the prospect of seeing the sea for the first time in his life. Moreover, he was sure that his friend and representative could not help but sell the best modern painting — his — to all the rich people living in expensive hotels or in villas purchased from insolvent Russian princes. Soutine expected sales. It should be remembered that he had once said to Modigliani: 'If I weren't certain of making a fortune out of my painting, I'd drop it immediately and go in for boxing.'

For his part, Modigliani was not at all unhappy to think that he would be near Italy again. Since he had been rejected by the Foreign Legion he had got into a singular frame of mind, which may have been due to the direct effect of the long war on his drug-racked nerves, thereby increasing his pacifism, or else to the fact that his tortured nerves were being affected by the German shells which were beginning to fall on Paris a little too regularly.

As for Fujita, he was not averse to a change of air, either. He was practically a recluse in the Rue Delambre, where he had turned into a studio the working-man's house he had taken. During the war he had been unable to sell anything for months except a patriotic drawing which had been published in Léon Bailby's *L'Intransigeant*, and a small carved box which he had lacquered and gilded and sold to the collector Jacques Doucet, who bought it for twenty francs to prove to himself that he had a heart, after turning down thirty or more of Fujita's canvases.

Modigliani: A Memoir

After talking at great length to the three painters about the campaign he planned to carry out on the Riviera, Zborowski appeared one evening at the Rotonde, where he had made an appointment to meet them. He jubilantly waved five pieces of printed cardboard at them as he entered the door, and called out 'Here are the tickets!'

He was actually more pleased that he had been able to pay the fares than he would have been if the railway company had given them to him as a present.

The tickets he continued to wave so gleefully looked at a distance like miniature playing cards. For Zbo they represented trump cards and the chance of a wild game of poker.

When the little party arrived at the station they went on to the platform and got into their train just as the guards were shouting 'All aboard!' Suddenly it was discovered that Modigliani was missing. Reassuring the woebegone Zborowski, Soutine had the presence of mind to rush out to the refreshment-room, where he found the young Italian in a state of excitement because he wanted to know whether the train had a dining-car so that he could be sure of getting a drink between meals. Soutine hauled him back to their coach in the nick of time. Mme Zborowska had brought along a flask filled with hot coffee from the Rotonde, but Modigliani would have none of it. Fortunately Zborowski had thought of putting a small bottle of alcohol in his bag, and to that Modigliani did full justice.

It is to Fujita that we are indebted for some of the more imaginative details of their stay on the Riviera. Reminiscing about it years later, he gave me the following account:

'Zborowski and Mme Zborowska, Modigliani, Soutine, and I, left together for Cagnes-sur-Mer, where the great Renoir was living. It was just a year before his death. The Zborowskis and I stayed in a villa belonging to Papa Curel. Have you ever heard of Papa Curel? The painters of the previous generation

must have known him well. He was an amateur trumpet-player, and he played his instrument all the time. He made a reputation for himself with the artists of his day, not because he played his trumpet so loudly but because he was a great friend of the noted Meissonnier. At any rate Papa Curel lived in Cagnes with a woman named Mlle Rose. Their villa was situated at the top of the hill in old Cagnes. As Curel's trumpet would have annoyed Soutine, he was given a room in another house, and Modigliani was installed in a place at the back of one of the valleys flanking the town.'

At this point we must refer to the painter, Osterlind, whose house it was that Modigliani stayed in.

'He came round to see me one day in my garden at Cagnes,' Osterlind said. 'He had the distinguished face of an Italian prince, but he was tired and dirty, looking as if he had been unloading cargo boats in the port of Genoa. With him was the poet Zborowski. As I was only too glad to do him a favour, I gave Modigliani the best room in the house. It was white and clean, but he didn't sleep much in it. He spent his nights coughing, drinking, and spitting on the walls as high as he could aim while he watched the saliva run down. He painted some quite fine things in that room, notably a portrait of a woman. He also did a few drawings.

'Zborowski supplied him with paints and canvases and just the right amount of alcohol, which seemed indispensable in view of the mental state the poor boy was in. Zborowski kept hoping that Modigliani would not go down to the village and make the rounds of the cafés, where he had seen a poster he much admired advertising Pernod. It represented a bottle and two glasses set against a dark background, and he never tired of singing its praises. "No one," he would say, "has ever painted anything more beautiful than that." '

Osterlind did well to note that detail, for Modigliani was right about the poster. He was not judging the still life from the point of view of a perpetual drunk, but from

that of a conscious artist. It should be added, in passing, that Derain also had a high opinion of the anonymous masterpiece.

'My house was not far away from the Renoir property, which was covered with olive trees and rose-bushes,' Osterlind continued. 'The place stirred Modigliani's imagination and he wanted very much to meet the Master. One day on returning from the village, where he had evidently spent quite a while admiring the Pernod poster again, he asked me to take him to see Renoir.'

Although the Master was in failing health, he consented to receive the young Amedeo. He knew nothing about his work, of course, not being much inclined at his age to keep up with what was being produced by the new generation. Moreover, he was not really interested in the work of a total stranger from Montparnasse. Renoir was seventy-seven, and years of arthritic rheumatism are a double affliction for a painter. He was racked with pain. Nevertheless, he made an effort to give Modigliani a courteous welcome. He was probably gratified to receive homage from the young, and for someone to wish to meet him was a form of homage.

On the appointed day Osterlind took Modigliani and Zborowski to Renoir's house and introduced them to the illustrious old man. They were shown into the dining-room, where he was sitting quietly after the day's work in his outdoor studio. He had been brought back to the house in his wheel chair, which the maid pushed about for him.

Even as late as 1918 the war had made little impact on the drowsy town of Cagnes. The brutal conflict had not worried Renoir very much, except for his anxiety over his two eldest sons, who had both been wounded. Now, adjusting his cap on his head, he stared curiously at Modigliani and asked: 'Are you a Florentine or a Venetian?'

'I am from Leghorn.'

'I don't know the place.'

Good friend as Zborowski was, Modigliani never confided his private opinions to him. For that reason we have no way of knowing whether the young painter found Renoir the kind of genius he would have expected from his work, or whether he proved to be a wholly different sort of personality.

Zborowski, meanwhile, was wondering whether his protégé would ever achieve a fraction of the renown which Renoir had deservedly attained. It was Zborowski's aim and ambition to launch Modigliani this time. Zbo had every confidence in both Modigliani and himself and, indulging in the most optimistic fancies, he already had visions of what he would do with the fortune he was about to make. He pictured Modigliani a wealthy man like Renoir, the owner of an equally beautiful estate, loaded with honours and acclaimed by all in his old age.

Renoir spoke again: 'So you are a painter too, young man?'

Modigliani, who had been looking at a Corot and admiring the four or five Renoirs next to it, turned to his host and replied in a low, rumbling voice which conveyed all the anguish of his dissatisfaction with his life and himself: 'Yes, I paint.'

Renoir asked the maid to take several of his canvases down from the wall so that his visitors could examine them more at their ease. Modigliani was glad of the opportunity to go over them in detail, for they were works of different periods and very beautiful. He was relieved, too, because it meant he could dispense with further conversation without being impolite. Besides, since Renoir had no need of praise from a younger artist like himself, he was not called upon to express an opinion.

Presently Renoir broke the silence by saying to Modigliani: 'You brought one of your canvases to show me, didn't you? Let me see it.'

Modigliani: A Memoir

Before Modigliani could make a move, Zborowski hurried over to get the picture on its stretcher-frame which Modigliani had put down on the floor on entering the room. More intimidated than his protégé, Zborowski held the painting out at arm's length for the older man to see. Renoir inspected it but made no comment. All he did, according to what Osterlind and Zborowski related afterwards, was to ask Modigliani: 'Do you paint with a feeling of joy?'

Then he hastened to explain his question, far more interested in his own elaborations than in Modigliani's reply: 'You should paint with joy. Paint with joy, young man. Paint with the same joy you feel when making love to a woman. You must caress your canvases, caress them for a long time. I spend days and days stroking the backsides of the nudes in my pictures before I finish them.'

On this point Osterlind had taken care to jot down in his notes: 'I had the feeling that Modigliani was so appalled by Renoir's advice that a catastrophe might occur any minute. And it did.'

In a mad desire to get away from the Master, his masterpieces and his disquisition, Modigliani rushed to the end of the room where the awed and trembling Zborowski was standing. He grasped the handle of the door and, face twitching, cried out: 'I, monsieur, do not like backsides!'

Neither Osterlind nor Zborowski has left any record of Renoir's reply.

Ill-mannered as he was, Modigliani spoke sincerely. He was revolted by the thought that mere flesh should be given so much importance, that flesh should take precedence over an ideal interpretation of it. His delightful and profound art had always a hint of the precious, in spite of his dissipated life and his shabby clothes; yet he was the last aesthete, the only one who could be placed in the first rank of the School of Paris.

Meanwhile the three artists were having their difficulties

facing: Jeanne Hébuterne

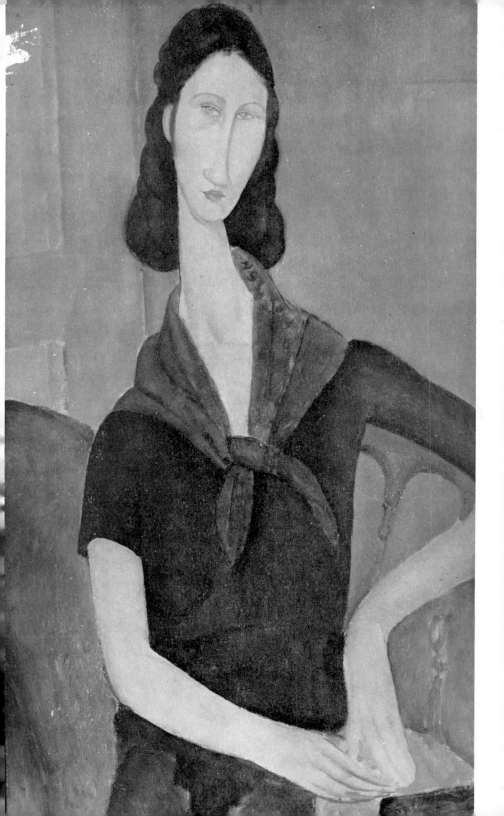

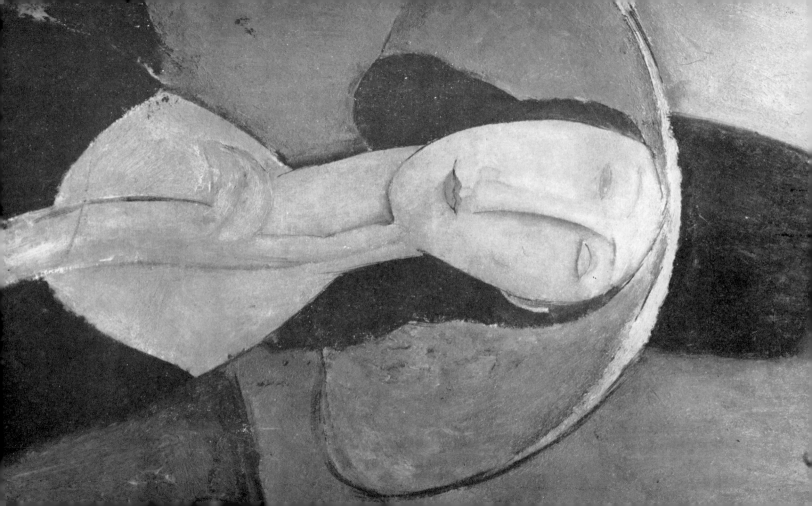

under the gracious supervision of Mme Zborowska. The problem of money had become acute. The most solvent member of the group was Fujita, who had not yet recovered from his surprise at receiving a monthly stipend of a hundred and twenty francs from Chéron, the picture-dealer in the Rue de la Boétie in Paris. Soutine had obtained a few francs from Zamaron, the extraordinary chief of police who had such a passion for modern art that he had transformed several of the grimiest offices at headquarters into a private art gallery in order to make room for his latest acquisitions. Modigliani, however, had no hope of money from any source except Zborowski, and on occasion from Osterlind, in whose house he was living.

With part of his hundred and twenty francs Fujita decided to give himself the pleasure of treating Soutine to a good scrubbing, because, as all Montparnasse well knew, his lack of personal hygiene was beyond belief. He began by presenting him with a toothbrush and a tube of toothpaste and showed him how to use them.

'Soutine had never brushed his teeth in his life,' Fujita afterwards related. 'I gave him the necessary materials and his teeth became white and glistening in no time. He was so entranced with the result that he spent the rest of the day in front of the mirror admiring his fangs, which were like those of a wild beast. And Modigliani spent the rest of the day watching Soutine gazing at himself.'

Soutine worked very little at his painting while in Cagnes, and his chief occupation was waiting for Zborowski to come back from one of his excursions in search of buyers and money. Fujita described him as waiting 'like a lizard sunning itself on a wall'. As soon as Zbo's figure appeared around the bend of the road, the 'lizard' would get down from his perch and go to meet him — though he would have done better to continue dozing where he was, for the poor poet-dealer always returned with less money in his pocket than he had

started out with, all his business negotiations having come to nothing.

The dazzling campaign Zborowski had carefully planned in Paris petered out completely. He had supposed that he would have no difficulty at all in settling Modigliani, Soutine and Fujita in Cagnes, where they would be fortified by the fresh air and could work at their leisure, while he, their representative, raced up and down, finding collectors in Nice, Cap Ferrat, Beaulieu, and even Monte Carlo. Unfortunately it did not work out quite like that.

There is no telling how many potential buyers Zborowski contacted while on the Riviera. The hotel concierges, whom he tipped lavishly and vainly, may have introduced him to a few, but they might have done more for him if he had been astute enough to let them see a few samples of the wares he had to offer first. In one instance he described his three artist-protégés in such lyrical terms to a wealthy prospect that a sale was practically a foregone conclusion. The man, a wholesale pork-butcher, was anxious to pick up a large painting for his villa near Paris, and it looked as if it might be a very lucrative deal. Fortunately Zborowski had enough humour not to propose that the meat magnate buy one of Soutine's ox-carcass pictures, and the purchaser himself came straight to the point.

'What I want,' he explained, 'is a nude.'

Zbo immediately thought of one of Modigliani's paintings.

'A large nude?' he ventured.

'Large? Well, yes. Life-size, you know. With a good figure — like a mannequin.'

'A mannequin?'

'Do you have anything like that?'

'Maybe. I'll speak to the artist.'

'Tell him I want a female nude — the kind you can see right away is a beautiful woman. Something to tickle the fancy. I'd prefer her lying face downwards, the head turned

to one side, and smiling — you know — with her bottom stick-
ing up. When could you deliver? I can wait a week, provided
it's realistically painted and would look well in a bedroom. As
to the price, for something really lively I'd be willing to go
to — '

Zborowski's heart sank. The transaction would have to fall
through. He could never mention it to Modigliani, who did
not like backsides. And it would be easy to give a long list of
of similar setbacks which the idealistic dealer encountered.

The question of funds had now become dramatically urgent.
Heaven knows how the poet art-dealer and his party managed
to live, since he never succeeded in putting through a single
deal. He was short of money, yet he kept on spending. None
of the others could fathom the mystery. It may have been that,
unknown to them, he was more accomplished as a poker-
player than as a picture-dealer. Whatever the case, Modigliani,
Soutine and Fujita adjusted themselves to the crisis with
seeming nonchalance. The worse their predicament became,
the more Mme Zborowska exercised her soothing influence
over the group with the utmost poise and tact, while Zborowski
made a few more attempts to do business and his three artists
divided their time between sketching, painting, and disporting
themselves on the beach.

It was Soutine's first contact with the sea, and he could not
have enough of it. After having shunned water all his life,
he now could not bathe too often and he delighted in plunging
into the waves and pitting his strength against them. Fujita
had been a swimmer since childhood and was a methodical and
expert athlete, but to encourage his Russian friend to learn
the sport he amiably pretended that he too was a beginner. As
for Modigliani, he so revelled in sea bathing that it seemed to
wash away all his drunkenness. It filled him with another sort
of intoxication, and the Mediterranean became for him what
Leconte de Lisle had called 'the sea which cradles in its waves
the reflections of many worlds'.

Modigliani: A Memoir

Despite his unsociable nature, Modigliani was always genuinely interested in the work of others. He was keen to learn, to know, to find out new methods, styles, conceptions. He wanted to see how other artists solved their artistic problems; how they interpreted their vision and feelings. He felt it essential to study even the most contradictory styles and techniques so that he could evolve his own *genre*, and not imitate anyone else's.

Moreover, the work of other artists stimulated him. Alcohol is not always contained in bottles, nor is hashish taken only in pill form or in pipes. Modigliani could derive stimulation from similarities and analogies, from the happy meeting of minds via the medium of form and colour. He studied other painters' work to reassure himself that he was not producing anything resembling this or that type of perfection, which his highly personal art refused to imitate.

Fujita tells how one afternoon he was working at his easel when he felt a strange presence behind him. The expression 'strange presence' was very apt, for Fujita was gifted with extra-sensory perception and he had literally 'felt' the presence of someone behind him.

'I turned round,' continued Fujita, 'and saw Modigliani a short distance away from me. He must have been standing there for about three hours, watching to see "how I begin a canvas and how I finish it". When I turned round, he said to me "Now I understand." '

Modigliani claimed to have understood, but he was careful not to tell Fujita what it was he understood ...

By now the wretched Zborowski had given up trying to find some way of recouping his finances and was beginning to despair, though he made a brave show of hiding it. For her part, Mme Zborowska had to summon all her reserves of tact and taste to keep from betraying her anxiety as she wondered bitterly how she was to cope with the daily problem of food.

It may have been a coincidence, but the fact could not be ignored that M. Curel their landlord, was not playing his trumpet so often. At the same time his friend, Mlle Rose, seemed to be becoming more and more of a shrew.

'Ah yes, indeed,' she remarked quite openly, 'you may well say that it was smart of us to let the house to these clowns and good-for-nothings. I am not saying that to offend you personally, Mme Zborowska, because you're too much of a lady to contradict me. I'm just sorry for you — from the bottom of my heart, you poor dear.'

'What is that concierge yelling about now?' demanded Soutine one day when he had just come in.

Modigliani intervened and tried to appease the irate landlady. He had become much more even-tempered now that it was obvious that they were all headed for disaster. He would even joke whenever he coughed up blood. 'Keep quiet, Soutine,' he commanded. 'You are speaking to the owner of this place.' And, addressing Mlle Rose, he inquired amiably: 'We'll straighten everything out, Madame. Would you like me to do a portrait of you?'

'Curel!' shrieked Mlle Rose, mortified. 'He's insulting me! Are you going to stand there without saying a word?'

Zborowski owed M. Curel a good deal of money, and the trumpet-player, encouraged by his mistress, was in no mood to take it lightly. Inevitably, a first-class row ensued. Fujita described the ending as follows: 'Papa Curel got an injunction to distrain on everything we had with us — trunks, suitcases, even the ropes we had tied around them because the locks were broken. But Papa Curel was a fool. He never thought of seizing our paintings. For years afterwards he ate his heart out when he heard that our pictures were beginning to be worth something. The old miser finally died of chagrin.'

Zborowski abandoned all hope of making a fortune in the Midi and serenely turned to other schemes just as fanciful. He and his troupe managed to get back to Paris somehow, and

they all seemed relieved to resume their life amid familiar surroundings. Fujita amused himself for a time by inducing Soutine to make use of one of those public bathing-establishments which serve many Parisians as a substitute for the seashore, and Modi found his Noix de Coco again.

8 *A Pair of Lovers in the Night*

THE war came to an end at last.

The night of the Armistice, however, the populace of Montparnasse had little desire to parade German guns up and down the boulevards. They danced, and thought of their soldier friends whom they would never see again.

With peace came the pursuits of peace. The war was soon forgotten. Admittedly far too many friends had died in Belgium and Alsace, at Carency and Verdun and in the hospitals, but new ones poured in from the four corners of the earth to take their place. Montparnasse began slowly to fulfil the prophecies that had been made about it. It became a world-famous international artistic and cultural centre and remained so for ten years or more.

Montparnasse also had another reason for sentimentality. Was Modigliani really showing signs of being a man like any other, with a spark of genius thrown in for good measure? Was he behaving himself at last? He had a home, he was a good 'husband', and in his fashion a good father, for Jeanne had borne him a little girl who was being cared for somewhere by Italian relatives.

As a past-mistress of sorcery, Beatrice Hastings had been able to inspire Modigliani to return to his painting. She had given him the courage and the true creative feeling for it. Now Jeanne Hébuterne, the real Beatrice for whom he had been waiting unawares all these years, watched over him and his art in all her purity of heart and gentle nature. Beatrice Hastings had revived his courage, but it was Jeanne's faith in him that gave him strength.

Thanks to Jeanne's benign influence, the artist who had hesitated for so long was at last able to fulfil himself and achieve his best work. In swift succession he produced the

portraits of Anna Zborowska, the Blonde Woman, the Sleeping Woman, the Little Girl in Blue, the Woman with a Necklace, the Woman with a Hat, the Girl in a Chemise, Elvira, Nude on a Divan, Woman with a Fan, the companion portraits of Jacques Lipchitz and his wife, Soutine, and among several others, the moving portrait of the The Artist's Wife.

Modigliani still drank, but he drank less, and if he took hashish it was only occasionally. He had a better grip on himself. He no longer made scenes in public, and even his outbursts were beginning to be forgotten.

No one is more tractable than a violent man who has calmed down. As Jeanne Hébuterne's lover, Modigliani experienced moments of tranquillity such as he had not known since he was a boy. Her loving solicitude might have given him a little real happiness in life, if his sense of realism had not forced him to look death in the face. Death was approaching rapidly, and it was perhaps in a desire to defy it that he resorted to drinking again.

Jeanne was nearly always able to pacify Modigliani, but only by sacrificing her own personality and merging it with his could she subdue him completely. It is possible that she innocently imagined she had to take him or leave him, and that if she could not cherish and admire him as he was, she ran the risk of harming him. She may have thought — and rightly — that if Modigliani were cured of his bad habits and his passions it would thwart his genius. Nevertheless the artist did try to control the worst elements of his nature in a sincere desire to please her, and to savour the undreamed-of happiness which the gentle Jeanne had brought him.

No one in Montparnasse, not even the most hard-hearted or mean-spirited, ever thought of laughing at Jeanne and Modi as they went about hand in hand, the epitome and symbol of eternal love. Gradually the pair left off associating with any but a few of their more intimate friends, such as the faithful Ortiz de Zarate, who kept jealous and discreet guard over their

singular destiny. If I say little about them here, it is because I too wish to recognize the love they bore each other by respecting their privacy.

Jeanne and Modigliani did not set up house together at first, for Jeanne was reluctant to break with her parents, who still permitted her to live at home, however distressed they might be by her behaviour. When Jeanne was away from him, Modigliani could not bear to remain alone in the studio. He took to visiting his friends more than he had done for some time. Kisling's studio was his great refuge. He also liked to go and call on Mondzain, who had a studio on the outskirts of Montparnasse. When with Mondzain, Modigliani was hardly more communicative than he was when at a café, and Mondzain's chief recollection of those visits was Modigliani's eternal habit of saying 'Sans blague!' apropos of anything and everything.

Modigliani may originally have picked up the expression from some clown in a circus. He had presumably found it amusing at first, but now he overdid it. He used the phrase either because he thought it the last word in irony or else because his mind was beginning to fail owing to his prolonged indulgence in alcohol and drugs. In the same way Baudelaire was the victim of aphasia towards the end of his life, and could never answer anything that was said to him except by the expletive 'Cré non!' ('Good God, no!'), uttered with every conceivable variation of meaning and inflection.

Fortunately Mondzain had other, more cheerful, memories of Modigliani at this time. He often saw him walking with Jeanne at nightfall near the Observatory. They usually stopped and sat down for a while, according to Mondzain 'at the foot of the Admiral Courbet monument'. He described them as 'truly romantic lovers, arm in arm and pressed close together'.

Mondzain was not quite right about the monument, which in fact commemorates Captain Garnier, who captured and explored the Mekong River region, but otherwise I have no doubt he is accurate enough, despite the fact that the lovers

had strayed far from the neighbourhood of the Dôme and the Rotonde. Mondzain apparently never asked himself what they were doing in that area, but a chance encounter one evening enabled me to clear up the mystery. They were now living together, and the monument lay on Jeanne's way to her parents' home, where she was returning for a visit, and provided a fitting point for a farewell embrace.

Modigliani could not bear her to leave him, unreasonable though it was. He had no scruples about going off on his own now and then with some of his companions, or on a drinking bout, and he did so whenever he felt like it. Yet when Jeanne wanted to go and see her parents he opposed it stubbornly. He could not understand how she could yield to a sentiment which he regarded with horror. Why should she want to visit her family? He had broken with his long ago, though he had not entirely forgotten them ... his mother ... his brother, Umberto ... Emmanuel, the socialist deputy ... But Jeanne's parents he loathed, even though he did not know them. He imagined them tyrannical, bigoted pillars of the church, whose daughter no one but he, the impassioned Modigliani, could have succeeded in stealing away from them.

Yet Jeanne wanted to see them. He did not understand why, but he was deeply in love for the first time in his life and he therefore gave in, acquiescing because of his ardent love. He had accompanied her part of the way, saying that he would not go farther than the Place de l'Observatoire — though this was not because he felt lost outside his usual haunts, for he often went far beyond them when she had left him.

As they sat there in the gathering darkness, he calculated the distance Jeanne would have to cover after leaving him; but whether she went via the Rue Saint-Jacques or up the Gobelins, for him the whole area where her family lived was enemy territory. Since he was both happy and unhappy to have given in to her, since he was deeply in love and therefore like any other young man in love, he kept delaying her

departure, holding her to him, begging her to stay a little longer, always a little longer ... He talked to her like any lover murmuring to his sweetheart the whole world over. Then Mondzain would see them clasp hands and give each other a final kiss before separating.

On the evening I saw them it was a different story. I chanced to be returning home that way when I suddenly heard a snarl suggesting a demon in torment in front of me. It came from the gentle lovers of the Place de l'Observatoire, who were walking slowly along by the high iron railing that encloses the Luxembourg Gardens. Modigliani was in one of his towering rages, choking over the vile words he was pouring out in a torrent of unjust reproaches on the silent, martyred Jeanne. He had never set eyes on her parents, but he hated them for what he imagined them to be and for supposedly trying to poison her mind against him. She was *his* beloved, however badly he treated her.

Jeanne had come from her parents' house to the café in the Latin Quarter exactly on time, just as she had promised. Being impatient, Modigliani had arrived well in advance and had passed the time in drinking. He was in an ugly mood when she appeared, quite as much from rancour and unreasonable fury as from alcohol. What might have seemed ridiculous to anyone else was to him logic itself, the irate logic of a madman surrendering to love after holding it at a distance for so many years.

The scene that followed was appalling. Just when Modigliani had such need of Jeanne's comforting hand to lead him back to the studio in Montparnasse, he seized her viciously instead and behaved as if he were some jealous husband, bent on punishing a wife whom he thought guilty of some dangerous escapade. Jeanne submitted to his brutality without a word. He seized her by the arm, his hand clenched on her fragile wrist. He dragged her along by the hair, letting go only to fling her against the iron railing of the Gardens.

Modigliani: A Memoir

I did not know what to do. It was no use my interfering with them. It would have done no good for me to go with them to their miserable home. Besides, this was certainly not their first quarrel. It was not my duty to save Jeanne. Even if it had been, from what would I be saving her? From herself? It was not in my power to reform Modigliani, whom nothing could save. There was only one thing I could do. Concealing myself in the shadow, I waited for the couple to move on a little farther and then called out: 'Modigliani! Enough of that!'

My cry of protest had its effect. Modigliani released her. She fled, yet it was not from him that she was fleeing. She was frightened by the hordes of rats which at that hour of the night emerged from the sewers and ran about under the feet of pedestrians going along that part of the Boulevard Saint-Michel. Perhaps, paradoxically, she recovered from her fear only when Modigliani caught up with her again and seized her by her long plaits. Then the two young people vanished into the night, just as Modigliani had so often vanished into the night when alone.

'Bury him like a Prince'

AFTER this ugly episode Modigliani was not seen for some time, and when he finally reappeared at the Rotonde he assumed a studiedly cold manner in order to hide his tremendous pride in announcing to his friends that Jeanne was pregnant once more. Their first child, a girl, had been born in the summer of 1919 at the Tarnier Maternity Clinic in the Rue d'Assas. The young couple had been obliged to have the child brought up away from home as there was no room for a cradle in their slovenly, comfortless studio, although the lack of facilities was not so serious as the risk that Modigliani's nervous habit of grimacing might literally have frightened her to death.

As for the second child, it was never to have a cradle, nor was its father ever to see it smiling up at him. Zarate, Modigliani's old friend and confidant, told me how the young Italian had said to him about this time: 'You know, I have only a little bit of brain left. I feel the end is near.'

Only a little bit of brain ...

He hardly ever worked now. He did not bother to read any of the favourable reviews of his latest paintings. The press had at last been won over or was in process of capitulating. Yet Zborowski was no longer in a position to do much for him and Modigliani did not dream of appealing to Paul Guillaume, who would have helped him without thinking too much about the possibility of getting a bargain.

As for Ambroise Vollard, whose dingy shop in the Rue Laffitte Modigliani had visited when he first arrived in Paris, he was a long time in making up his mind about Amedeo's talent. He was to regret it for the rest of his life, and he confessed that because of his indecision he had failed to acquire a Modigliani canvas which was being offered for a mere three

hundred francs. When later on he believed he might be able to get it for thirty thousand, he was astounded to learn that it could not be had for less than three hundred thousand. Even so, it would have proved a good investment, since today it is worth more than a million francs. After Modigliani's death, Vollard, who had a habit of starting almost every sentence with the words 'Tell me, now — ', never failed to wind up the numerous discussions we had on art with the same refrain: 'Tell me, now, that young man Modigliani — If you know of any other like him ... '

But Modigliani was unique.

Modigliani could no longer bear anyone near him except Jeanne and occasionally Zarate, who now had a studio over his.

'I ordered a supply of coal to be delivered to him every week,' Zarate told me afterwards, 'and I used to take them tins of sardines.'

Jeanne endured everything quite contentedly. She had decided long ago to dedicate her life to this young man whom she adored and revered because, in her eyes, he was handsomer, finer, purer, than any other man. She was even willing to share his last agonies.

When Ortiz de Zarate returned after an absence of eight days, during which the young couple had been left entirely on their own, and succeeded in breaking down the door with the aid of the coal-man, he found Modigliani and Jeanne lying on a bed that had the ghastly aspect of a bier. The floor of the studio and a sheet which had slipped down were spotted with oil. Empty sardine tins were scattered everywhere.

Zarate described what followed:

'I asked the concierge to bring them some broth. Then I got word to our closest friends and I called a doctor. After one look at the sick man, he said: "Get him to hospital at once."'

Zarate took him to La Charité, and it was he who heard the

dying man's lucid yet cryptic utterance: 'Before leaving for the hospital with you, I kissed my wife goodbye. We are agreed on our eternal happiness.'

'Later I understood what he meant,' Zarate said, and added: 'A hypodermic injection was to put him to sleep for ever.'

Modigliani was going to die. Nothing could save him now; neither devotion nor medical skill were of any avail. All these doctors and nurses ministering to the sick among the poor were reduced to the role of faithful attendants, preparing a master to receive with dignity the visit of a very great lady — the greatest of them all.

Although he had fought tuberculosis since his adolescence, undermined his whole constitution by alcohol and hashish, exhausted his strength by too little food, a lack of physical comforts, and the violence of his own temperament, no one to this day has said what caused Modigliani's death.

Towards the end of his life Modigliani's old friend Kisling settled at Sanary-sur-Mer in the Midi, where he died in 1956. During Kisling's last years he was attended by Dr Tony Kunstlich, who became a close friend. Dr Kunstlich could not have known Modigliani, but he knew of him, and Kisling often talked to him about the young Italian and his illness. As a psychologist as well as a very learned doctor, Dr Kunstlich was well qualified to analyse Modi's case, and he formulated the following medical opinion:

'To judge from the meagre evidence available, I am led to believe that it was an attack of cerebral meningitis of a tubercular nature that caused the death of the young painter. We are able to deal with tuberculosis effectively nowadays, thanks to recent medical discoveries, but at that time it could only be treated by rest, extra nourishment, and care in a favourable climate, such as Modigliani had had in Italy. We know the deplorable conditions in which the painter lived in Paris, and

the combination of his unwholesome lodgings, his irregular meals, his turbulent sexual life, and his addiction to alcohol and drugs, quickly destroyed the delicate balance of health which had been maintained so long as he remained with his family.

'We know that tubercular meningitis in adults is very different from the kind which spreads rapidly throughout the bodies of younger victims. Once it takes hold in an adult, it develops gradually over a period of months or even years without giving rise to any outstanding symptoms. Sometimes the only signs of tubercular encephalic disorder are headaches, visual and auditory disturbances, and, in particular, modification in the patient's character, as evidenced by extreme irritability, violent outbursts of anger, unsociability, withdrawal into the self, and so on.

'It is only in the final phase that the classic symptoms of meningitis supervene in the form of paralysis, rigidity, comatose states, and the like, all of which indicate the progress of the disease in depth and extent. It is an open question to what extent the morbid irritation of the brain played a part in Modigliani's final burst of creative activity. It is part of the great debate on the subject of Morbus et Genius.'

Whatever the answer, it was a beneficial fever that sent Modigliani to bed with Beatrice Hastings and caused him to fall in love with Jeanne Hébuterne, the two guiding stars of his life.

Illness had not destroyed his face of a fallen angel. The head that lay on a pauper's pillow at La Charité was that of an artist and an aristocrat. The sculptor Jacques Lipchitz was to say of that dead face: 'He was so handsome it is not difficult to understand why all the women were mad about him.'

The obstreperous and sometimes alarming Modigliani would never again fill the streets with his raucous cries. There would be a great silence at the Dôme and the Rotonde, in the Rue Campagne Première and the Rue de la Grande Chaumière. He had always been sparing of words, but would he really never speak again? Was it possible that he had gone to

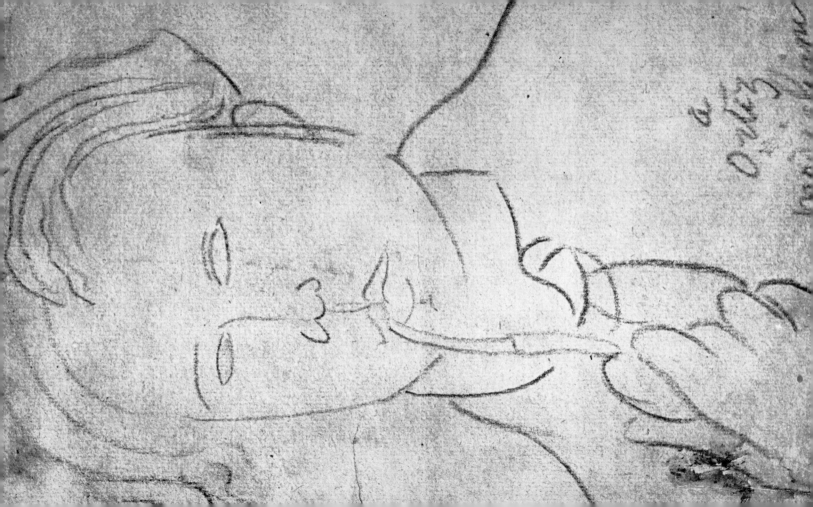

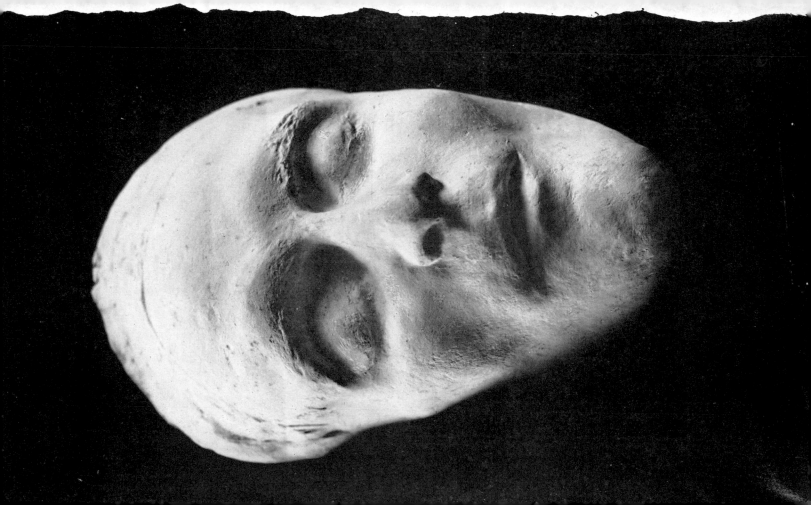

sleep for ever? A moment before, the dying lips had framed two words, caught anxiously by the watchers round the bed: 'Italia ... cara Italia ... '

It was January 25th, 1920.

As if sent out by mystic telegram, the news flashed over Paris from Montparnasse to Montmartre. Kisling notified the dead artist's relatives in Leghorn. He also sent word to Modigliani's brother, Emmanuel, the socialist deputy. In reply, Emmanuel wired: 'Bury him like a prince.'

Before the funeral several of Modi's friends were anxious to take a death-mask of him. Accordingly, in collaboration with Dr Raymond Barrieu and Conrad Moricand, Kisling tried to make a mould of Modigliani's face. They were unsuccessful. Horror-struck, they were obliged to rush to the sculptor Jacques Lipchitz for aid, bringing with them the broken pieces of plaster 'full of bits of skin and hair'. Horrified in his turn, the sculptor put the fragments together and replaced 'the missing parts' as well as he could. In this way he succeeded in obtaining twelve plaster moulds, which were distributed among Modigliani's family and friends.

It was in the mortuary at La Charité that Jeanne saw for the last time her dear one, whose violent love for her surpassed anything that could possibly be imagined here below.

She was pregnant. More beautiful because of the child she was carrying within her, she slowly approached the corpse. So pure and beautiful as to be frightening, Jeanne with her long plaits inspired awe in even the most hardened members of the hospital staff. They tried to pull her away as she leaned over her dead lover, whose cheeks and forehead were now open wounds. She thrust the well-meaning attendants aside with a light but firm gesture. When they persisted, she struggled with them fiercely, as if her fury came from the violent man who was now at peace for ever.

facing: Modigliani's Death-mask

They had to yield and permit her love's last rites.

The ever-faithful Kisling came into the room to be with her. He was never to forget her cry, the most terrible, heart-rending cry that ever woman uttered over a dead husband, as she stood there gazing at Modigliani. He went away quickly, unable to bear the sight of Jeanne kneeling down to embrace her lover in a long farewell, and also because she had said to him in a voice of ashes: 'I wish to be alone with him.'

When Jeanne reappeared among her friends they were astonished to see her face as composed and serene as they had known it in the days of her greatest happiness. Her tears had left no trace; they had not marked her pale and luminous face in any way.

In vain Mme Zborowska and Haricot Rouge pleaded with her to let them take her to the Tarnier Clinic. A room had already been reserved for her, and her child would be born soon, perhaps the next day. Their pleas were of no avail. Jeanne went straight back to her parents. They opened the door to her, but said nothing. One wonders what they may have said in private, what decision the family took on the eve of this birth which could only mean a scandal. Did they accept it as a tribulation sent by God?

Their silent daughter was to save them from it.

She went up to her room and opened the window wide. In the street below, the people swarmed as usual. In the window above stood the touching image of a 'Maternity' such as the great but penniless artist Modigliani might have painted. He had once been obscure and unknown; he was now well on the way to fame. He had come from Leghorn to Paris, haunted by a dream; he had paid a heavy price for genius; he was one of the chief figures of the School of Paris; and he had died in the paupers' hospital of La Charité, bequeathing the treasures he had created to the world and to Italy, *'cara Italia'*, his

native land, which was to take him to her heart and open the portals of her fanes of glory to him.

Suddenly a scream of panic rose from the street.

A pitiful heap of bleeding flesh lay on the pavement. A woman had just thrown herself out of the window.

'Go, Christian soul ... '

Suicide, of course, yet the Catholic prayer for the dying was not out of place here. The labourers and hard-bitten characters standing in the door of the wine-shop not far away removed their caps in silent respect. A woman, bent under her damp burden, made the sign of the cross as she trudged by on her way from the laundry.

The Hébuternes had been willing to allow their prodigal daughter to return home, but this tragedy put a new aspect on the matter. Society has certain rights over the dead, who must not be permitted to upset the normal course of events. The police took charge of the affair until friends came to the rescue because the family were too overwhelmed to act. Nevertheless, Jeanne's austere father made one decision: the torn and bloody remains of the young suicide and her unborn child should go back to the slum of a studio in Montparnasse. On the way from the bourgeois home behind the Panthéon to the Rue de la Grande Chaumière there was a grisly halt at the morgue. Consequently there was nothing for Amedeo's friends to do but arrange for his funeral, to 'bury him like a prince', as his elder brother had telegraphed before boarding the train for Paris.

IT seemed that there would not be time to wait for Emmanuel to arrive. The hospital authorities were anxious to get rid of Modigliani's body without delay.

A collection was taken up; a subscription opened. In one café a woman in a fashionably short skirt, her calves much in evidence, her curls poking out from her cloche hat, held out a few sous: 'For Modigliani's flowers.'

Three carriages loaded with wreaths, sprays, and bunches of flowers, from the most elaborate down to the most humble, were drawn up in the hospital courtyard. Emmanuel Modigliani, who had just arrived after all, stood apart, weeping silently. He and Kisling and I headed the long line of mourners.

Kisling, like me, was recalling the delirious gaiety at the time of his wedding, and all the wild pranks in that studio where Modigliani had so often come to work. Max Jacob had given a number of improvisations, caricaturing people we all knew, and to add to the fun Amedeo, whose drunkenness that day was light-hearted, had stolen the bridal couple's sheets, draped himself in them, and gone about playing ghosts from Shakespeare's plays. Now his own ghost was to haunt the paths of the Père Lachaise cemetery.

A long procession followed the hearse. Onlookers wondered who the celebrity could be. Such a vast crowd of mourners was not seen every day. In the cortège the mourners exchanged comments in low tones.

'Did you see the cops? They're saluting everywhere.'

'They're obliged to.'

'I know, but all the same — these are the men who used to chase Modi every time he kicked up a row at night.'

A Crown of Glory

Has night reclaimed you, Modigliani, master-painter of light, or have you indeed entered into the light everlasting?

The next day the ceremony was repeated, but for Jeanne there were scarcely a dozen mourners.

We assembled like so many conspirators at the appointed meeting-place. Zborowski had stationed his new car at the corner of the Boulevard Montparnasse and the Rue de la Grande Chaumière. Kisling and I had hired taxis. Our wives had come with us. The hearse stood in front of the tumble-down building which housed Modigliani's studio. We waited at the end of the street, flattening ourselves against the wall, hiding the bouquets of white flowers we had brought.

A car drove up and two men got out: one had a white beard, the other's was blond. Father and son. Father and brother of the dead Jeanne.

None of us took any notice of the glance the father threw in our direction. Orders had evidently been given to be as quick as possible, and a coffin, hardly larger than a child's, was brought out and placed in the hearse.

The macabre procession moved off, not to the stately Père Lachaise cemetery, but to the dreary burial-ground at Bagneux in the suburbs.

They did not dare ask us to leave the cemetery. The ceremony was short, but adequate. There was no priest, of course. The family had prayed privately beforehand. No doubt it was their prayers which prompted the father not to face the intruders, the handful of friends who now came forward with a mass of lilies, roses and carnations to serve as a white shroud for the dead girl. Father and son, father and brother, went off without looking at us, the son following his father's dramatic example. They looked an infinitely pathetic pair and we all pitied them.

Modigliani had swooped down on them like an eagle,

breaking into the quiet of their pious household. He was the Dantesque thief who had ravished their treasure and devastated their prim way of life. How could such people account for what must have seemed to them a divine punishment, something sent expressly to try them?

Three years later Modigliani's grave was opened and his beloved laid beside him, she who as death approached had agreed on 'eternal happiness' with him.

Now, to our tribute, our wreaths and flowers, Fame has added a crown of glory.

Acknowledgments